ICONS
and IMAGES
of the
SIXTIES

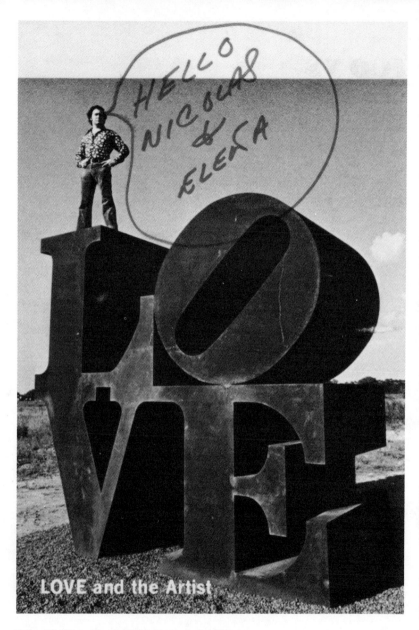

Robert Indiana: *Love*. 1969. Carved aluminum.

ICONS
and IMAGES
of the
SIXTIES

by NICOLAS CALAS and ELENA CALAS

E. P. DUTTON & CO., INC., NEW YORK, 1971

 A Dutton Paperback

First Edition

Published simultaneously in Canada by
Clarke, Irwin & Company Limited, Toronto and Vancouver

Library of Congress Catalog Card Number: 73–122796

SBN 0–525–13110–8 (Cloth) SBN 0–525–47285–1 (DP)

The following essays included in this book were originally published in
Arts Magazine in somewhat different form: "Roy Lichtenstein: Insight
Through Irony," "James Rosenquist's Angular Vista," "Leon Polk Smith,
the Pioneer," "Sylvia Sleigh," "Harold Keller," "Frank Stella, the
Theologian," "Art and Strategy," "The Phenomenological Approach,"
"Recent Developments in Tek Art," and "The Sphinx 1970."

About the cover design:
The cover painting by Arakawa is taken from his *Mechanics of Meaning.*

The text at the top of the painting reads as follows:

10 REASSEMBLING

AN INVESTIGATION OF THE ELEMENTS OF REASSEMBLY AND
OF THE POSSIBLE APPLICATIONS OF THESE IN ORDER TO
CHANGE USAGE

The text at the bottom of the painting reads as follows:

TO WHAT EXTENT IS = A FUNCTION OF + ?
The range of values for each + and = is wide open as long as the
above relations hold.
Other considerations are: $A + + + + + B = C$ $A + B = = = = = C$
 Color, positional changes in A. B
 If + is ten years (minutes) ahead of =
 Or a shift in any other dimension · · · · · · · · · ·

Contents

7 Contents

Illustrations

9 Illustrations

11 Illustrations

12 Illustrations

ICONS
and IMAGES
of the
SIXTIES

U.S.A. 1960–1970

According to Hegel, Romantic art corresponds to a historical period in which the contradiction between the universal and the subjective is made the subject matter of art. It is by means of a decomposition of art's elements that the artist, in a lyrical outburst, reunites himself with the universal, negating thereby the great negation, Death. This grandiose conception of art has haunted the atheist post-Hegelians, among whom the Surrealists and the Existentialists should be counted. Traceable back to Hegel are the aesthetic theories of the two principal apologists of the New York School of Art, Clement Greenberg and Harold Rosenberg. Greenberg reinterpreted universality in terms of a historical evolution with artists striving for immortality (i.e., fame) through the purification of art. For Rosenberg the artist's function is to exacerbate the contradiction between self and elements of composition to the point at which art is reduced to self-expression.[1]

The pioneers of the New York School, Gorky, Pollock, Rothko, de Kooning—each to a larger or lesser degree—discovered new poetic horizons and new means of expression through Surrealism and contacts with European artists living in and around New York in the forties. André Breton, the founder of Surrealism, has said that the mannequin is to Surrealism what ruins had been to Romantic art. The shift of emphasis from ruin to mannequin marks the transition from the archetypal disintegration of a masterpiece (exemplified by the ruin) to man's alienation from reality typified by de Chirico's faceless mannequin.

Far removed from a post-Hegelian outlook of the world is the generation of artists who came into prominence in the sixties. Their

[1] Nicolas Calas, *Art in the Age of Risk* (New York: E. P. Dutton & Co., Inc., 1968).

prophet is the composer John Cage, who emphatically dismisses history. In *Silence,* he has declared: "Contemporary music is not the music of the future, nor the music of the past, but simply music present with us: this moment, now, the now moment."[2] For the Existentialist's "experiences," Cage substitutes the magician's experiments. Cage's view of the *now* is theatrical, manifesting itself in performances undertaken by an assembly of experimenters in sound and movement, noises and gestures, in a spectacular happening.

Allan Kaprow's Happenings are to the theatre what Cage's silences are to music, a radical endeavor to liberate the present from past and future sequences. In a challenging article Kaprow develops his idea of the relationship between art and life.[3] Kaprow makes a distinction between cultural attitudes and cultural acts. Attitudes are to be applied to a zone "still unmarked between what has been called art and ordinary life." He is for the breakdown of lines separating one art from another and "between art of any kind (Happenings) and life." Among the artists influenced by the early Happenings should be counted Oldenburg, Segal, and Dine.

According to Kaprow the "experimentalist is one who is not only considered by the public and his colleagues as 'far out' but believes this about himself." Kaprow points out that "such an alienation has *nothing to do* with the social plight of the artist" (italics not in text). For him to be far out means "the detachment of the cultural experimenter from the body of culture." As we know from Margaret Mead, deviation is culturally determined. Kaprow himself notes that "the very notions of experimentation and brinkmanship are themselves a heritage of the last hundred years," which amounts to Harold Rosenberg's "tradition of the new."

Experimental art should be distinguished not only from traditional art but also from enigmatic art—whether mystic or Surrealist. The enigmatic provides us with new icons, the experimental with a new way of seeing. The enigmatic has to be interpreted, the experimental

[2] John Cage, *Silence* (Middletown, Conn.: Wesleyan University Press, 1961), p. 43.

[3] Allan Kaprow, "Experimental Art," *Art News,* March 1966.

debated. Currently, two different methods are used to account for the artistic experiment. The pragmatic-genetic method resorts to explaining the procedure involved in obtaining new images, as does David Antin in his study of Warhol. The formalist approach involves accounting for retinal effects of combinations of colors and forms, as in the case of Michael Fried's analysis of Stella, or the emotional impact attributed by Lucy Lippard to the variations and redundancies of the Minimalists.

On the grounds that freedom to provide new information could have revolutionary effects, experimental working hypotheses and experimental art can come to be seen as expressions of a revolutionary vitality.[4] Historically, reactionary institutions, be it the Catholic Church or the Politburo, fear that experimentation could promote revolutionary activities. The complementary opposite is in the assumption that all art of protest, being inflammatory, is by definition revolutionary. Even psychedelic art as such is considered by some as experimental since it is the product of experimenting with drugs (great visionaries, De Quincey, Baudelaire, and Michaux to the contrary).

By the end of the decade the substitution of earthworks to artworks poses the question in novel terms. This art is certainly anti-revolutionary since it is an escape from the cities, which are, potentially, epicenters of revolutionary activity. Historically it is a neo-Romantic movement which substitutes frustration for spiritualization, the pseudo-excavation for the ruin (Heizer), the useless wall for the remnant of an ancient wall (De Maria), senseless wrappings for ceremonial consecrations (Christo), the literal for the unknown, nostalgia for hope in the future.

The businessman who patronizes experimental and pseudo-experimental artists may well recognize in the endeavor of enterprising artists the aesthetic version of his gambling spirit.

Experimentation in art has had the paradoxical effect of making of methodology the subject matter of art, an idea most eloquently illus-

[4] Jean-François Revel, *Ni Marx, ni Jésus, la nouvelle révolution mondiale est commencée aux États-Unis* (Paris: Robert Laffont, 1970).

trated in Lichtenstein's use of the brushstroke as the content of a new image. In the sixties, art illustrates methodology the way the imagists of old illustrated the Légende Dorée, with this difference, that today it is the critic who has to justify the use of this new subject matter. When critics treat pictures as texts rather than as images, the public is expected to see art in terms of problems and solutions. Marcel Duchamp was fond of comparing critics to parasites feeding on artists; today many formalist artists would seem to aspire to be fed on.

When artists gave up making works that conformed to preestablished canons of beauty, critics who undertook to champion their cause had to renounce praise in the name of universals for a set of assumptions. In contradistinction to enigmatic representations which call for clarification through verbalization, recourse to methodology as subject matter has to be accompanied by theoretical elaboration.

The boundaries of the universal have been reduced to the rules of a game, played pictorially by the artist and verbally by the critic. Hence, the game's options serve as substitutes for the will and categorical imperatives of the Kantians, and for the repressed desires of depth psychologists. However, since existence cannot be reduced to a game, the historian will have to treat the language game artists and critics are playing as a cultural phenomenon to be projected into a time sequence including future as well as past.

Having learned from Lévi-Strauss that culture is a system of intervention, traceable back to laws of exogamy, we surmise that all basic cultural phenomena are systems of intervention. It would seem that art's main function is to substitute a fiction for a reality that culturally must be avoided.[5]

Since the artist acquired the right to paint the way he wants, three basic attitudes came to the fore, the Impressionist, the Expressionist, and the Constructivist. Impressionism focuses on changes in appearance, whether of a cathedral (Monet) or a cube (Judd); Expressionism stresses distortions of forms betraying the emotional involvement

[5] Nicolas Calas, "Art Intervenes, Anti-Art Interrupts," *Art International,* January 1969.

of the artist, whether of a piazza (de Chirico) or landscape (de Kooning); Constructivism restructures in new terms (Nevelson and Snelson). Since no art can be reduced to pure structure, all modern works carry overtones of either Impressionism or Expressionism.

Historically, most art that emerged in the late fifties to assert itself during the sixties marks a reaction to Abstract Expressionism. One of the most striking phenomena distinguishing the art of the sixties from Abstract Expressionism is its development of a new vernacular. The sculpture of Oldenburg and the painting of Lichtenstein are to the sophisticated painting of Pollock and Kline what the poetry of Ginsberg is to Auden's.

The reemergence in the sixties of the cult of Marcel Duchamp was a healthy reaction to the Abstract Expressionist's sin of pride. The artist's self-criticism finds its fullest expression in the work of Jasper Johns. It was left to a follower of Clement Greenberg to detect in the "purity of the painting situation" cultivated by Morris Louis and Noland a "nobler and less manifestly self-centered mode of expression."[6]

In 1964, for the first time in its history, the Venice Biennale gave its much coveted first prize to an American painter and, perceptively, awarded an artist who more than any other seemed to be possessed by the demon of experimentation, Robert Rauschenberg. Only four years later, propelled by a revolutionary ardor which first exploded in Berkeley in 1964, European artists and students made a shambles of the Venice Biennale of 1968. Since then this venerable institution has renounced the practice of awarding prizes. An excellent substitute for the discredited prize system was the effective price-boosting of works of living artists at prestigious auction centers.

At the beginning of the seventies the promising artist is caught between attraction to the restless campus youth and the temples of Moloch. The liberal critic, dealer, and collector tells him that they are not irreconcilable and that, in the name of art for art's sake, he can have his cake and eat it, too. It does not take very noble sentiments to

[6] Alan R. Solomon, "Four Germinal Painters," in catalog for *XXXII* Esposizione Internazionale d'Arte, Venezia 1964.

elaborate geometric patterns, nor very perverse ones to distort a toilet and a bathtub. As long as art is but a game, the soundest pragmatic criterion of a work will be the market price.

N.C.

Art of Assemblage

Assemblage with its basically trial-and-error approach is the opposite of planned structuring. In planned art, whether geometric painting or constructivist sculpture, parts function in relation to the whole as in works by Tatlin, Mondrian, Max Bill, Vasarely, Stella, Judd. Assemblages in their pure form are composed of heterogeneous parts which are apt to have a significance for either the artist or the viewer or for both, independent of their functional role in the composition as a whole. Assembled objects, natural and man-made, differ widely, ranging from personal mementos to industrial waste, from bric-a-brac to hardware.

The Surrealists' found object (*objet trouvé*) is a glaring example of substitution for a lost, mourned, and forgotten treasure of childhood days. Assembling presupposes a reexamination of objects already hoarded in the "treasury," a tentative selection of those suited to immediate needs. This is equally true of the present-day artist and the magician of a primitive tribe, but unlike the African or Australian aboriginal,[1] the modern assemblagist has at his disposal a variety of means for collecting new acquisitons. The wastepaper basket was Schwitters' treasury; most go further afield, hunting in backyards and lofts or shopping for supplies. Only one artist, Louise Nevelson, undertook to reconstruct the treasure box itself.

Contemporary assemblages are traceable to Cubist and Dadaist collages, to such famed works as Marcel Duchamp's *Bicycle Wheel* (1913) and André Breton's *Objet-Poème* (1941). Retrospectively, the assemblages of the twentieth century have emerged as a new genre to be distinguished from sculpture and painting, reliefs and mosaics.[2] Size most notably differentiates boxed or framed assem-

[1] Claude Lévi-Strauss, *Pensée Sauvage* (Paris: Plon, 1962), p. 29.
[2] Dore Ashton, Lawrence Campbell, Parker Tyler, Elaine de Kooning, Ber-

blages from "environments," with the two retaining in common an aura of impermanence reflecting, as it were, the spontaneity that brought them into existence.

Joseph Cornell

In this country Joseph Cornell, with his magic, fragile boxes, was the immediate forerunner of the assemblagists. Although influenced by the Surrealists, more specifically by the collages of Max Ernst, Cornell's work in spirit and technique is uniquely his own. In contrast to the Surrealists, Cornell does not seek to shock but to seduce, as he himself is nostalgically seduced by the baubles, bric-a-brac, and trivia which he collects, often haunting secondhand and antiques shops, or picking up debris on beaches and in backyards.[3] Cornell's art is evocative: never resorting to storytelling, he invites the viewer to make his own associations. Through the years the artist became increasingly involved in formal relationships. The spare, almost abstract composition *Multiple Cubes* (1946–1948) (undoubtedly influenced by Duchamp's *Why Not Sneeze?*), is one of his most beautiful works.

Joseph Cornell was the first contemporary artist to enclose "found objects" in boxes, systematically making the latter an integral part of the composition. He introduced repetitive elements (borrowing the effect from early cinema), both images—cutouts—as in his Medici series (*Medici Slot Machine,* 1942), and objects, as in his *Pharmacy* (1943), with their rows of similar glass jars arranged neatly on cabinet shelves (albeit each jar differing in its contents). Repetition within a single box is paralleled, from the forties on, by series of boxes treating the same theme with variations in the arrangement of similar objects as in the case of his *Soap Bubble Set, Aviaries,* and *Pharmacy.* Cor-

nard Pfriem, and Jeanne Reynal, *Mosaics of Jeanne Reynal* (New York: George Wittenborn, Inc., 1964).

[3] Elena Calas, *The Peggy Guggenheim Collection of Modern Art* (New York: Harry N. Abrams, 1967), p. 122.

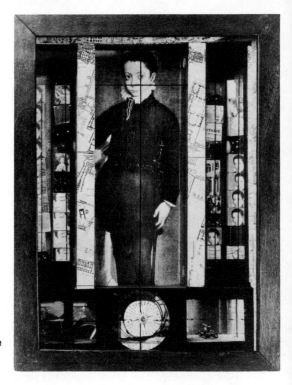

Joseph Cornell: *Medici Slot Machine*. 1942. Construction. 15½" × 12" × 4⅜". In the collection of Mr. and Mrs. Bernard J. Reis, New York. Photograph courtesy of The Metropolitan Museum of Art, New York.

nell is among those who anticipated Serial art, although, perhaps paradoxically, each of his creations is a miniature world in its own right. Assemblagists who inherited Cornell's concept of boxed units are moreover indebted to him for the use—very early in his career— of reflecting mirrors which dramatically enhanced the presentation. Sound and movement, although requiring hand manipulation, were first brought by Cornell to the art of assemblage.

Assemblage, as such, made its official debut in New York in 1960. With a sigh of relief an art world fed on gestural painting for some 15 years, welcomed the exhibition "Junk Art" sponsored by the late Martha Jackson. This was followed by an impressive exhibition at the Museum of Modern Art (1961) under the title "Art of Assemblage," a survey of works from the collages of Picasso to the combines of

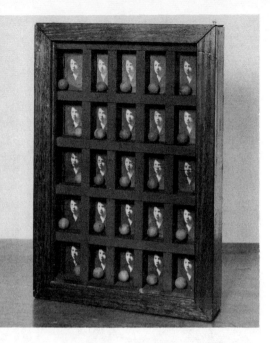

Joseph Cornell: Untitled (sometimes referred to as *The Medici Boy*). Late 1950s. Box construction. 15½″ × 10¼″. Photograph courtesy of Cordier and Ekstrom Gallery, New York.

Rauschenberg. The show was organized by William Seitz, whose informative introductory essay helped direct the public's attention to the development of this largely nonpainterly art. The exhibition of assemblages held in 1962 at the Janis Gallery, the stronghold of Abstract Expressionism through the fifties, confirmed the timeliness of the new orientation. It was labeled "New Realism" by its organizer, the Parisian critic Restany, to lend emphasis to the circumstance that the works were constructed from mass-produced parts.

Icons of the new reality came to be provided by Pop art.

Nevelson's Shadows and Reflections

We had grown accustomed to being impressed by Louise Nevelson's great wood assemblages for some ten years, ever since the exhibition of her first *Sky Cathedral* (1959) with its improbably irregular

composition and the extravagant diversity of component units: stacked boxes of every size and depth crammed to overflowing with "found objects," each unit of the whole uniformly dipped in mat black paint, visually fusing the agglomeration.

This was followed by *Dawn's Wedding* (1959), a stately white enclosure, an environment, consisting of a wall sculpture and free-standing pieces, i.e., the wedding columns, squared wood pillars richly encrusted with diverse wood fragments. (Before the advent of the boxes and the "wall," the artist concentrated on free-standing sculpture while the idea of the column was shortly further developed in an exhibition devoted exclusively to columns, both ascending from the floor and descending from the ceiling.)

Nevelson's found objects have as common denominators their material, for it is limited to objects of wood; their fragmentation and apparent interchangeability, apart from considerations of form; their intended lack of intrinsic interest or power of evocation. Seitz, in his *The Art of Assemblage,*[1] most completely and lovingly details the materials of this period, which he views as amounting to a painter's palette: "Boxes of many shapes and sizes, newel posts, the arms, seats, splats and backs of chairs, legs from many kinds of tables, wooden disks and cylinders, balusters and finials, chunks of natural wood and, from the lumberyard, lengths of patterned moulding, acanthus scrolls, and clean boards."

According to Colette Roberts,[2] Nevelson originally got the idea of enclosing her finds in boxes from commercial liquor cases with their built-in, crossed separations: ready-made crates to house found objects. This led to the use of shadowboxes of varying sizes and depths which, in the years to come, were to differ widely in content, mood, and concept and to the stacking of boxes to form ensembles.

The early assemblages, resorting to stacked shadowboxes, were simple and sparse, often stark. *The Moon Garden Reflections* (1957)

[1] William C. Seitz, *The Art of Assemblage* (New York: Museum of Modern Art, 1961), p. 118.

[2] Colette Roberts, *Nevelson* (Paris: The Pocket Museum Series, Editions Georges, Fall 1964), p. 21.

consisted of three boxes with but a few found objects to each box. Yet already clearly displayed was the premise that the tension inherent in the right angles of the enclosures, the verticals and horizontals, held the piece together, created architectural unity. Seminal to the artist's whole oeuvre was her concept of the shadowbox with the interplay between space and shadow, depth and surface reflection.

The artist has said: "I really deal with shadow and space. I think those are the two important things in my work and for me because I identify with the shadow."[3] Her titles of the sixties confirm this attitude: *Diminishing Reflection* (1965), *Expanding Reflection* (1966), *Shadow Sphere No. 1* (1966), *Shadow and Reflection I* (1966). Succinctly Seitz wrote describing the effect of gilding on an assemblage: "Depth is flattened, but the reflecting surfaces delineate each block, sphere or volute, dowel hole, slot or recess, with scholastic thoroughness and precision."[4]

In the sixties Nevelson brought to a prodigious climax the flamboyant style inaugurated by her *Sky Cathedral* while already experimenting with works to be dominated more and more by strict regularity. Of the former, the two extreme examples differ widely in the mood they convey, although both are "walls" completed in 1965. *An American Tribute to the British People* (1961–1965), a great golden iconostasis endowed with semblances of cross, altar steps centrally positioned, and balanced side wings, is a glorious manifestation of majesty and equilibrium (Tate Gallery, London). An almost brutal forcing together of elements is the effect produced by the black *Homage to 6,000,000 II,* which is in exceptionally high relief with far-projecting vertical crates, recessed great disks, sharp edges and points, rough planks, nailed and glued together crudely (Israel Mu-

Louise Nevelson has said of the cube that Picasso had resolved it, Mondrian had flattened it out, and that she herself has both deseum, Jerusalem).

[3] John Gordon, *Louise Nevelson* (New York: Whitney Museum of American Art, 1967), p. 11.

[4] Seitz, *op. cit.*, p. 118.

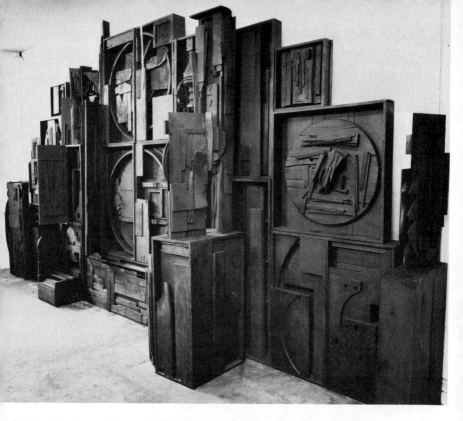

Louise Nevelson: *Homage 6,000,000 II.* 1959–1964. Wood painted black.
108″ × 216″. Photograph courtesy of Pace Gallery, New York.

veloped it and endowed it with poetry. Nevelson's cube truly came
into its own in the sixties with the orderly regularity of the stacked
boxes, uniform in size. The contents of the boxes, at first richly
varied, becomes more simple and geometric. Repetitiveness in the
sense of variation on a theme is introduced (but never actual repeti-
tion). In *Shadow Sphere, No. 1* (1966) the precise verticals and
horizontals of the cubes are essentially contrasted to an interplay of
arcs and a counterpoint of small spheres. The verticals of the en-
closed columns accentuate the verticals of rectangles in works such as
Night Zag IV (1965). In *Diminishing Reflection: World Gesture*

Louise Nevelson: *Diminishing Reflection: World Gesture.* 1966. Silk-screened plexiglass and wood. 76″ × 46″ × 3″. In the collection of Mr. and Mrs. David L. Paul, New York. Photograph courtesy of Pace Gallery, New York.

(1966) inserted cubes, big and small, of irregular aspect call attention to the austerity of the enclosures; in this latter work Plexiglas was included while in a number of others of this period mirrors were used to heighten reflection.

In the middle sixties the artist moved away from the exclusive use of wood, as well as from the found object, to work with industrial materials, resorting to Formica, Plexiglas, Lucite, aluminum, magnesium, and so on. Basically her quest remained unaltered: though the solutions may vary, her preoccupation is with the interplay of

shadow and reflection, of verticals and horizontals, rectangles and curves. The projections and recesses of the "walls" are translated into the patterns formed by the solids and voids of free-standing constructions. The very personal handicraft effect of her earlier empirical approach to her work is replaced by the precision and perfection of factory execution when directed in every minute detail by a meticulous craftsman.

A series of works entitled *Atmosphere and Environment* is undoubtedly the most impressive of the later sixties. *Atmosphere and Environment VI* (1968), of black enameled aluminum, is part of a collection on view at the Museum of Modern Art, summer 1969. Structurally and visually a single free-standing unit, it consists of six evenly staggered sections which form, however, a perceptibly unbalanced amphitheatre with three of the sections receding in space and three advancing.

The great sculpture is composed of deep open-ended (with the exception of four) rectangular compartments, uniform in size, which appear to vary because of the staggered position of the sections and the disposition in depth of the pieces within each compartment or box. It is the ingenious variation in the setting of the pieces that

Louise Nevelson: *Transparent Sculpture IV*. 1967–1968. Clear lucite. 20″ × 34″ × 31″. Photograph courtesy of Pace Gallery, New York.

fascinates, for the pieces are all but limited to disc sectors, cylinders, and rectangles of different sizes. The disposition of the pieces never repeats itself, no two boxes-containers are the same, however slight the transpositions. The pieces are parts of a three-dimensional puzzle whose geometric pattern emerges or disappears as the pairings of the boxes change while we gradually shift our vantage point to enjoy the magic effects created by the artist.

Transparent Sculpture IV (1967–1968) is a small-scale version of *Atmosphere and Environment VI,* presented, so to speak, on its back—i.e., reclining on four of its sectors. This enchanting construction of pure Lucite and a small number of others akin to it, such as *Model for Atmosphere and Environment: Ice Palace I* (1967), consists of tiers of transparent cubes shimmering with refraction. The cubes and their enclosures—an absolute minimum of geometric variants—are held together by polished steel pins which subtly emphasize the interplay of geometric elements. This interplay is emphasized more aggressively with the addition of dark bolts as in the *Canada Series* (1968).

Bewitching as those structures are, the time-consuming process required for their production prompted the artist toward other creative ideas. In no way does this account pretend to cover the range of Nevelson's creative ramifications of the past decade which must include works such as the triangular, mirror-lined *Silent Music I* (1964) and the lyrical complex of *The Tropical Rain Forest Presence* (1967).

Undoubtedly, the furthest removed from the shimmering, airy, and icy Lucite structures are the massive coffers of black-tinted wood which she included in her exhibition in Paris in 1969. Entitled *Cryptic Series,* those coffers might have been inspired by the so-called captains' chests of New England whaling days, as well as by pirates' legendary treasures. Their lids held open, the chests are mostly crammed with heavy loot; however, the encrustation on lids and sides is paradoxically weightier. Is it the result of decades on the ocean floor? Those mystery-laden chests cannot be seen as entirely unexpected, for they were foreshadowed in concept by *Ancient Secret* (1964), a double-door standing cupboard seemingly jammed with

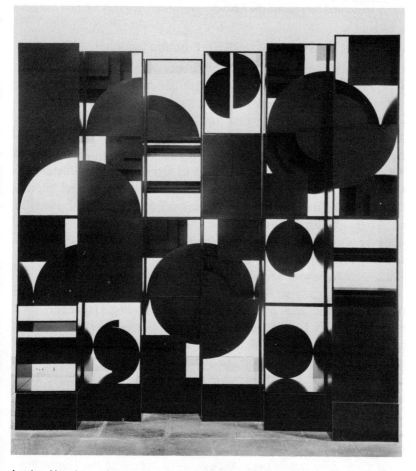

Louise Nevelson: *Atmosphere and Environment VI.* 1968. Magnesium and black epoxy enamel. 102″ × 96″ × 48″. Private collection, New York; photograph by Ferdinand Boesch.

secret revelations. The minimal variation on a theme displayed in her recent great metal constructions, and, even more, in her 1969 austere black wood murals such as *Night-Focus-Dawn* (1969) gives way in the chests to a veritable outpouring of riches.

E.C.

George Segal's Earthbound Ghosts

Segal's squat, lumpy plaster casts have been with us since 1961. Their appearance is dictated by their very origin: those casts of real men and women are reassembled pieces of outside molds, thicker by the width of plaster and cloth than the models themselves. Throughout the years Segal has continued to experiment with his method of casting. The lumpiness of the finish—if it can be rightly called that—is the product of his hands, his only tool to give molding and texture. In modeling the face he is not interested in portraiture; a general impression suffices. This accords with the intended anonymity he lends to his sitters by his impersonal titles, *Woman in Doorway* (1964), *Walking Man,* (1966), *Girl Brushing Her Hair* (1965). There are exceptions such as the portrait-casts of *Richard Bellamy Seated* (1964) and *Sidney Janis with Mondrian's Composition* (1967).

It is widely held that Segal's early work was much influenced by his friends' experimentations with Happenings (the first Happening took place on Segal's New Jersey farm). Understressing the individual in favor of generic man, a desire to question and equate the relative standing of man and object, the preoccupation with "total environments": to a degree, these were Segal's attitudes. But there were important differences. As man and artist, Segal did have a warm, underlying interest in the human condition and was to take into account more and more psychological considerations and seek to capture evidences of the interplay between persons. Conceptually, the main divergence was between the space-time focus of the Happenings and the gesture frozen in time, the "significant pose" or "the weighty repose" of Segal's mummies. With them nothing is happening, they simply exist. Thirdly, the spontaneity and minimum direction, so central to the excitement and tension created by the Happenings, were unacceptable to Segal, who, after carefully selecting appropriate models, goes on to choose and direct their poses and gestures.

The hallmark of Segal's work has consistently been the combination of his plaster casts and real objects from the environment. Those may be as simple as a plain wooden chair on which a woman is

seated, hands folded, or as "total" as a room and sections of a real truck, bus, subway, and as elaborate as a dentist's office with its true-life dental unit and chair (recently the whole painted off-silver), the interiors of *The Diner* (1964–1966), *The Butcher Shop* (1965) *The Gas Station* (1964) with their customary or transient inhabitants, and two recent settings portraying the artist at work in his studio. Through the years Segal has appeared to have given varying relative importance to the figures and the environment. It is noteworthy that in *Laundromat* (first exhibited in 1967) he placed the waiting woman, who is seated and reading a book, in a setting which includes the laundry machine to her left and an unoccupied chair and a clothes dispenser at her right; the next version of the work[1] omits the laundry machine. By 1969 the work has been reduced to the waiting woman against a corner of a wall, in yellow and blue, the latter with imitation tiling, appropriate to a laundromat, but not really a feature of identification. Yet, *The Subway* (1968) requires a very elaborate installation, not only a section of a subway car but flashing electric lights to suggest motion between stations. It has sometimes been said that the real functional objects that Segal uses for his sets seem more unreal and functionless than his plaster set of characters, for example, the man stepping out of the bus in *Man Leaving a Bus* (1967). Phyllis Tuchman has written: "Strangely, these plaster figures seem more real than the 'real' objects which surround them. *The Dentist* (1966–1967) will leave his office before his tools will help a patient."[2]

Segal prefers to make casts of persons he knows well, family members, relatives, friends, and to place them in characteristic poses and in surroundings familiar to them. Segal says that when the body is relaxed ,"then it reveals itself." An admiring critic has written: "The language of the body—relationships between limbs and torso, muscle tensions, posture and carriage—offers a rich vocabulary of signs . . . The bodies of Segal's faceless (wordless) people become all

[1] Reproduced in the catalog of the Chicago Museum of Contemporary Art, Spring 1968.

[2] Phyllis Tuchman, "George Segal," *Art International,* September 1968.

face."[3] Interestingly, this quotation is from an article in part subtitled: "George Segal's plaster people, caught in poignant gestures of loneliness. . . ." As another critic has pointed out, Segal's very method of casting contributes to a sense of isolation: "As man can feel imprisoned within himself, Segal can imprison him within a mold, capturing his solitude and uncertainty as the prevailing mood."[4] Segal's solitary figures have the strongest impact on most viewers, perhaps because they best lend themselves to self-identification. An early work, *Woman in a Restaurant Booth* (1961–1962), is the very personification of isolation and self-absorption, as she sits on the edge of her seat in the furthest corner of the bench, over a cup of coffee which we presume to be cold. A powerful sense of alienation is provided by *The Restaurant Window* (1967), in which the solitary occupant of a small empty table and the chance passerby in the street are totally unrelated, in formalist composition.

In *Legend of Lot* (1966), which includes four figures, there is a curious juxtaposition of action and withdrawal. The action is provided by the eldest daughter portrayed mounting Lot, who is on his back listless in his drunken stupor. Lot's wife, looking backwards and turned into a pillar of salt, literally embodies immobility and isolation. It is the younger daughter who watches the carnal scene standing alone, aloof, with arms folded across her chest, that, psychologically, is of the most interest. From the Old Testament we know that she will follow her sister's example, but what in her isolation is she

[3] John Perreault, "Plaster Caste," *Art News,* November 1968.

[4] Jan van der Marck, Introduction to catalog of Museum of Contemporary Art, Chicago, Spring 1968.

(*Right above*) George Segal: *Woman in a Restaurant Booth.* 1961–1962. Plaster, wood, metal, leather, and formica. 48″ × 78″ × 60″. In the collection of Wolfgang Hahn, Cologne. (*Right below*) George Segal: *Legend of Lot.* 1966. Mixed media. 72″ × 96″ × 108″. In the collection of Kaiser Wilhelm Museum, Krefeld. Photographs courtesy of Sidney Janis Gallery, New York.

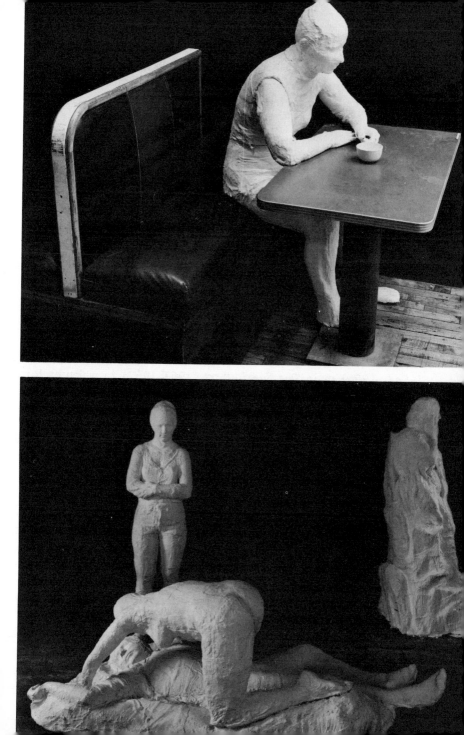

thinking and feeling at this precise moment, here frozen for all time?

The reverse of self-absorption and isolation is also present. *The Bus Driver* (1962) in the cropped bus section is calmly concentrating on the road ahead while steering; in *Gottlieb's Wishing Well* (1963) the slightly stooped figure is intent on the pinball machine; *John Chamberlain Working* (1965–1967) conveys engrossed and powerful activity. Inert vacuity is embodied in the relaxing *Farm Worker* (1962–1963) whose sloping shoulders and rounded spread of legs are in immediate contrast to the rectangles of window and bricks of the house wall; the bathos of boredom coupled perhaps with fatigue is evinced in the sloppy pose of the idle attendant in *The Parking Garage* (1968); cheerful, alert, comfortable conviviality is obvious in the figures of Segal and his companions at the *Dinner Table* (1962), as well as cunningly reflected in a hanging mirror. Naturally enough, Segal has made casts of a number of couples and lovers in his wish to explore and hold fast an intense moment of human interaction. However, the result as often as not reflected not heightened mutual concord, but again isolation, whether in postcoital sleep in *Couple on a Bed* (1966) or in *The Sun Bathers* (1963–1967) in which each of the pair is withdrawn into his and her moment in the sun. Over the years the latter work has undergone changes—as is frequently the case with Segal's sculptures—but the couple has not been brought together. Segal in his quest has experimented with extreme forms of human interaction, sexual intercourse, and Lesbian lovemaking, but according to him too many out-of-context tensions interfered—hardly surprisingly.

George Segal is very conscious of formal considerations. He takes great pains with composition and spatial relationship. When working on *Artist in Studio* (1968), he has been described as preoccupied with how much of his actual studio should be included: the studio rafters? the linoleum on the floor? and always the matter of spacing: the precise distance between cast and object, between casts, between objects. The recently completed *Man on Scaffold* (1970), an outdoor sculpture, vividly exemplifies his approach. The yellow scaffold itself is a functional commercial article used by small-home builders. The

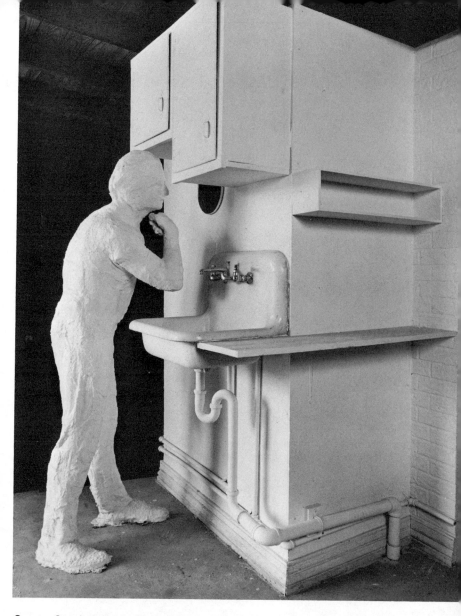

George Segal: *Artist in His Loft*. 1969. Plaster, wood, porcelain, metal, and glass. 7'7" × 68" × 64". Photograph courtesy of Sidney Janis Gallery, New York.

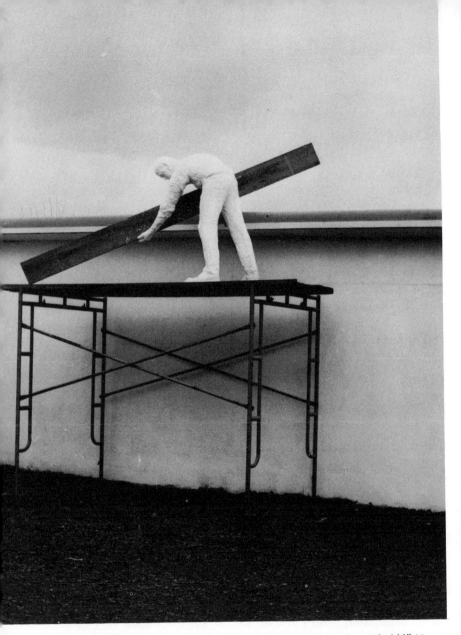

George Segal: *Man on Scaffold*. 1970. Plaster, wood, and metal. 144″ × 96″ × 60″. Photograph courtesy of Sidney Janis Gallery, New York.

plaster cast is that of a true-life workman (and a friend of the artist's), hence the tension evidenced in the arms and back of the man lifting a ten-foot plank is true to life; "he would break his back if he did not know how to handle that weight," Segal commented. The workman is placed on the first aboveground level of the scaffold and initially Segal intended to end the environment at this level, but he found that the figure was "lost against the sky" and went on to "define space" by adding a second level of flooring. To make explicit the workman's effort, the second level of flooring is still missing a plank, this last plank which he is shown as lifting.

With some exceptions, not too successful, Segal has limited use of color to the environment. (Segal started out as a painter and has remained color-conscious.) The yellow tiles of the bathroom is a very felicitous choice against which to set the cast of *Woman Shaving Her Leg* (1963). His famed *Cinema* (1963) expands his use of color to include electric lighting: the brilliant red of the cinema sign is seen against a white Plexiglas field, lit from behind the glass. In his most recent works Segal wants to dramatize white-black juxtapositions and starker "constructivist" settings, as he himself points out. In *Shop Window* (1969) the cast of a girl (with inserted glass eyes) is placed standing against a black door in a space defined on one side by a white, empty, brightly lit store window and, on the other, by a corner of a black wall with a rectangular inset of glass which permits us to view the figure from another angle.

An innovation was introduced in *Glimpses You See Down a Street* (1969). This work consists of four black-framed units or boxes of equal size (5′ × 2′) hung side by side, each enclosing a tableau that might be glimpsed when walking down a small-town street. The interest lies in the composition. The boxes are hung in a row on a wall some two to three feet up from the ground; thus the head level of each figure varies depending on whether he or she is sitting, standing, or whatever. The lowest head level is that of the woman in the first box, seated as she is in the window of a cafeteria (at a cropped table with a cropped extra chair and a cup and saucer; in contrast to saucerless cups in *Woman in a Restaurant Booth* and *Ruth in Her*

Kitchen). The second box contains the cast of a man in a doorway with his head level normal for a standing man but legless because of the frame. The third box represents a bar window curtained sufficiently low to display the top half of a male figure on a bar's high stool. The fourth has a woman looking out of a second-story window of an imitation-brick house front with only her head, shoulders, and arms visible, but her head level is, naturally enough, the highest of the four. (Almost inevitably, a casual viewer would be ready to assert later that the boxes themselves were staggered.) Instead of isolating episodes, Segal here presents them as a series, a succession of house fronts, reduced to window or door, forming a unit as in a set. The subject matter of each box is not new. What is new is a readjustment of each scene to fit what might be called the "aesthetics" or the series.

E.C.

Edward Kienholz: The Assembler as Preacher

It has sometimes been asked whether Kienholz's assemblages should be considered as works of art. His violent depictions of human degradation shock, his faint regard for aesthetic considerations are unacceptable to the formalistically oriented. With Pop-culture exponents, despite their common fixation on the American experience, he cannot be fully identified because of the ferocity of his message or rather the brutality lent by the figurative elements to which he resorts, the language in which he chronicles the moral evils of our society. From the vantage point of the West Coast, Nancy Marmer sees Kienholz as sharing the mental climate of the beat poets of a decade ago with their "ambivalent nostalgic-damning vistas" of the American scene. As Miss Marmer points out, this proto-Pop artist "has transformed motifs and bits from American urban folklore (e.g., the automobile as passion pit, or the John Doe family, the abortion underground, patriotic sentiments as household decor) into bizarrely gothic alle-

gories on the decay, human contamination, and psychic disorders underlying banality."[1]

Kienholz started out in the mid-fifties with "broom paintings," wall-panel assemblages of discarded bits of timber painted over crudely with dense pigment and a broom.[2] He went on to affix found objects to the panels, whose bulk and aggressiveness grew apace. To single out one panel: in *Conversation Piece* (1959), mannikin legs, severed thigh-high and booted, are thrust out at a straight angle at the viewer (44" × 30" × 37").

The erstwhile found objects gave way to preferred ones, those which were to constitute his basic vocabulary: mannikin parts, plaster heads, dolls and doll parts, bones, skulls, fur, stuffed birds and even a fish, stuffed toys, stuffed cloth, clothing, cans (garbage and milk), pails, mirrors, lamps, as well as sheet metal, steel wool, various metal parts and gadgets, entire machines. In his *Odious to Rauschenberg* (1960, free-standing) he included, appropriately enough, a stuffed deer's head, a motor, a diathermy machine, a tape recorder, as well as painted wood and canvas. This vocabulary was vastly and painstakingly expanded according to the staging requirements of each of his increasingly complex assemblages.

Such objects could not be wall-bound effectively. Kienholz was soon led to the use of the box as framework and then to both free-standing assemblages and to his environmental assemblages which he prefers to call "tableaux." Kienholz continues to see his environments, specifically his famed *The Beanery* (1965), as "a large box or shipping crate"; this would apply to his other "walk-in" enclosures, such as *Roxy's* (1961, brothel's front parlor), *While Visions of Sugar Plums Danced in Their Heads* (1964, bedroom interior with a bedded couple), *The State Hospital* (1964–1966, a six-sided complete cell which, however, is viewed through a peephole in its locked door).

[1] Nancy Marmer, "Pop Art in California," Lucy R. Lippard, ed., *Pop Art* (New York: Frederick A. Praeger, 1966), p. 140.

[2] Maurice Tuchman, "A Decade of Edward Kienholz," introductory essay to the exhibition at the Los Angeles County Museum, 1966.

Increasingly, each assemblage has a tale to tell, one with a pointed moral. (There are exceptions: the series of juxtaposed objects since 1963 without any apparent social message of criticism, such as—perhaps—the much publicized *Friendly Gray Computer* [1965]). An early free-standing work ("freewheeling" would be more exact) is a broad satire on male self-delusion. *John Doe* (1959) is represented by the clothed upper portion of a store dummy endowed with every standard status symbol, inanely smiling in a baby stroller equipped with white-wall tires. The unclad lower part of the mannikin is seen only from the rear.[3] In the rebus presented by *History as a Planter* (1961) moral criticism goes far deeper, for here we are confronted with a reminder of human atrocity and society's apathy to an evil that passage of time conveniently blurs, the mass extermination of Jews in Nazi ovens. Undoubtedly, the most offensive work to date is the *Illegal Operation* (1962), an ensemble portraying the aftermath of an abortion which includes such nauseating objects as bloody pans, stained chair, scalpels, an empty box of "coets" in a pail.[4]

Hard to stomach is a later tableau, *The State Hospital* (1964–1966).[5] This tableau shows an emaciated old man lying naked and in an arm restraint in a bare cell with a bare light bulb overhead and a bedpan that is out of reach. In an identical position, in an identical cot above his own, he has an alter ego, a duplicate of his suffering self. The pathos embodied in the old man and his double is real, despite their fiber-glass bodies and the device of enclosing glass bowls with two live black fish each in their heads. The upper figure, enclosed in a transparent fishlike bubble, is connected to the lower figure by a finlike projection reaching just above the latter's head: it represents the old man's only thought, his awareness of the misery of this moment and of the duplication of this moment ad infinitum.

[3] *Ibid.* (quoting Donald Factor).

[4] The enumeration and description of medical props used to add gruesome realism to the scene has been given, interestingly enough, by the Minimalist painter Jo Baer, "Edward Kienholz: A Sentimental Journeyman," *Art International,* April 20, 1968.

[5] Described briefly by the artist in his *Concepts,* i.e., summaries of projected works which may be bought before their construction.

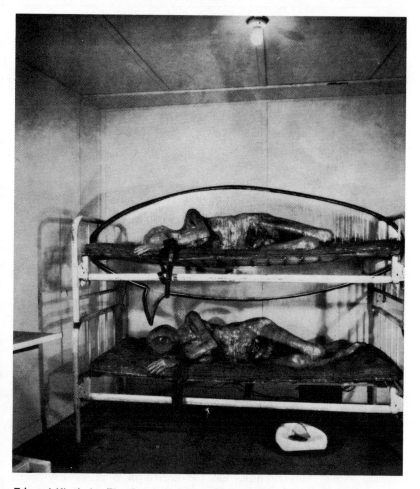

Edward Kienholz: *The State Hospital* (interior). 1964–1966. Mixed media. 8′ × 12′ × 10′. Photograph courtesy of Dwan Gallery, New York.

This is a far cry from his store dummies, his simplistic mannikins of a few years back, whether dismembered, truncated, or split vertically. However, even fiber-glass figures are apt to differ broadly in *vraisemblance,* as well as the depth of meaning conveyed, witness the two absurd swollen-headed humanoids bedded together in *While Vi-*

sions of Sugar Plums Danced in Their Heads (1964). The grotesque heads constitute an ironic counterpoint to the painstakingly staged bedroom of the "average" couple, crammed as it is with real-life minutiae. But what goes on inside those heads? Through an alternately lit peephole in each of the oversized heads, we glimpse tiny tableaux of past sexual deeds or fantasies. These memories, these visions from the past secreted within each of the partners, presumably feed the lust of the present coupling.

Kienholz is obsessed by the passage of time. He takes extraordinary care to set his works in a chronologically relevant time setting. Newspapers bearing dates are already on view in his early tableaux— see *History as a Planter;* objects associated with a given epoch are carefully included, such as the coon's tail attached to the radio aerial of the *Back Seat Dodge—'38* (1964), a work composed in 1964. Here a striking effort is made to confront the viewer with the feel of a not too distant past: a number of mirrors within the Dodge enclosure forces anyone looking in at the pair locked in coitus to lose his detachment as a latter-day observer when he sees himself held in reflection and somehow guiltily involved in this happening of some two decades ago. Kienholz instigates voyeurism again and again, whether the peeping is grossly physical as in *Birthday* (1964) ("If one looks between the legs of the girl mannikin giving birth, one is confronted by a mirror")[6] or mind reading as in *Sugar Plums.*

Many of Kienholz's works suggest that his obsession with the passage of time are linked to the Biblical view of the transitory aspect of life, human vulnerability, and the horror of a mindlessly spent lifetime. The human condition as such is portrayed devastatingly in *Birthday,* which evokes an apparently agonizing, dismal, and unwanted birth, and in *The Wait* (1964–1965), the desolate ebbing of life in skeleton-like old age weighted down by senseless mementos. In between are the joyless couplings of robots.

The most ambitious real-life tableau of Kienholz is his famed seven-foot-high interior of *The Beanery* with its patrons and barman copied from a real joint which the artist frequented. Tape-recorded

[6] Max Kozloff, *Renderings* (New York: Simon and Schuster, 1968), p. 245.

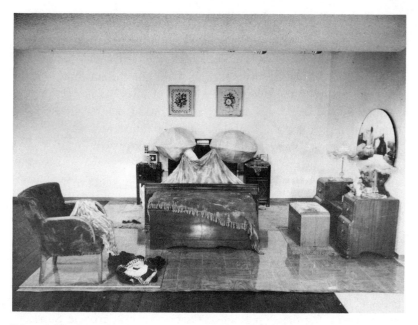

Edward Kienholz: *While Visions of Sugar Plums Danced in Their Heads.* 1965. Mixed media tableau. 12′ wide. Photograph courtesy of Dwan Gallery, New York.

Edward Kienholz: *The Beanery.* 1965. Mixed media. 7′ × 6′ × 22′. Photograph courtesy of Los Angeles County Museum of Art, Los Angeles.

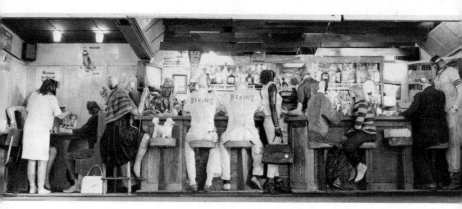

voices of the real "Beanery" customers are to be heard intermittently, there is the pervasive smell of stale beer, mingled with the smells of cooking and a lavatory disinfectant. While all the attributes of the joint are faithfully reproduced, the heads of all 17 mannikin-patrons enclose clocks, timepieces ticking away toward death. Kienholz has commented: "A bar is a sad place, a place full of strangers who are killing time, postponing the idea that they're going to die."[7]

E.C.

[7] Peter Bart, *The New York Times,* October 28, 1965.

Alfonso Ossorio's Eccentric Congregations

Ossorio's style is Expressionist, his method is one of assemblage; his material is too rich for the Existentialist, too impure for the Formalist, too eccentric for the Pop Realist. Ossorio's work, from a Surrealist period in the forties, through the abstractions of the fifties and to his latest assemblages, abounds in allusions to primary fixations, individual and cultural, and to ultimate values, often of questionable orthodoxy. Aesthetically, also, Ossorio is a heretic, if by heresy in modern art we mean identification with the primitive and the hallucinatory: art brut and preciosity.

Ossorio's overall pattern, even when imprecise, is never overwhelmed by the mass of detail he brings in. In contradistinction to the mosaic wherein bland units are combined to form an image, Ossorio's heterogeneous units are recognizable images which, when combined, fall into an abstract pattern—when he is at his most successful. Through insight, Ossorio drew startling conclusions from Pollock's work. Once we cease looking at Pollock's paintings in terms of gestures and drippings, they become assemblages of lines and dots. To assure the independence of his particles from all graphic associations, Ossorio has chosen to use images as particles. Simultaneously he isolates each image from obvious associations to neighboring pieces, wishing to avoid building up a story. Even in his most

crowded, huge "congregations" (the artist's term) of the mid-sixties, the units are juxtaposed to avoid emphasis on one order of association: of body images at the expense of geometric forms, of found objects at the expense of industrial products, of glass eyes at the expense of pebbles. As in all Abstract-Expressionistic works, the viewer is expected to scan the surface in order to appreciate improvisations, to catch glimpses of parts highlighting the whole, and to shuttle in all directions seeking out new surprises.

Body parts, whether artificial or once belonging to a living creature, abound in Ossorio's assemblages. Natural ones include skulls, bones, antlers, tusks, horns of just about every variety, teeth, hides, and bristles. Recently Ossorio has added to this collection the shells of giant tortoises. Seashells, whether "found" or otherwise acquired, are a staple with him, as are timbers, driftwood, and odd bits of wood, whether from the beach, the lumberyard, the secondhand shop. A recent sculpture, *Land and Sea* (1968), incorporated an oxen yoke and a giant driftwood. Manufactured objects range from everyday plain ones such as bowling pins, spectacle frames, dominoes, mirrors, through hardware and tools to hypodermics and handcuffs. According to B. N. Friedman,[1] Ossorio searches for his pieces in places such as dental schools and taxidermy shops, as well as chemical plants and plastics manufacturers. Plastics and plastic waste—at times resembling intestines—have become a very important ingredient. Fascinated by texture, shape, and color, Ossorio is continually varying his choice of materials. However, there is one constant in his work: the marked inclination to menacing objects. Menace quite literally is present in *Embrace* (1968), a high-relief with its projecting sharp horns and heavy phalloid objects pointed at unwary viewers, at least those inclined to view details at close range. A large driftwood forms the anthropomorphic figure central to the composition, the "embracing arms" are antlers extending outward from either side of the driftwood; a limb (membrum) of the driftwood, red-tipped as is one branch each of the antlers, and forward-directed quoit pins—one painted red and black protruding from the head of a mannikin—con-

[1] B. N. Friedman, "Alfonso Ossorio," *Art International,* February 1967.

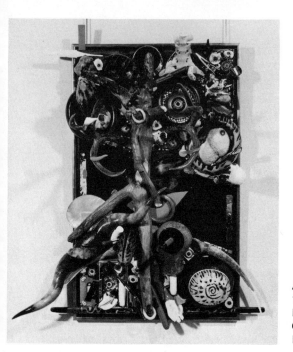

Alfonso Ossorio: *Embrace.*
1968. Mixed media. 55″ × 50″.
Photograph courtesy of
Cordier and Ekstrom Gallery,
New York.

note phallic aggression. The entire composition is topped by a verte-
bra and includes eyes of various sizes and provenance and a scatter-
ing of large rusty nails.

Ossorio's use of plastics influenced his composition. In the early
sixties he began experimenting with plastic paints and adhesives,
which were to offer him new opportunities. While his earlier assem-
blages remained fairly uniform in depth, fairly flat, the new plastic
glue was capable of supporting considerably larger and heavier
objects jutting out at sharp angles when called for. To those bulky
configurations the artist gradually opposed empty areas of plastic.
This juxtaposition of solids and voids is evident in *Embrace* and more
so in *Sea Present* (1969), where plastic undulating cutouts form a
"background" which becomes an important part of the composition
as a whole. However, some of Ossorio's recent works are free-
standing sculptures.

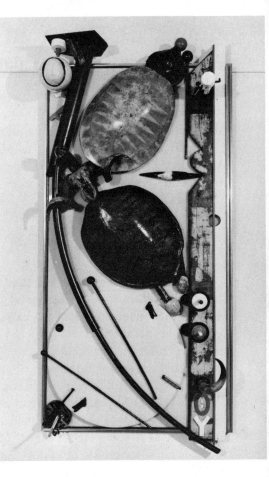

Alfonso Ossorio: *Target Gone.*
1969. Mixed media. 96″ ×
48″. Photograph courtesy of
Cordier and Ekstrom Gallery,
New York.

Influenced perhaps by the austere artistic climate of the late sixties, Ossorio produced a number of much simpler assemblages. Most beguiling is *Target Gone* (1969). Its basic pattern can be reduced to a tall yellow plastic rectangle with a yellow plastic disk superimposed on the rectangle, as are two circular shells of giant sea turtles; balanced by an arc formed of three plumbing pipes loosely fitted together.

E.C.

Abstract-Expressionist Sculpture
(Stankiewicz Through Sugarman)

Abstract-Expressionist painting transformed pictorial handwriting into structural composition. Attempts to duplicate this effect in tridimensional terms is doomed to failure. The Abstract-Expressionist welders of the fifties both failed to evoke expression and produced but clumsy structures. To structure, certain artists in the late fifties began to oppose the heterogeneity, spontaneity, and improvisation possible in assemblage.

RICHARD STANKIEWICZ

The imagistic revival of the late fifties was largely interpreted as neo-Dada and the most Dadaist of all the sculptors on the New York scene was undoubtedly Stankiewicz, a pioneer of junk art. He assembles his scrap-metal parts to construct more or less anthropomorphic machines, manifestly unusable. Unlike Picabia and Ernst, who in their collages and drawings tended to eroticize the machine, Stankiewicz emphatically retained the rusty surfaces and broken-down parts which gave his constructions a post-mortem appearance. Assemblages such as the one entitled *The Candidate* (1960) can be seen both as a scrap-metal version of an African sculpture and a discarded old robot. His *Untitled* (1963) is a conspicuously nonfunctional machine, the angled metal arm helplessly paralyzed by its attachment.

Historically of paramount importance is his introduction of a new dimension into junk assemblage: kineticism. His only motorized sculpture, *The Apple* (1961), has been succinctly described in motion by K. G. Pontus Hultén: ". . . The tantalizing apple swings but is never caught. The noise of the machine's vain effort is so great that the floor trembles. When more money is put in, the apple swings again, the jaws snap, and the raucous noise is repeated."[1]

[1] *The Machine* (New York: Museum of Modern Art, 1968), p. 177.

(*Left*) Richard Stankiewicz: *The Candidate.* 1960. Steel. 30″ × 23½″ × 14″.
(*Right*) Richard Stankiewicz: Untitled. 1963. Iron and steel. 20″ × 10″ × 10″.
Both works in the collection of Dr. and Mrs. Robert Mandelbaum. Photographs courtesy of Stable Gallery, New York.

If the elegant sketches of the Dadaists' machines gave impetus to Stankiewicz's steel and iron monsters, it is befitting that his introduction of scrap metal as valid material for sculpture should fascinate Europeans. But again what a difference in mood between the frustration and impotent rage expressed by *The Apple* and the cheerful clatter, however earsplitting, of frenetic Tinguely pieces.

JOHN CHAMBERLAIN

John Chamberlain is probably the most stylized Abstract-Expressionist sculptor. Yet his most successful pieces, although free-standing, can best be likened to bold high-reliefs, lacking as they are in solid mass. The seemingly disjointed and brute agglomeration of junked car parts is actually tightly compressed and welded together. The jagged surfaces folded upon one another, hollow within, create

(*Above*) John Chamberlain: *Dandy Dan-D.* 1963. Welded auto metal. 45″ × 47″. In the collection of Mr. and Mrs. Michael Sonnabend, New York. Photograph courtesy of Leo Castelli Gallery, New York. (*Left*) John Chamberlain: *I-Chiang.* 1967. Urethane. 15½″ × 25″ × 19″. Photograph courtesy of the artist.

the impression of a relief, scarred by deep crevices, torn by abrupt spacing, distorted by sharp projections. The image is manifestly derived from de Kooning's paintings such as *Excavation* (1950) with its suggestion of overlapping forms. Chamberlain's method of construction and the material itself lead one to read his work in terms of depth: the mind's eye seeks to penetrate canyons, follow subterranean paths, probe hollows, unfold the folds. Color improvisations and angular ingenuities permit us to detract attention from the sinister origin of the parts with its background of accidents which have delivered the death blow to beautiful machines. For Chamberlain, the car cemetery became a quarry of ready-made "gestures" which he uses expressionistically.

Recently, in quest of a new image, Chamberlain, interestingly enough, resorted to the use of the very opposite of metal, foam rubber. He produced mushroom-like forms by cinching the foam rubber "at the waist" with nylon cord. Rubber lends itself to the development of the antithesis between expansion-concentration and looseness-tightness. By drawing attention to the formal qualities of foam rubber, Chamberlain has pioneered in the now fashionable field of soft sculpture. Although so far the knot has not been exploited as an archetypal soft form, Chamberlain may have paved the way to the rediscovery of a Gordian knot.

MARK DI SUVERO

Enthusiastic critics have claimed that in breadth of inventiveness and in his structural sense di Suvero is most impressive. Yet di Suvero is the one who has tried hardest to evoke the Abstract-Expressionist image in sculpture. Works such as *Hankchampion* (1960) looks like a three-dimensional Franz Kline. The rough, broad wooden planks and heavy, scarred beams are patently the counterparts of Kline's thick, dynamic brushstrokes, while the narrow, light chain attached to the planks and seemingly binding them together is the equivalent of a tenuous line of drippings. Structurally the sculpture is clumsy, perhaps intentionally so in an effort to imitate its powerful model. The most violent structure of this period is undoubtedly *For Sabatère*

(1961). *Love Makes the World Go Round* (1963) is like a merry-go-round for two or a swing that bright kids might have improvised from three discarded tires, some upright steel rods, and a yoke fastened to them. Another piece in the same vein has tires hanging low from the ceiling, swinging erratically. Lacking both grace and craftsmanship, these might be seen as humorous parodies of Calder.

Sensitive to the change in fashion, di Suvero has more recently swung an "excavator" in such works as *Mohican* (1967) and *"Yes"* (1968–1969).

GEORGE SUGARMAN

Since the technique of assemblage is apt to result in weak structure, the Abstract-Expressionist artist is faced with the choice of which of the two, i.e., expression or structure, is he prepared to sacrifice. Louise Nevelson in her famed monochrome wood constructions brilliantly demonstrated what a disciplined artist can achieve with controlled Expressionism. An extreme example of the alternate choice is Sugarman. (They were born a little more than a decade apart, but Sugarman came into his own two decades later than she did.)

Inscape (1964) is perhaps the most far-out assemblage in many a year. It may well be the first horizontal work which owes nothing to Giacometti's *Woman with the Cut Throat* (1932), its incongruity accounted for in purely abstract terms since each wooden unit is strictly nonfigurative: the variations between the units must be appraised in terms of differences not only in shape and density, but also in those of weight and color. Amy Goldin has pointed out that in Sugarman's works the largest elements are apt to be the lightest and that the most felicitous effects derive from contrasts between closed and open forms.[2]

A number of critics have noted that Sugarman had been influenced by the paintings of Stuart Davis such as *Hot Stillscape in Six Colors* (1940). There is something mechanical about this composition,

[2] Amy Goldin, "The Sculpture of George Sugarman," *Arts Magazine,* June 1966.

(*Above*) Mark di Suvero: *For Sabatère*. 1961. Wood. (*Below*) Mark di Suvero: *Yes.* 1968–1969. Steel. 54′ × 40′ × 30′. Photographs courtesy of LoGiudice Gallery, Chicago; Noah Goldowsky Gallery, New York; and Richard Bellamy Gallery, New York.

despite the jazziness and playfulness—so minor when compared to the lightheartedness of both Matisse and Kandinsky and their soaring colors. Sugarman is overcome by playfulness. The colorfulness of his low-lying wood constructions gives them the look of unwieldy toy trains, trailers, buck trucks, many times enlarged.

The resemblance to toys is, of course, superficial, belied as it is by the multiplicity of shapes and the vitality of the assemblages. Sugarman is a pioneer in the use of color. Unlike Laurens, who exploited color contrasts to emphasize the difference between light and dark planes, Sugarman resorts to a series of exuberant color clashes to prevent the disjointed parts of his floor pieces from appearing scattered, giving staccato rhythm to the movement of expanding or contracting forms. As Amy Goldin has noted, he uses related colors to speed movement, complementaries to slow it down. In a pedestal sculpture as compact as *Axum* (1963), the gaudiness of the bouquet is a match to the uninhibited sculptural forms. In certain upward-slanted pieces, color is used to define and emphasize each separate structural unit. In *Black X* (1964), the two black slabs forming the X are in sharp contrast to the green loops against which they are posed and the variegated cluster of small petal forms to the right. In *Ritual Place* (1964–1965), thanks to the title, one is apt to read in symbolic meanings and visualize a yellow flame, black smoke, and a red altarpiece.

Sugarman seems always to have been in opposition to prevailing preferences. His open forms and structural dissonances of the early sixties are emphatically at variance with the neo-Constructivists. His great recent structures *Double White* (1967) and *Ten* (1968–1969) are enchanting hybrids challenging the stark geometrics of the Minimalists. *Ten* is composed on ten laminated-wood sections, divided by slits and curved to form an ovoid enclosure around empty space. One of the narrow ends of the structure suggests the front of a Doric temple with the difference that in Sugarman's version the columns melt into elephantine feet. The opposite, convex end might be the supporting wall of a rotonda. No entrance is provided into the empty

George Sugarman: *Ritual Place.* 1964–1965. Wood. 5′6″ × 4′2″. Photograph courtesy of the artist.

cella; one may but glance in. The artist would seem to be proposing that the sculpture be regarded in terms of the interplay between outer shell and inner space. The denial of admission is a valid alternative in a time of "environments," whether narrow as a labyrinth or vast as scaffolding.

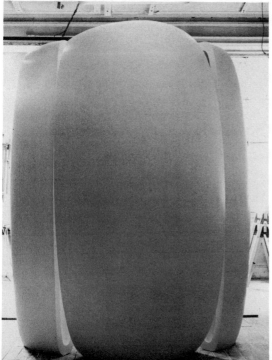

George Sugarman: *Ten.* 1968–1969. Painted wood. 7'6" × 12'. (*Above*) Front view. (*Below*) End view. Photographs courtesy of the artist.

Larry Rivers, One-Eyed Face Maker

Larry Rivers did most to free his generation from the Abstract-Expressionist's compulsion to reduce forms and figures to elements of a pictorial handwriting. To the continuity of gestural painting he opposes the dissociation of units. He disconnects the patch of color from the outlines of a figure, the nose from the face, the image from the written word. He does not hesitate to change a red patch into a female head: in one picture the patch is in the upper corner and the head in the center, while in another version a red square appears in the center and the head in the upper corner. Yet today Rivers' *Washington Crossing the Delaware* (1953), as well as its far more extreme 1960 version, might be reappraised by an assemblagist as combinings of images. Nor could Rivers himself feel betrayed by such an interpretation since in *Me II* (1958) a casual asymmetrical arrangement of family photographs "assembled" on a wall provided the artist with the cue to the composition of his self-portrait.[1]

Rivers' assemblages involve bringing together contrasting figures, some merely outlined in charcoal, others in varying degrees of color, producing thereby the antithesis fullness-emptiness and the suggestion of continuous improvisation, perhaps best exemplified in a series titled *How to Draw* (1962). In one, subtitled *Corps,* the composition centers about a low table, actually a block of brushstrokes with superimposed, irregularly stenciled letters forming the word "corps," and includes some six female figures, each in a different stage of completion or, rather, incompleteness. A watercolor and collage subtitled *Noses* can be visualized both as a fragmented face and as an assemblage of noses with the words for nose written in four different languages.

[1] Catalog of Larry Rivers Exhibition, Brandeis University, The Rose Art Museum, April 1965.

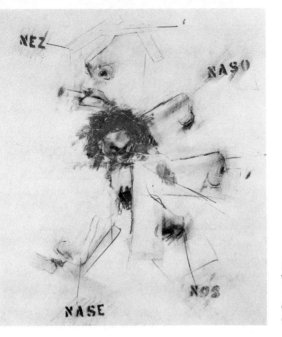

Larry Rivers: *Noses*. 1962. Watercolor and collage. 14⅝″ × 12½″. Photograph courtesy of Marlborough–Gerson Gallery, New York.

By assembling and improvising the artist courts chance. In contrast to Jackson Pollock, who improvised with dripping, Larry Rivers dramatized the accident by making it the subject matter of one of his best-known fragmented compositions. *Accident* (1957) provided a key image of post-Expressionist iconography. Adopted by Rauschenberg, Warhol, Rosenquist—to mention only the most famous—the highway accident became the Pop counterpart of the battlefield.

While workng on *Me,* Rivers bragged: "It will be an extra-extra-large canvas with glimpses of everything that happened to me from birth to the present. I expect it to go down in history as the most egomaniacal painting ever."[2] Egomaniac Rivers directs his irony against the national ego that wills paintings to be "great" when the subject treated is an important historical figure or event, such as Washington crossing the Delaware. In Rivers' 1960 takeoff all that

[2] Frank O'Hara, "An Interview with Larry Rivers: 'Why I Paint As I Do,'" *Horizon,* vol. 2, No. 1, September-October 1959.

remains of the original Lutze are fragments of figures supporting by their presence on the canvas an assemblage of brushstrokes, colors, and scribblings. In our day, patriotic images are apt to be promoted by mass media. Thus *Life* magazine struck a strong sentimental note by its photograph of the last Civil War veteran shown dying alongside the Confederate flag and his old uniform. In *Last Civil War Veteran* (1959) Rivers disassembles, as it were, this myth in the making. By restructuring the photograph in Abstract-Expressionist terms, Rivers shifts the emphasis from an event of historical significance to a stylistic innovation, its experimental approach a challenge to sentiments of veneration.

Not limiting himself to Americana, Rivers sets out to demolish the traditional image of Napoleon. His version of Gerard David's famous portrait of the emperor is as much a takeoff of the pompous painter as it is of the model. The classicist finish of David gives way to three incompleted studies of Napoleon, which, when seen together, form a typical Rivers variation of the Expressionist method of process painting. The word "David" stenciled alongside Napoleon provides the clue to the unexpected title of the work *The Greatest Homosexual* (1964), for it is an allusion to Michelangelo and his giant David to whom Rivers wants us to contrast the glorified smallish emperor.

In the early sixties Rivers resorted more and more to the transposition of mass-produced images or portions thereof while his technique remained Expressionist. He made series of paintings based on the Camel cigarette pack, a 1960 Buick, playing cards, French money, Rembrandt's *Syndics of the Drapery Guild* from Dutchmasters Cigars etc. Rivers has said: "If I am moved to work from these products it's for what I can take from them for my ideas of a work of art. . . . In order to paint I must look at something and I must think that in some way it is about the thing I'm looking at. I think what I choose to look at is based primarily on 'what out there will allow me to use what's in my bag of tricks.' I'm quite a one-eyed face maker and probably think my drawing is greater than anyone's around."[3]

[3] A statement read to the International Association of Plastic Arts by Larry

Rivers disclaims that he has any special sentiment for "Images of Mass Production."[4] The late poet Frank O'Hara, a friend who had served on occasion as an informal model, offered a convincing explanation: "As with his friends, as with cigarette and cigar boxes, maps and animals, he is always engaged in an esthetic athleticism which sharpens the eye, hand and arm in order to beat the bugaboos of banality and boredom, deliberately invited into the painting and then triumphed over."[5] Rivers' "bag of tricks" had already been evoked in an article I wrote in 1961: "In his playing cards Rivers liberates lines from trodden paths, blacks from darkness, yellows from the omnipresence of red, faces from the sharpness of predictable design. Rivers' cards—such as *Queen of Diamonds* (1960)—belong with a postwar style in which chance 'dripped' its way into the contents of a painting. However, instead of turning his canvas into a superpalette where colors, like chromosomes, are expected to react upon each other for the delectation of amateurs of push-and-pull, Rivers exposes a crevassed world: figures emerge or fade under the pressure of bodies of color, here and there thickly pigmented."[6] Improvisation came effortlessly to Rivers, who began his artistic career as a jazz player.

After a long series of works connected with his African journeying, Rivers reverted lately to historical Americana in his "tryouts" for *Boston Massacre* (1967–1968) and *The Paul Revere Event* (1968), as well as resuming an autobiographical chronicle. In his summing

Rivers at the Museum of Modern Art Symposium on "Mass Culture and the Artist," New York, October 8, 1963.

[4] *Ibid.*

[5] O'Hara, *op. cit.*

[6] Nicolas Calas, "Larry Rivers," *Art International,* March 1961.

Larry Rivers: *The Greatest Homosexual.* 1964. Oil and collage on canvas. 80″ × 61″. In the collection of Joseph H. Hirshhorn. Photograph courtesy of Harry N. Abrams, Inc., New York.

up, Sam Hunter writes in his book: "Whatever the verdict of history on Rivers' ultimate stature, it is impossible to separate his restless personal energy from the subject matter he chooses to test himself against. There is no question that his art is a function of 'personality,' with a directness rare, if not unknown, since the romantic period. But it is also true on the evidence that it transcends theatrical posturing and autobiographical obsession and offers itself to us on the same basis as the most exalted formal expressions of our time, as the concrete and autonomous object of ordered perception."[7]

[7] Sam Hunter, *Larry Rivers* (New York: Harry N. Abrams, 1970), p. 50.

Robert Rauschenberg at the Controls

Rauschenberg was for his early admirers the model of the modern experimental artist whose all-white and all-black canvases of the early fifties suddenly confronted the busy and noisy Abstract-Expressionists "face to face with a numbing, devastating silence. . . . An implication that no work was done, no expected artistry was demonstrated, left the viewer with himself and the void in front of him."[1]

Robert Rauschenberg glued, stretched, or crumpled like a hide newspapers dyed black. Whenever the hide did not cover the whole canvas, he painted the naked portion black as well. For Rauschenberg blackness is not so much a color as a condition in which paper, paint, ink, canvas are to be found. Careful not to confuse painting with action, Rauschenberg assembles different blacks placing a glossy one alongside a rough one, a thick one, or a torn one and fits them over the surface of the canvas. From the blacks that do not form a single black we turn to paintings composed of seven identical white canvases. Inescapably the question poses itself: Which one is the whitest white?

Since 1958 Robert Rauschenberg has been in full control of his means of expression; he knows how to beat the life out of an umbrella and how to replace a rainbow by a necktie. He was taught that colors are not adjectives but has not forgotten that images, too, are words. There is no need for Expressionism to be either figurative or abstract for it can also be atonal. When Rauschenberg asked himself, "What is black? What is white?" he plunged headlong into the world of painting. He emerged strong enough to include the world in his painting. Surfaces become denser, events more crowded. Temperamentally Rauschenberg is at the opposite pole to those who reduce the

[1] Allan Kaprow, "Experimental Art," *Art News,* March 1966.

world to an archetypal icon, a square filled with deodorized or vaporized colors.

No one is more aware than Rauschenberg of the structural difficulties involved in the use of images in the language of modern painting. He proceeds from the Cubist tradition enriched with the knowledge acquired from painters who had expelled the image from their canvases. It is the sharpness of Rauschenberg's observations that first drew public attention to his work.

With Rauschenberg, the imprecise forms of the Abstract-Expressionists and the precise rectangles of the Bauhaus artists become fused into an indeterminate pattern of images. While Max Ernst planted dreams in Mondrian's white fields, Rauschenberg loosened

Robert Rauschenberg: *Hymnal.* 1955. Combine painting. 65″ × 60″ × 6″. In the collection of Mr. and Mrs. Michael Sonnabend, New York. Photograph courtesy of Leo Castelli Gallery, New York.

Robert Rauschenberg: *Pilgrim*. 1960. Combine painting. 80″ × 54″. Photograph courtesy of Leo Castelli Gallery, New York.

Albers' squares and set them to dancing with images. Rauschenberg's ear is attuned to the noise of photographs: this is particularly true of paintings he made between *Charlene* (1954) and *Barge* (1962). His view of the image is explosive; he divorces the photograph from the photographer's *I*. Picasso stepped over Cézanne, Rauschenberg over the miniaturist Schwitters. Picasso visualized the horrors of Guernica through the accounts of Parisian newspapers, Rauschenberg sees his world through illustrated weeklies, a layout of a multiplicity of unconnected events. He is the Henry Luce of the silk screen. His famed *Barge* is a map of news, history reduced to colorful informa-tion—but on what a grandiose scale! 33 feet.[2] It is the first major work in which Rauschenberg resorted to the silk-screen process which made of the photograph the perfect ready-made image which can be enlarged at will, reused at variant angles and in various colors, as well as various degrees of opaqueness and transparency. By means of Expressionistic brushstrokes and superimpositions, Rauschenberg neutralizes photographic depth.

John Cage undertook to abolish the sequence of time in music, Rauschenberg abolished it in the picture sequence. It is as if he were saying that all that happens, happens now—one immense Happen-ing. One might just as well tilt the clock as he did in *Third Time Painting* (1961). Tintoretto was great for having dramatized the tension between the mundane and the supernatural, Rauschenberg for expressing his generation's tension by jamming time in the now.

Rauschenberg skillfully absorbs the shock of unexpected juxtaposi-tions of images by means of structural correlations. Yet he exposes his pictures to misinterpretations, for the viewer is tempted to read meanings into them which were not intended. Once released, images have a power of their own, being loaded with associations which the artist cannot control. Seurat wanted his paintings appreciated solely in terms of his technical achievement, Rauschenberg would want his work comprehended literally. He must be loath to reconcile himself

[2] The above descriptions have been taken from N. Calas' article on this artist first published in *Kulchur* in 1964 and then reprinted in *Art in the Age of Risk*, 1968.

Robert Rauschenberg:
Third Time Painting.
1961. Combine painting.
84″ × 60″. In the col-
lection of the Harry N.
Abrams Family, New
York. Photograph cour-
tesy of Leo Castelli
Gallery, New York.

to the idea that imagistic art is a source of misinformation and that its psychological spectrum ranges from absurdity to anxiety. Imagistic painting prompts the critic to use insight, for much is left unsaid by the artist struggling to solve the contradiction between seeing and making. Recently, however, Rauschenberg has been replacing "not saying" with "silences" introduced into a series of images organized in a time sequence. To this end, he sought the aid of technology, more specifically, the collaboration between artist and engineer.

In 1969 Rauschenberg exhibited his *Carnal Clocks.* Each clock

consists of a mechanism that controls the lights substituting for the hands of the clock, a box holding five Plexiglas panels with silk-screen images of eroticized body zones, and a mirror. Every two and a half minutes the image changes clockwise. Every half an hour the big hand introduces a new image. This clockwise movement of images strikes one as anachronistic. The great clocks of the past, such as that of the Strasbourg Cathedral, were mechanical models depicting correspondences between celestial bodies. Rauschenberg replaced celestial bodies with male and female body parts and provided the mirror to include the viewer's own image in the ensemble (a device resorted to by Kienholz in 1964). It would have been more advanced to use the viewer's image on a monitor. The *Carnal Clocks* are pre-*Curious (Yellow)*.

Rauschenberg's well-known interest in technology led to an invitation to witness the launching of Apollo 11 and eventually to lithographs of photos wittily named *Stone Moon Series* (1969). Rauschenberg's aptitude for punning prompted him to juxtapose a Florida crane to a technological "bird," more commonly known as a rocket. Rauschenberg's obsessions with birds has been evident since his early "combines." He says of the takeoff: "The bird's nest bloomed with fire and clouds."[3] It was far from Rauschenberg's intention to recreate a "Firebird." He is full of admiration of the performance of the launching control: "aware of two ideologies, man and technology, responsive responsible control and countercontrol."[4] Most aptly Alloway remarks that "this kind of moralistic reflection confirms Rauschenberg's withdrawal from the principle of random order." So as to remain at the controls Rauschenberg limited himself to Impressionist effects of photographs, often delightful, but tiny steps when compared to his giant strides of the past.

N.C.

[3] Quoted by Lawrence Alloway, "Introduction" to *Rauschenberg, The Graphic Art*. (Philadelphia: University of Pennsylvania Institute of Contemporary Art, 1970).
[4] *Ibid.*

(*Above*) Robert Rauschenberg: *Quote.* 1964. Oil on canvas. 96″ × 72″. In the collection of Kunstsammlung Nordrhein, Westfalen. (*Left*) Robert Rauschenberg: *Marsh.* 1969. Lithograph. 35½″ × 25″. Photographs courtesy of Leo Castelli Gallery, New York.

Jasper Johns: And/Or

Jasper Johns enjoys the unique privilege of being a forerunner of Pop art and, with his flags and targets a precursor of Noland and Stella, he is also credited with both expanding the pictorial horizon of Abstract Expressionism and of reviving interest among young artists in Duchamp. He is at the center of contemporary "aesthetic puzzlements." Clement Greenberg, who has a sharp eye for danger signals, felt it necessary to minimize his importance. Johns, he claims, "brings de Kooning's influence to a head by suspending it clearly, as it were, between abstraction and representation." He goes on to claim: "Just as the vivid possibility of deep space in photographs of signs or housefronts, or in Harnett's and Peto's paintings of pin-up boards sets off the inherent flatness of the object shown, so the painterly paintedness of a Johns picture sets off, and is set off, by the flatness of his number, letter, target and map images." From this assumption Greenberg correctly deduces that Johns did not need to imitate de Kooning's manner of painting: "The original flatness of the canvas, with a few outlines stenciled on it, is shown as sufficing adequately to represent all that a picture by Johns really does represent. The paint surface itself with its de Kooningesque play of lights and darks, is shown, on the other hand, as being superfluous to this end."[1] The implication is that to paint circles or stripes one should give up Expressionist techniques. Curiously enough Rosalind Krauss fails to realize that Greenberg downgrades Johns for the sake of upgrading those who dissociate stars from stripes.[2] Greenberg could not care less whether or not "Johns points up the ironic dissipation of color put to the service of modeling illusionistic space" by means of con-

[1] Clement Greenberg, "After Abstract Expressionism," *Art International,* October 1962.

[2] Rosalind Krauss, "Jasper Johns," *The Lugano Review,* II (1965), pp. 84–87.

trast between color and color names as explained by Rosalind Krauss. From a formalist point of view his criticism of Johns is unassailable. For a critic such as Greenberg, dedicated to the idea of pure painting, combining painted reproductions of flags, targets, and maps with brushstrokes and collages is an extension of a method so effectively used by de Kooning when he flattened the image of a woman's face to weave it into the fabric of gestural painting.

According to Max Kozloff, Greenberg failed to realize that Johns' merit was to have denatured illusionism.[3] Surely "illusionism denatured" is just as much anathema to the purists as is natural illusionism. Furthermore, it is hard to believe that denaturing illusionism is an important factor in Johns' oeuvre. What Kozloff may mean is that Greenberg should be grateful to Johns for providing Noland and Stella with the opportunity to denature his targets and flags.

Jasper Johns has shown a marked predilection for boyhood and classroom images: targets, maps, alphabets, numerals, brushes. Their meaning is related to the process of learning. Johns' jokes are those of a schoolboy, as is the sculpture of a shoe with a mirror embedded in its toe, the broom to denote the painter who "paints" by spilling color on a canvas stretched on the floor, the shade identified with the canvas, the flashlight of lead and hence dead as night. Even the beer can is a joke, for it has been remarked that Castelli could convince a customer that a beer can is a work of art. Johns proved that *his* beer cans can indeed be sold.

An all-white American flag, an all-green target of encaustic and bits of newspaper are objects that we refer to as flag or target but for the lack of a better name. It would be more precise to say: "It is not a flag, it is not a target." Johns has said in an interview: "I am concerned with a thing not being what it was, with its becoming something other than what it is."[4] To judge from a statement of his in which he quoted from Duchamp's *Green Box,* he would want this otherness to be enigmatic: "to reach the impossibility of sufficient

[3] Max Kozloff, *Jasper Johns* (New York: Harry N. Abrams, 1969), p. 13.
[4] G. R. Swenson, "What Is Pop Art? Interview with Jasper Johns," *Art News,* February 1964.

visual memory to transfer from one like object to another the memory imprint."[5] This is far more difficult to achieve than one might think, for only the invisible is without any similarity to things we have seen. Actually, the artist deals only with degrees of dissimilarity, as does Picasso in relation to Velásquez and Miró to Jan Steen. However, the most difficult modern work to relate to known images is Duchamp's *The Bride Stripped Bare by Her Bachelors, Even.*

Before he came under Duchamp's spell, Johns exploited the handwriting process of Abstract Expressionism to loosen the relation between his images and its prototype. Johns is most resourceful in developing variations. To his monochrome targets are now added others whose colors detract from the bull's-eye as when the concentric circles are violet, orange, and green—a color scheme Johns obviously borrowed from Frank Stella. To the calligraphic elaborations of superimposed numbers, Johns in his recent lithographs inked with spectrum-like colors, developed a new set of variations on numerals.

When the typography hinders rather than enhances the reading of a number, when a five or a seven is modified by color gradations, when what is read contradicts what is shown, the viewer is confronted with a new area of doubt. Jasper Johns first dramatized this point in *False Start* (1959), which might have been taken for an Abstract-Expressionist painting if it were not for the stenciled words. Each word indicated a color—blue, red, yellow, etc.—that did not correspond to the color upon which it was stenciled nor mostly to the color in which it was stenciled. Contradiction between the picture and the written word can be traced back to Magritte, who wrote "snow" beneath a bowler hat and "desert" beneath a hammer (*The Key of Dreams*). While Magritte limits himself to a dissociation between image and label, Johns' painting requires a continuous shifting between signs and images produced by combinations of primary colors, leaving open the question whether those can mentally be visualized the way a

[5] *Sixteen Americans* (New York: Museum of Modern Art, 1959), p. 22.

Jasper Johns: *False Start.* 1959. Oil on canvas. 67¼″ × 54″. In the collection of Mr. and Mrs. Robert C. Scull, New York. Photograph courtesy of Leo Castelli Gallery, New York.

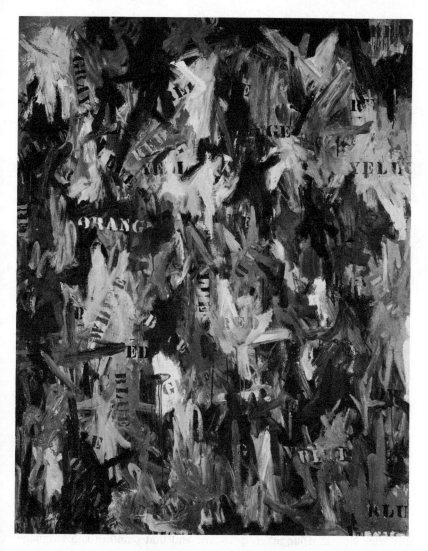

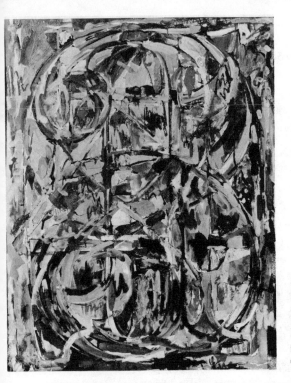

Jasper Johns: *0 Through 9.*
1961. Collage, plastic paint,
and encaustic on paper.
25¾″ × 20″. In the collection
of Dr. and Mrs. André Esselier.
Photograph courtesy of Leo
Castelli Gallery, New York.

musician is able audibly to translate a score. Another problem is
presented by those monochromes which submerge the image in an off-
white or gray field, by charcoals, such as *0 Through 9* (1961), which
enmesh numerals in an advisedly scrambled whole. Kozloff believes
that the "sculpmetal" light bulbs are a comment on the McLuhan
statement that electricity ended the distinction between night and day.
Yet, psychologically, these light bulbs and flashlights are variations
on the ambiguity of perceiving.

It is no coincidence Jasper Johns should have been influenced at
this stage of his development by Wittgenstein and his dramatic shift
from an earlier belief that the proposition was an image of reality to
his later view that language is a game and that painting is a language
game. The artist might be seen as a player who makes variations in a

game of his invention. Johns needed to go beyond the set of ambiguities that had made him famous before he was thirty. It was Duchamp's example that led him in the sixties to assert his dissimilarity to both Pop art and Field painting. Kozloff has carefully pointed to the Duchamp features in the work of Johns: the ruler, the thermometer, the color chart, self photograph; he might have also mentioned the spoon.

Inklings of the kind of game that Johns is playing are to be found in a fragment of his "Sketch Book."[6] Those notes concern a set of paintings mostly finished the preceding year, especially *Souvenir, Watchman,* and *According to What. Souvenir,* largely empty but for brushstrokes, has three striking "foreign bodies" attached: in the lower left corner a plate with a photo of the painter and the stenciled names of three colors; in the upper right corner a driver's mirror and below it a flashlight. *Watchman* is an earlier version of *According to What.* Each includes an "arrogant object," a part of a chair with a wax fragment of a seated figure. The chair is reminiscent of Rauschenberg's work that includes a chair attached to the canvas. In *According to What* there is a small hinged insert in the lower left corner with the stenciled words "according to what." On its reverse side, the traplike insert carries the profile of Marcel Duchamp. The painting covered with Expressionistic brushstrokes is subdivided perpendicularly by two "color lines." The first consists of a double row of words—"RED, YELLOW, BLUE"—stenciled sideways; the second color line consists of a row of colored discs as in a color chart. The Rauschenbergian left area is balanced by a Hoffmannesque "panel" on the right. The latter is connected to the whole by a long narrow strip of newspaper suggestive of a yardstick. This manifestly is a painting about painting. But what are the implications? From the "Sketchbook" we deduce that *According to What* and *Souvenir* were conceived in terms of a game played with two "chessmen," the "watchman" and the "spy." Johns writes in his notes: "Make Neg. of part of figure & chair. Fill with these layers—encaustic (flesh?), linen, Celastic. One thing made of another. One thing used as

6 *Art and Literature,* No. 4, 1965.

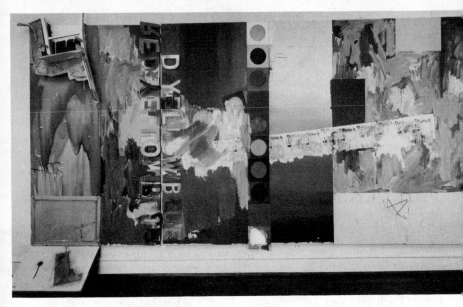

another. *An arrogant object.* . . . Avoid a polar situation. Think of the edge of the city and the traffic there. Some clear souvenir—a photograph (a newspaper clipping caught in the frame of a mirror). . . . Profile? Duchamp (?) Distorted as a shadow. Perhaps on falling hinged section. . . . In *What* use a light and a mirror. . . . Dish with photo & color names. Japanese phonetic 'No' (possessive 'of') stenciled behind plate? . . . Take flashlight apart? . . . Watch the imitation of the shape of the body. The watchman falls 'into' the 'trap' of looking. The 'spy' is a different person. 'Looking' is and is not 'eating' and 'being eaten.' "

Johns makes clear that the spy is a different person from the critic, whom he has represented with spectacles over toothy thick-lipped mouths in lieu of eyes (*Critic Sees,* 1961).

Each painting of this series can be viewed as a chess game with movements and countermovements. Johns jots down: "(Cézanne?— Each object reflecting the other.)". That is, there is continuity of some sort among the watchman, the space, the object. The spy must

(*Left*) Jasper Johns: *According to What*. 1964. Oil on canvas with objects. 191¾″ × 88″. In the collection of Edwin Janss, Thousand Oaks. (*Right*) Jasper Johns: *Souvenir*. 1964. Encaustic on canvas with objects. 28¾″ × 21″. In the collection of Minami Gallery, Tokyo. Photographs courtesy of Leo Castelli Gallery, New York.

be ready to "move," must be aware of his entrances and exits. The watchman leaves his job and takes away no information. The spy must remember and must remember himself and his remembering. The spy designs himself to be overlooked. The watchman "serves" as a warning. Will the spy and the watchman ever meet?

One is tempted to hazard a guess that the "spy" might be the artist himself represented by the coin-machine photo taken in Tokyo and included in *Souvenir,* a painting made in Japan. Jasper Johns, "Jap" to his friends, would here be the foreign object with "I" punning with "eye." Johns adds cryptically: "In a painting named *Spy,* will he be present? The spy stations himself to observe the watchman. If the spy is a foreign object, why is the eye not irritated? Is he invisible? When the spy irritates, we try to remove him." "Not spying, just looking.— Watchman."

Contained in the insert of *According to What* is Duchamp, who, it should be recalled, made a parody of the color charts of the Realists, Impressionists, and Cubists in *Tu m'*. Johns now extends the parody

to the games of Pop and Minimalist artists. What are the rules of Johns' game? He says in the "Notes": "Processes of which one knows the rules. Avoid them." Brush them aside as he did in the Expressionistic *Fool's House* (1962), in which he hung a broom instead of a brush over the painting. Or as he does in an untitled painting of 1965 which holds a broom and all-gray strips of canvas. In *Edingsville* (1965) a ruler attached to wax cast of a man's hand and arm, as well as to some twisted cans, points to a canvas where gestural painting is pitted against field painting.

The game proceeds from picture to picture, weight is shifted from assemblage to gestural painting and their opposite, geometric forms —the ubiquitous ruler marks the absence of rules in the game. In *Harlem Lights* (1967) the hard-edge flagstones evoke Johns' own Expressionist versions of the American flag, while the impression of a door recalls Duchamp.

According to What was preceded by *Field Painting* (1963–1964), which included wooden letters hinged to the canvas, spelling the words "RED YELLOW BLUE." In 1959 Johns had made a painting from which he hung a metal hanger (and named it *Coat Hanger*). In *According to What* there is an outline of a twisted hanger. In *Field Painting* the projecting letters support objects associated with the process of painting, notably a brush. The word "DYE" conspicuously formed by "RE*DYE*LLOW" is in dead-pan confrontation with the artist's brush (this detail of *Field Painting* is reproduced on the paper cover of Kozloff's book on Jasper Johns, which would underline its importance). For Johns, brushstrokes are but part of a process involved in making an object. In his "Sketchbook" he writes: "Take an object. Do something to it. . . . Take a canvas. Put a mark on it. . . . Put another mark on it. . . . Make something. Find a use for it. AND/OR. Invent a function. Find an object. . . ." Johns' composite object is assembled with wit. Wit is all that remains of imagination. It is the stronghold of improvisation. Through irony Socrates saved philosophy from theology. Only through irony can art today be saved from the philosophy of art.

How is it possible to assert, as does Kozloff, that *According to*

What is "a real allegory" in which Jasper Johns has reconstructed his life the way Courbet reconstructed his in his *Studio?* Johns is not recapitulating and remembering but assembling and playing with Duchamp as watchman. Kozloff would like to save Johns from his mentor, believing that with Duchamp, "art, or rather artifice, may well transcend natural fact, but only at the cost of falling into a perpetual meditation on itself."[7] Kozloff's preference is for "meaning embedded in experience."[8] This experience is undoubtedly embedded in Courbet's *Studio,* where a nude woman got out of bed to pose for the artist! By "embedded in experience" Kozloff means memory of things past. We have learned from Freud that repression of memory

[7] Kozloff, *op. cit.,* p. 35.
[8] Max Kozloff, *Renderings* (New York: Simon and Schuster, 1959), p. 5.

Jasper Johns: *Harlem Light.* 1967. Oil on canvas with collage. 78″ × 172″. In the collection of Philip Johnson, New Canaan. Photograph courtesy of Leo Castelli Gallery, New York.

is of paramount significance for the understanding of human conduct. Surrealism's historical contribution to art is to have substituted both in poetry and in painting the surprise caused by unexpected juxtapositions of images to the memory of past experiences. Surrealism proclaimed the primacy of the image over its symbolic meaning, of the unexplained happening over the sequence of past events. Carried to its logical conclusion this leads to a restructuring of the poetic and pictorial syntax. The concept of art as language game could stimulate young artists to develop processes whose rules are yet unknown. Viewing painting as a game without fixed rules, the artist can assume the role of both the chess piece and the chess player, which is what Johns has done in the spy-watchman situation.

Johns has sometimes chosen for partner a player who, in contrast to Duchamp, plays his own game according to strict and difficult rules, Frank Stella. Johns' superb lithograph series of *Color Numerals* provides an impure alternative to the aggressive color-form exercises of Stella. Johns develops his variations on an interplay of primary and secondary colors in relation to numerals treated as figures in a fluid color space.

An orderly inversion of colors has led Johns to produce a green, orange, and black version of the American flag for the antiwar-moratorium rally—surely an original and forceful way of using pictorial values to protest America's military venture in Vietnam.

Let us go on watching how Johns performs, how he repeats a move, or tries a new maneuver, pitting black against white, green against red, blue against orange.

I will watch his performance in and out of his game, for this is my game.

N.C.

Pop Art

Surrealism opposed illusion to reality, Abstract Expressionism the self to the world. To the Expressionist's writing on the wall, the Pop artist substituted the image pasted on the wall. Pop art welcomes assimilation, abhors alienation. Pop art is idly, self-indulgently gluttonous. Its icons display the ubiquitous hot dog, the monumental hamburger, the soup can, the beer can, the Franco-American spaghetti can, the buttered frying pan. Pop art mirrors consumption and highway accidents in which men are consumed. Gooey banana splits, dripping ice cream cones, and cold blood. The electric frying pan and the electric chair. Pop art accommodates aggression by cultivating a cool attitude on occasion bordering on the grotesque or the burlesque.

Confronted by an unrecognizable image (as in a de Kooning) or object (as in a Nevelson), the beholder is apt to ask: What is it? While confronted by a banal image or form, he may well ask: Is it art? Pop imagery is prosaic but Pop art at its best is "written in excellent prose." Pop art shares with Matisse the peculiarity of stylizing the vernacular, but with this difference: the French master introduced content into the decorative Art Nouveau while Pop art improves the syntax of the advertiser and the cartoonist.

For the giant exhibition of "New York Painting and Sculpture: 1940–1970" held at the Metropolitan Museum of Art (1969–1970) works of Pop art were selected primarily on the basis of style. In his "Introductory Essay," Henry Geldzahler, the organizer of the exhibition (Curator of Contemporary Arts at the Metropolitan Museum), expressed the opinion that Pop art—like Surrealism—is "not a major art movement." In the context of his statement, Abstract art alone is of lasting significance. Yet, with Pop art, the antithesis abstraction-representation is considerably reduced. The difference between a

Claes Oldenburg: *Tube.* 1964. Wood, lacquer, metal, rubber vinyl, kapok, and polyurethane foam. 168″ × 40″ × 6½″, blade: 1″ thick. In the collection of the Vancouver Art Gallery, British Columbia. Photograph courtesy of Sidney Janis Gallery, New York.

Lichtenstein and a Stella is primarily iconic; a series of Warhol faces or cans invites comparison with Alber's series of squares. Pop art looks at the picture on the billboard, Minimal art looks at the billboard minus the picture. Art is a cultural phenomenon through which key images are revealed—by this is meant images at the center of a system of cross references, contemporary and historic, stylistic and iconic.

Claes Oldenburg's Contented Objects

Since Duchamp-Villon's *Horse,* a sculpture is primarily a structured object. Today any sculptured object, including a ready-made, can be apprehended as a sculpture; conversely, a sculptured object such as one by Giacometti or Calder can be viewed as a vehicle for the manifestation of the artist's personality. Famed is the Surrealist's found object, a substitute for a lost and forgotten one of early childhood. Giacometti's post-Surrealist sculpture expresses attempt-and-failure to *isolate* himself from the world. Claes Oldenburg has reversed the situation and manifests his attempt-and-failure to *join* the world. This attitude was anticipated by Swift, who had Gulliver discover in Laputa that the learned and wise expressed themselves by things, the only inconvenience being that "if a man's business be very great, and of various kinds, he must be obliged in proportion to carry a great bundle of things upon his back. . . ." Gulliver adds that he "often beheld two of those sages almost sinking under the weight of their packs, like peddlars among us; who when they meet in the streets, would lay down their loads, open their sacks, and hold conversation for an hour together. . . ." The purpose of this method of communication was that it would serve "as an universal language to be understood in all civilized nations, whose goods and utensils are generally of the same kind, or nearly resembling. . . ."

Oldenburg quotes the passage in his catalog of 1967,[1] which is accompanied by a photograph showing him carrying, with consider-

[1] Claes Oldenburg Sidney Janis Gallery catalog, 1967.

able difficulty, a semisquashed human-sized tube of toothpaste. Facing the sculptor and his object is a sandwichman bearing a fortune-teller's ad. We assume that contrary to the wise men of Laputa the wise bearer of the sculpture and that of the ad drawing attention to the wisdom of the fortune-teller will bypass each other without conversing for they lack a common language. This photograph clearly suggests a scene in a Happening, the history of which is indissolubly linked to the wit of Oldenburg. In the Happenings great prominence was given to objects filling the now in contrast to the sequence of events in the plot.

In the early, lean years of his artistic life Oldenburg, on the lower East Side, would pick up junk materials from the street such as corrugated cardboard and embellish them with oil wash. The artist was still talking to himself and, indirectly perhaps, to his elder, the famed Jean Dubuffet. From the street Claes would enter "The Store," his version of a studio, filled with objects of consumption in hard and soft versions, shirts and pants, steaks and chocolate eclairs, yellow and green ice cream cones ten feet long, cushion-soft furniture-like hamburgers. Oldenburg was later to say: "Food equals painting, furniture equals sculpture."[2] Could his point of departure have been Dali, the inventor of soft watches, who said that painting could be appetizing?

"I am for art you can sit on. . . . I am for art that is flipped on and off like a switch. I am for art that unfolds like a map, that you can squeeze like your sweetie's arm or kiss like a pet dog."[3] Oldenburg's approach to home appliances, toasters, juicers, light switches, telephones, as well as more expectedly to items of clothing, is avowedly and happily sensual. He feels, for example, his typewriter to be an extension of himself (1963 series) and longs for it to become more yielding, more tender. His soft wall switches (1964 and 1967 series), with one pair entitled suggestively *Soft Wall Switches,* (1964), *Pink,* are touchingly titlike; while *Four Models, Dormeyer*

[2] Claes Oldenburg, Moderna Museet catalog, Stockholm, 1966.
[3] Statement in *Environments, Situations, Spaces,* Martha Jackson Gallery catalog, 1961.

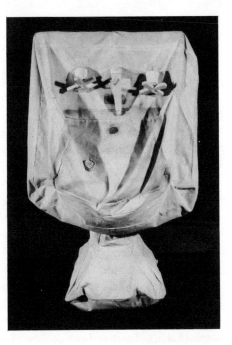

Claes Oldenburg: *Soft Wash-stand—"Ghost" Version (Model "Ghost" Washstand).* 1965. 55″ × 36″ × 28″. Liqui-tex, canvas, wood, and kapok. In the collection of Dr. Peter Ludwig, Wallerf-Richartz Museum, Cologne. Photograph courtesy of Sidney Janis Gallery, New York.

Mixers (1965) are resolutely phallic, if questionably virile. Some of those home appliances exist in both soft and hard versions, the former more enticing for they seldom fail to surprise us. After *The Store* (Green Gallery, 1962) came *Bedroom Ensemble* (1963), which included a bed, a dresser, a settee, two nightstands, wood constructions designed in false perspective as parallelepipeds and with the upholstered pieces in fake fur. A woman's coat, fake leopard, and a handbag were propped up as though "seated" on the settee. According to Oldenburg, those were meant to convince you of the presence of someone very special in the room with you.

The geometric rigidity of the *Bedroom* is in the sharpest contrast possible with the *Bathroom Ensemble* (vinyl with Liquetex; 1963), its fixtures drooping, drooling, gutted, yet shiny and spotlessly white and dressed up in pretty colors: the basins of washstand, toilet, and the bottom of the bath are Mediterranean-blue vinyl, the shower

spray of salmon pink, the overflowing contents of the medicine closet, blue, pink, and off-yellow.

Oldenburg speaks of his car as if it were alive and kicking: "My auto is a hypochondriac. It lies to me, telling me its manifold, or whatever horseshit it can think up, is out of order. I kick it, I say: run you mother, drive, or whatever you call what you do. I can't believe so many parts and details have no sensation. Can't the bloody thing be proud for example of its steering wheel, its carburetor?"[4] While swearing at it, he tenderizes it and out of canvas, sprayed with enamel, he makes an amazingly precise replica of *Airflow, Soft Engine with Fan and Transmission* (1966).

Some objects affect us as though we were seeing someone naked for the first time. Oldenburg has said: "Basically collectors want nudes. So I have supplied for them nude cars, nude telephones, nude electric plugs, nude switches, nude fans, newd electretcetera and sew on."[5] Nude, too, is his *Saw* (*Hard Version I*), broken and bent in three, suggesting perhaps the backbreaking toil of sawing and recalling somewhat the famous bent coffins of René Magritte. "Electretcetera and sew on." Where lies the connection? Elsewhere Oldenburg says: "What is sewing? Sewing is connection. In making clothing, include the flesh that is covered."[6] Nothing shows better this connection than his inflated *Giant Blue Shirt with Brown Tie* (1963) set sideways.

It is a Mannerist trait to exaggerate the softness or hardness of the appearance of things. With Bernini the marble folds of the garment of an ecstatic saint melt and swoon together with their bearer; with Rodin the whole figure of Balzac in his gown shrinks out of form while the face is set ablaze with genius. Claes Oldenburg is the most eloquent soft sculptor since Rodin.

With Oldenburg, softness and hardness call to mind the small child's ambivalence toward objects which, for him, are divided into those he is expected to cuddle and squeeze and those he may not touch without permission even though they are as soft as pastry.

[4] Claes Oldenburg, "War and Sex, etc.," *Arts Magazine,* Summer 1967.
[5] *Ibid.*
[6] Moderna Museet, *op. cit.*

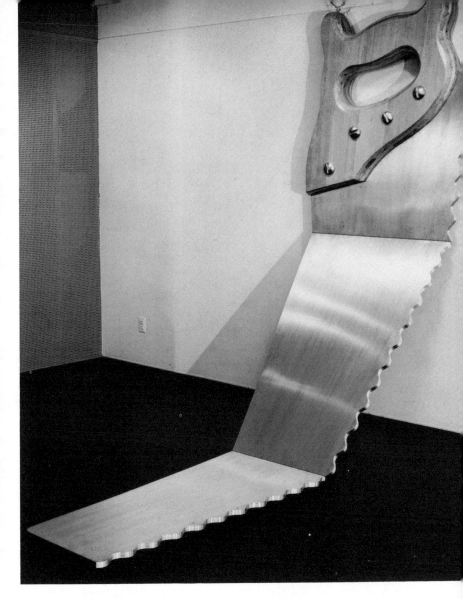

Claes Oldenburg: *Saw (Hard Version I)*. 1969. Laminated wood, aluminum, and polyurethane foam. 168″ × 40″ × 6½″, blade: 1″ thick. In the collection of the Vancouver Art Gallery, British Columbia. Photograph courtesy of Sidney Janis Gallery, New York.

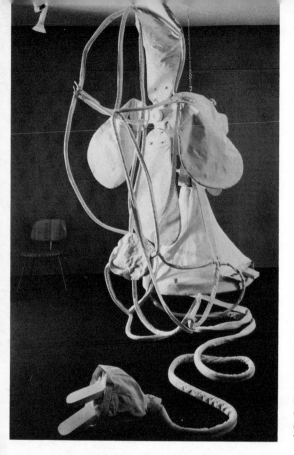

Claes Oldenburg: *Giant Soft Fan, Ghost Version*. 1967. Canvas, wood, and foam rubber. 120″ × 124″ × 76″. Museum of Fine Arts, Houston, gift of Dominique and John de Menil. Photograph courtesy of Sidney Janis Gallery, New York.

Oldenburg displays éclairs in glass cases, frustrating the viewer who would have wanted to touch the pieces and closes the entrance to his intriguing fake-fur bedroom with a chain "hung to touch just under the knee, a sensitive spot."[7]

Perhaps Oldenburg's most captivating works to date are his two *Giant Fans* (1967), the "ghost" version of Liquetex on canvas, the black one—with a barely perceptible green bottom—of vinyl and foam rubber. Both inertly hang from the ceiling. The petal-like drooping blades of the "ghost" with its baggy body and entangled coils, and

[7] *Ibid.*

the more compact form of the black vinyl are transformations of familiar objects into shape clusters surrendered to the pull of gravity. The softness of those fans is illusionary: the materials are too bulky and stiff for cuddling. These are no more giant soft toys than Pollock's drip painting is an elaboration of childish scribbling. In counterdistinction to the blades visibly rendered pliant, hence harmless, we have Oldenburg's *Lipstick Ascending on Caterpillar Tracks* (1969), which metamorphoses the gentle feminine lipstick into a phalloid, murderous war machine—an insipid fusion for an artist of such associative richness.

Jim Dine: His Identifications

American Pop art fluctuates between Expressionistic distortion and stylistic refinement. Failure to understand this inner contradiction poses a problem to those who view an art movement in terms of a development of a single style. Thus some critics have found it difficult to consider Jim Dine a genuine Pop artist, an attitude which Dine himself has encouraged by stressing his Expressionistic bent. Like Oldenburg, Dine belonged to the group of pioneers who, in the late fifties, experimented with Happenings. The rapid recognition his painting gained led him to concentrate on the latter. With his series of oversized items of clothing, jackets, ties, suspenders, he made a transition from the world of Happenings, feeling perhaps that clothes are an actor's first tools, the principal element of his extended personality. Jim Dine painted his vests realistically, on occasion adding real buttons as if to challenge our preconceived ideas about pictorial realism.

Without losing interest in ready-made clothes, Jim Dine next focused on industrially made hand tools. Grandson of a hardware merchant in whose store he spent much time in childhood, Dine "manipulates tools with a child's aggressive handling of toys. He spills color over his tools: vises are coated battleship gray, axes streaked with surf green, knives stained cherry rouge, oil cans

brightened by international orange, torches extinguished in a heavenly blue, shovels daubed in inexpensive black."[1] The most impressive work of the period is *Five Feet of Colorful Tools,* a canvas dominated by a frieze of polychrome tools set against their bright gun-sprayed shadows and subdivided into four unequal sections by saws and a brace which extend slightly below the other tools to avoid monotony.

Hatchet with Two Palettes State #2 (1963), a canvas with a hatchet chained to a raw plank and thickly spattered with paint, dares the viewer to violent action and makes explicit the conflict between making and destroying. (The axe was in fact used by art lovers to chop at the canvas at an exhibition, "For Eyes and Ears," at the Cordier and Ekstrom Gallery in 1964.) In a series of paintings devoted largely to the palette exhibited in 1964, Dine identifies himself with the palette, the hatchet, and clothing, specifically with a red robe. Among the works are those entitled *Palette (Self-Portrait #1),* *3 Palettes (3 Self-Portrait Studies),* *Red Robe with Hatchet (Self-Portrait).* The axe, moreover, is included in a photograph of the artist below the *Red Robe* canvas in the catalog of the show.

Alongside these explicit identifications, Dine depicts the home. Those are not environments but canvases with objects attached to them; evocations of rooms of which those of the bathroom are the most enticing. It has been well said of those "room paintings": "His unflat paintings, with pleasant paradox, are flattened cubes (rooms): the washbasin against a patch of black paint becomes a drawing, the white of the porcelain acting as a part of the 'paper.' "[2] Objects such as medicine chests, shower heads, electric appliances, toothbrush holder, towel rack have been carefully selected and set sparsely and in strategically important positions to enhance their formal qualities. The painting technique is apparented to the Expressionist work of Rauschenberg and Johns. Reversing the procedure of Hans Hofmann,

[1] Nicolas Calas, *Art in the Age of Risk* (New York: E. P. Dutton & Co., Inc., 1968), p. 196.

[2] Öyvind Fahlström, Preface to Jim Dine's catalog, Sidney Janis Gallery, 1963.

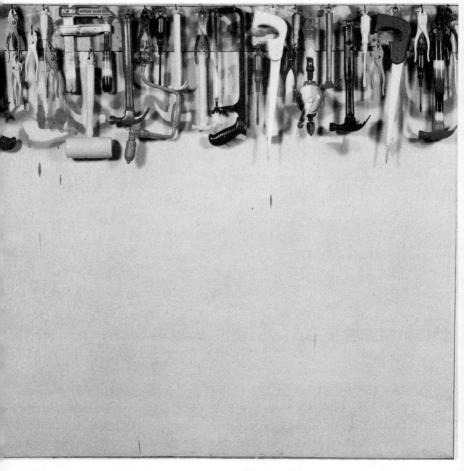

Jim Dine: *Five Feet of Colorful Tools.* 1962. Oil on canvas, surmounted by a board on which thirty-two tools hang from hooks. 55⅝″ × 60¼″ × 4⅜″. Sidney and Harriet Janis Collection. Gift to The Museum of Modern Art, New York. Photograph courtesy of Sidney Janis Gallery, New York.

which consisted of stabilizing Expressionist painting by means of monochrome rectangles, Dine resorts to "object forms" to enliven the picture plane, apt to be calculatedly undistinguished.

In this series ambiguity is evidenced in such witty works as *Green*

Shower (1962), where the shower against a background of dense-paint greenery ends in a light bulb dispensing light instead of water. *Small Shower* (1962) appears to spray paint while an electric light sheds painted beams in *The Flesh Bathroom with Yellow Light* (1962).

The originality of Dine emerges in his egocentric way of handling tension. This underlies his concern with the conflict between a tool's reality and an image's reality; hence the painted palette, viewed as the imagistic opposite of the real palette, makes paint brushed on it look as real as do the authentic buttons on the painted jacket. Dine's paintings are less dramatic than Rauschenberg's and less ambiguous than Johns': he is both less theatrical than the former and more direct than the latter. Unlike Oldenburg, who makes objects his expressive medium, Dine's objects are obstacles placed in the path of his expres-

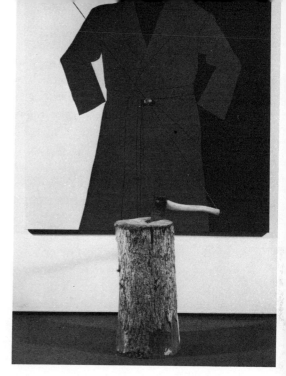

(*Left*) Jim Dine: *Long Island Landscape.* 1963. Oil, collage, and metal. 96″ × 162½″. In the collection of the Whitney Museum of American Art, New York. (*Right*) Jim Dine: *Red Robe with Hatchet (Self-Portrait).* 1964. Oil, metal, and wood. 60″ × 60″ × 23″. In the collection of Mr. and Mrs. Robert Mayer, Chicago. Photographs courtesy of Sonnabend Gallery, New York.

sion. Unconsciously at least, he seems to exploit the unresolved tension between physical reality and artistic reality in terms of a contradiction between the urge to express himself and the urge to satisfy personal needs. The bathroom thus appears as a key image of a release of tension in privacy, the complementary opposite of the hatchet which provokes public aggression.

Whatever the immediate subject matter and the psychological context, Jim Dine's painting is primarily about "the facts of painting." His palette series were followed by an eight-panel giant enlargement of an industrial color card in *My Long Island Studio,* subtitled "Large Color Chart" (1963). As described in an exhaustive and penetrating study by Alan R. Solomon, Dine merely takes his point of departure from the card, using paint unevenly and intensively, contrasting "passages of impasto, scumbling, transparent washes, drips

and shadings" to the flatness of most of the painted surface. "This flat passive regularity has been complicated in a number of ways. At the left another color chart has been superimposed, altering the original plane, the original scheme, the relation to the margin etc. At the right a transparent palette fills the whole panel, creating further spatial ambiguity. . . . The picture contains an inventory of different manners of handling."[3] Dine adopts a somewhat similar approach in *Long Island Landscape* (1963), although this is a recognizable Expressionistic landscape with two modified personal "color charts." To the flatness of most of the painted surface, Dine contrasts wash and dripping to suggest the sea, dense pigment to suggest the coarse grass. There is also a scribble like a straw in the wind. The canvas—actually formed by three canvases—is subdivided into squares by drawn lines with a further subdivision marked at far right as though to contrast geometric order to nature's disorder and messiness. The two collages, brightly and regularly striped, are attached to the very right of the painting, where the thick green pigment is mostly concentrated, thus providing the effect of a whimsical change in density.

In an interview with Swenson that year Dine said: "The thing that really pulls a painting out is you, if you are strong, if it's your idea you're wanting to say—then there is no need to worry about style."[4] Three years later he must have come to realize that his attitude could lead to a dead end, for he said to Robert Fraser: "One can't lose sight of the fact that there's just so much information in one's life, otherwise you're burned up."[5] If we are to judge from the naïvely sentimental collages that were reproduced to accompany the interview in print, the artist had lapsed from grappling with essentials. Dine started on a project that he entitled *Nancy and I at Ithaca* (*Straw Heart*, 1966–1969) for which he proposed making free-standing, huge objects. The completed works included a large metal triangle to which

[3] Alan R. Solomon, "Jim Dine and the Psychology of the New Art," *Art International*, October 1964.

[4] G. R. Swenson, "What Is Pop Art?", *Art News*, November 1963.

[5] Robert Fraser, "Dining with Jim," *Art and Artists*, September 1966.

he glued strips of fur, "furring" it, a richly textured heart of galvanized iron, red-sanded lips, a nine-foot-high metal cylinder fitted into a tight corduroy corba skin. At Cornell Dine said: "I'm changing, my ideas are changing, I'm more permissive. I don't see how you can avoid it."[6]

Amid this extravaganza, these monumental changelings "whose content is forever personal," one sculpture stands out, objective and harmonious. It is *Nancy and I at Ithaca (Formal Waterfall, 1966–1969)*, a static rendition of the curve of a waterfall. Of sheet metal, it was first covered with a layer of blue paint, then the surface sprayed with a flat white paint, "achieving a curious floating, sky-like effect."[7]

[6] Quoted by Wm. C. Lipke in the catalog of the Andrew Dickson White Museum of Art, Cornell University, April 1967.
[7] *Ibid.*

Marisol's Law of Frontality

Marisol's trademark is the recurrent portrayal of her own strikingly beautiful face and parts thereof, carved in wood, cast in plaster, painted, penciled, photographed, etc. In addition, there are replicas of her expressive, slim hands, her feet, her ears, and her *derrière*. Marisol works "cubistically." Basically she works in wood—elongated boxes built most frequently of pine planks. However, the majority of her constructions are described in catalogs as of "mixed media" because carving is combined with casting and real objects such as clothing. Recently she has experimented with metal sheeting, substituting it for wood, which has resulted in important simplification of the surface treatment.

Of her earlier sculptures, the well-known *Four Women and Dog* (1964) is an adaptation of a pre-Columbian Peruvian group sculpture to a contemporary theme, treated wittily.[1] (Marisol Escobar was born in 1930 in Paris of Venezuelan parents and first showed in a

[1] "Provocative Parallels," *Art in America,* July–August 1969.

group show in the United States in 1960.) She is nimble and resourceful in introducing variations, having limited herself to three equal hollow wood "cases" to represent the three adult bodies, half-height for the child and hat blocks for the heads. The figures, painted, stenciled, left in part raw, are furnished with some real accessories, the handbag, dog's collar and leash, child's hair ribbon. The hand holding the handbag and leash is a cast of Marisol's, as is the one on the child's shoulder, which matches in color and softness of form the little girl's real hair ribbon. Feet include the fully delineated black high-heeled shoes of the woman holding the leash to the stumplike, unfinished legs of the woman next to the child. Variations in the treatment of the head are quite elaborate, although (dog's stuffed head apart) all are portraits of Marisol. The three-faced head (on the left) makes do with two eyes and only the central face has a lipsticked mouth; the third head fronts us with four faces, each two-eyed, and those are supplemented by three more faces set in the back of the head. The middle woman (with the inflated breasts, who sports a small appliquéd *derrière* on reverse of block) has the most curious head, with the deep projection framing a Marisol photo; the child is in Marisol's own childhood likeness as she portrayed herself in *Mi Mamá y Yo* (*My Mama and I* 1968). Similar diversified treatment is accorded far more complex groupings.

While Picasso's and, in his wake, Ionesco's three-nosed fiancée are likely to have inspired the many-profiled Marisols, it may be that Magritte's *bilboquet*[2] suggested the queer projection of the head which holds and displays Marisol's photograph. But the consistent recourse to an interplay of two-dimensional and three-dimensional sections of a work is Marisol's contribution. She reaches a virtuoso high in her two large ensembles of 1965–1966: in *The Party* she displays 15 free-standing versions of herself in an array of evening gowns with surface embellishment predominating and intricate sculpture-in-the-round coiffures; head variations dazzle in her complex

[2] For a description of the *bilboquet,* see James Thrall Soby's *Magritte* and Magritte's presentation in *The Rights of Man* (1945) (New York: Museum of Modern Art, 1965), pp. 13 and 44.

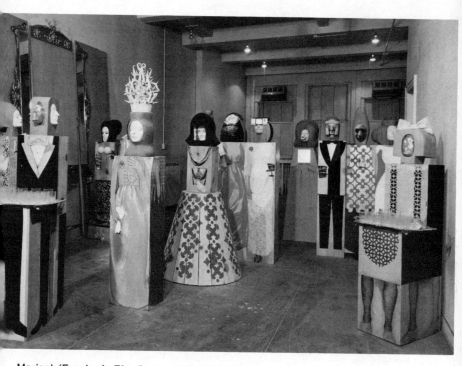

Marisol (Escobar): *The Party*. 1965–1966. Fifteen figures of mixed media. 119″ × 188″ × 192″. In the collection of Mr. and Mrs. Robert Mayer, Winnetka. Photograph courtesy of Sidney Janis Gallery, New York.

assemblage of 11 boxed-in figures in *The Dealers*. To single out one: seen frontally, the overlapping petal-like fragments of face masks form a curiously beautiful whole; seen from the sides, the eight fragments fall apart disjointedly, mounted as they are on staggered rods of varying length.

On the debit side, her early social satire directed, for instance, at the military is crudely contrived and ineffective; her later portrayals of statesmen—derived from mass media—are apt to be simplistic and meaningless; her family groups without interest. She is at her wittiest in works closer to her own milieu and of those the best perhaps are *Portrait of Sidney Janis Selling a Portrait of Sidney Janis by Marisol*

(*Left*) Marisol (Escobar): *The Dealers*. 1965–1966. Eleven figures of mixed media. 74″ × 74″ × 47″. (*Right*) Marisol (Escobar): *Mi Mamá y Yo*. 1968. Painted steel and bronze. 73″ × 56″ × 24″. Photographs courtesy of Sidney Janis Gallery, New York.

by *Marisol* (1967–1968) and *Guy* (1967–1968); both are highly successful, the former as complicated as is its title due to its sophisticated interplay of sculptural and graphic elements, the latter of sophisticated simplicity. *Guy,* fashioned from a narrow block (84″ × 12″) is in the guise of an elegant, slim cigarette lighter. The face is cast, so is the portion of one hand seemingly slipped into a pocket of his dark pinstriped suit, a phallic erection is discreetly traced as on a Hermes stele.

However, it is pre-Grecian art that Marisol is most indebted to, for she cunningly exploits an ancient Egyptian device by reversing it. Before hewing a figure out of a block, the Egyptian sculptor drew its front view and its side view on the surfaces of the block, Marisol produces her sculpture by equating the figure with a hollow rectangle instead of carving it out of the block. The large rounded laminated heads of Marisol in *Sun Bathers* (1967) as well as those of Harold Wilson and Sidney Janis evoke Egyptian headdresses such as that of Queen Nofret. Marisol's sense of irony would have prompted her to avail herself of still another trait of Egyptian art: the representation of

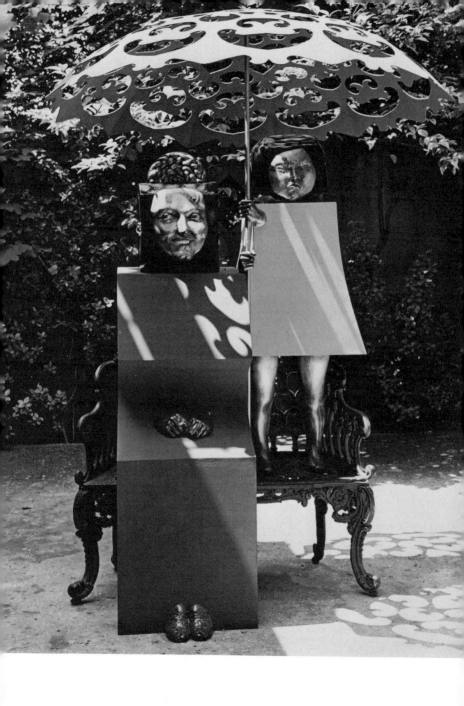

wife and children in miniature at the feet of a pharaoh. In *Portrait of L.B.J.* (1967) Marisol has placed tiny likenesses of his wife and daughters in the palm of the President's hand.

Nofret's sculptured hand posed against her body, barely differentiated from the limestone mass, may have influenced Marisol's treatment of the hand. She is fascinated by hands, notably her own. In her version of *Mona Lisa* (1961–1962), hewn from an elongated wood block, she transforms Gioconda into a stele and endows her with her own lovely hands folded in her own manner.

<div align="right">E.C.</div>

Roy Lichtenstein: Insight Through Irony

Lichtenstein is a merciless critic of illusion, both cultural and aesthetic.

In 1951, thus two years before Larry Rivers, he undertook to reinterpret *Washington Crossing the Delaware*. As he was to say many years later, he has always had an interest "in a purely American symbolic subject."[1] Lichtenstein was temperamentally unsuited to rework pictorial themes, either in terms of Expressionist distortion, as Larry Rivers excels in doing, or in terms of complicated syntactical reconstructions, as did the Cubists. Lichtenstein re-forms to clarify. The twentieth-century great masters of clarification are Matisse and Léger. Matisse, borrowing from a conventional Persian miniature, made compositions that focused on the interplay of figure and ground. Léger was at his best when he clarified in order to glorify the worker as the hero of industry. Lichtenstein clarifies in order to criticize: "I want my images to be as critical, as threatening, and as insistent as possible," he said to Coplans. His interviewer then asked, "About what?" and Lichtenstein replied: "As visual objects, as paintings, not as critical comments about the world." He adopts "a detached impersonal handling of love, hate and war," and believes "the closer my work is to the original, the more threatening and critical the

[1] John Coplans, *Roy Lichtenstein* (Pasadena: Pasadena Art Museum, 1967).

content."[2] It follows, it would seem to me, that only a work which touches upon a myth whose validity is accepted by the viewer, could be threatening. A viewer immune to the values inherent in the myth would remain insensitive to the threat.

Through an intensified and perfected promotion of a set of cultural patterns in behavior and taste, comics and ads came to be viewed as the raw material of a new iconology. How upsetting the image of a frankfurter that is both so similar and yet so unlike the one heroized by the ad! How threatening the image of a Greek temple which looks so harsh in comparison with the original hanging in a Greek restaurant or on a poster of a travel agency. Lichtenstein is quoted by Coplans as saying: "Oldenburg's *Fried Eggs* is much more glamorized merchandise and relates to my ideas more than Johns' *Beer Cans.*" While Oldenberg re-forms to distort Expressionistically, Lichtenstein re-forms to isolate. In his drive to glamorize his merchandise, Oldenburg grimaces before the camera; Lichtenstein prefers elegant poses. (Dali's photographer took an unfair advantage of this by making Lichtenstein, unknowingly, adopt a Beardsley pose.) Dali excels in elaborating half-truths. Lichtenstein is not, as he claims, the Beardsley of our day; Lichtenstein remains much closer to the cartoons than Beardsley did to the Japanese print. Beardsley wanted to seduce and pervert, not to threaten and criticize. He belonged to fashion, Lichtenstein transcends fashion. He blocks the way to total identification with the original by simulating the photoengraver's dots, which, on the printed page, can only be seen through a magnifying glass, and identifies the finished product with the process of reproduction. In other words, the Ben Day dots are to the painting of Lichtenstein what the brushstroke is to Abstract Expressionism, an image of process.

A key image for the understanding of Lichtenstein is his series of paintings of brushstrokes made to look as much like a Hokusai version of a brushstroke as Kline's were made to look like bona-fide action painting. In his interview with Coplans, Lichtenstein points out that "the very nature of the brushstroke is anathema to outlining and

[2] *Ibid.*

filling in as is used in cartoons." To the erratic and idiosyncratic tracings of the Expressionist, Lichtenstein opposes the standardized image or "stamp." He is closer to the stamp collector who is on the watch for imperfections in a stamp, but unlike the latter, who prizes the defective specimen, Lichtenstein re-forms it, as his purposes are not identical with those of the original designer: the illustration in the comics is meant to be seen in a narrative sequence, while his purpose is to unify.[3] To unify, he has to clarify, which he does by flattening figure and ground in what might be called an artistic reevaluation of the industrialized reproduction. It was Mondrian who unwittingly provided the basic rules for mass reproduction. Lichtenstein may well have deduced that, with Magna colors, a red or a blue can be made as impenetrable as black and therefore could be treated as line.

Unlike Mondrian, who structures his paintings on fundamentally Cubist principles, Lichtenstein abstracts by employing the figure and the ground of all "useless" elements. For instance, in his version of *Girl with Ball* (1961)[4] the girl's nose has been reduced to two dots for the nostrils, her teeth to a white arc, the horizontal line between chin and mouth was omitted, and the arms left jointless. Lichtenstein abstracts by subtraction. He is a master of the inverted close-up, for the closer our scrutiny, the more abstract the figure appears. The image is often thematically incomplete since it has been lifted from its context. Unlike the narrative illustrator, who follows a time sequence, Lichtenstein conceives in purely spatial terms.

Lichtenstein's paintings may be considered as aggressive and threatening by the Andy Wyeth kind of Realist and by the Minimalists. To the event depicted by the Realist, he opposes the interrupted event and to the primary structure, arbitrarily chosen representational elements.

Through with the comics, Lichtenstein took on reproductions of modern masterpieces, for those too, as he correctly observed, form part of the popular myth. I think he failed with the Cubists, especially with Picasso's *Woman with the Flower Hat*. A convincing clarifica-

[3] G. R. Swenson, "What Is Pop Art?" *Art News*, November 1963.

[4] Lucy Lippard, *Pop Art* (New York: Frederick A. Praeger, 1966), p. 80.

tion of this portrait would require the dissolution of Picasso's complex fusion of the two poses. Lichtenstein's version is an unconvincing structure with an awkward figure and ground relationship.

Lichtenstein proved eminently successful with his series of landscapes. In his *Temple of Apollo* he froze the atmosphere by reducing the sky to a field of blue with white Ben Day dots and contrasted it to the sea—a field of white and blue Ben Day dots. Against this background, the ruins of the temple seen from the vantage point of the

Roy Lichtenstein: *Temple of Apollo.* 1964. Oil and magna on canvas. 94″ × 128″. In the collection of Mr. and Mrs. Robert Rowan, Los Angeles. Photograph courtesy of Leo Castelli Gallery, New York.

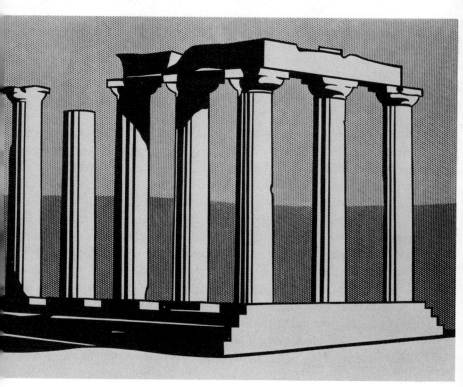

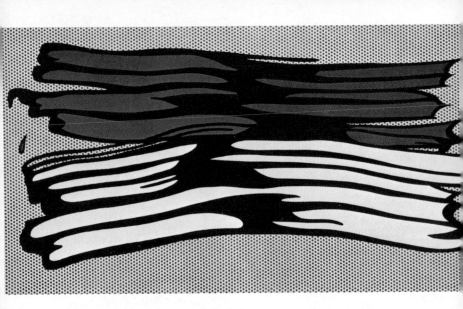

Roy Lichtenstein: *Yellow and Green Brushstrokes.* 1966. Oil and magna on canvas. 36″ × 68″. In the collection of Robert Fraiser, London. Photograph courtesy of Leo Castelli Gallery, New York.

single standing corner formed by the columns look harsh; and the mercilessly black shadows that fall upon the temple are as aggressive as the sun projecting vivid yellow upon the foreground. What a relief to have an artist kill that local color of romanticism that glows on all the advertisements of Greek and Roman temples.

From skies with temples or with sunsets, Lichtenstein turned to reproductions of Monet's cathedrals and haystacks. These are among his finest works. The mechanics are not easy to unravel, based as they are on a clever interplay between screens and dots. Thus, the bright color, whether screen or dots, corresponds to the bright sections of the cathedral while the black dots and the dark areas—screenless—indicate the somber part of the edifice. Through an interplay of yellow dots on black ground and black dots in yellow screen, a neo-Impressionist blur is achieved which approaches the haziness and diffusion of light Monet obtained with his brushstrokes. In other

versions, more complicated, a white screen with both blue and red dots is used to achieve a purplish haziness, presenting the edifice in varying light. With the relative instability of "microelements," Lichtenstein approximates the atmospheric effects of pointillism. Undoubtedly Lichtenstein has carefully studied the technique of the Op artists: while the latter use pattern as subject matter for kinesthetic effects, Lichtenstein, like Seurat, resorts to pointillism to create an image that is new.

Having made his critique of Abstract Expressionism through his reappraisal of the comics, Lichtenstein leveled his sights on Minimal art through a reexamination of the modernistic designs of the thirties. Alloway, the first to draw attention to the significance of Lichtenstein's work of this period, quotes the artist as saying that the forms of the thirties are "a discredited area like the comics."[5] As is well known, the modernistic was frowned upon by purists such as Le Corbusier, Gropius, Ozenfant, and also Alfred Barr. However, for artists of Lichtenstein's generation, Art Deco has a fascination akin to what Art Nouveau had for Dali and the Surrealists. Unlike Art Nouveau, whose soft forms and herborial motifs evoke the vegetative aspect of life we associate with sleep, dreaming, opium, Art Deco with its aggressive angles, metallic and plastic surfaces provides a dynamic image: that of mass-made massive furniture, often inexpensive but expensive-looking. Furniture and decoration intended to glamorize lobbies of movie theatres. As Alloway remarks, "We live among its monuments and its detritus, from the dazzling Chrysler Building to a thousand run-down 'swank façades' (Lichtenstein's phrase) stuck onto delies and bars all over the U.S."

A number of these mementos have been remodeled by Lichtenstein into flat sculpture, horizontal or vertical, mostly in brass, occasionally with mirror. These are reminiscent of the flat sculpture of artist-workers welding, painting, polishing steel with industry and for the glory of art.

Some of Lichtenstein's Art Deco paintings might be traced back to

[5] Lawrence Alloway, "Roy Lichtenstein's Period Style," *Arts Magazine,* September–October 1967.

(*Left*) Roy Lichtenstein: *Modern Sculpture*. 1967. Brass and mirror. 72″ × 31″ × 20½″. (*Right*) Roy Lichtenstein: *Pyramids III*. 1969. Oil and magna on canvas. 28″ × 68″. In the collection of Dr. and Mrs. Donald Dworken, Fairfield. (*Right below*) Roy Lichtenstein: *Modular Painting with Four Panels #2*. 1969. Oil and magna on canvas. 96″ × 96″ (Four panels: 48″ × 48″). In the collection of the artist. Photographs courtesy of Leo Castelli Gallery, New York.

Kupka's works, such as *Black Wheel* (1929) or *Hot Jazz* (1933). Lichtenstein's *Modular Painting with Four Panels #2* (1969) is a *tour de force*. The four panels are not just a repetition of four modulars, for together they form two large central disks which divide the picture vertically in two. When we focus on the disks and mentally subdivide the painting, we are faced with a contradiction, for the disks are but the effect of an optical phenomenon. The composition has to be reevaluated as an indivisible whole, for the borders of the overall square are not interchangeable. The picture is a feast to the eyes. The combination of vibrant colors with soft colors—dotted or screened— is most satisfactory. No artist today knows better than Lichtenstein how to use complicated design to enhance color. But for myths the pyramids would not have been erected. Lichtenstein sees them in the context of the tourist myth. His painting of the Great Pyramids is an

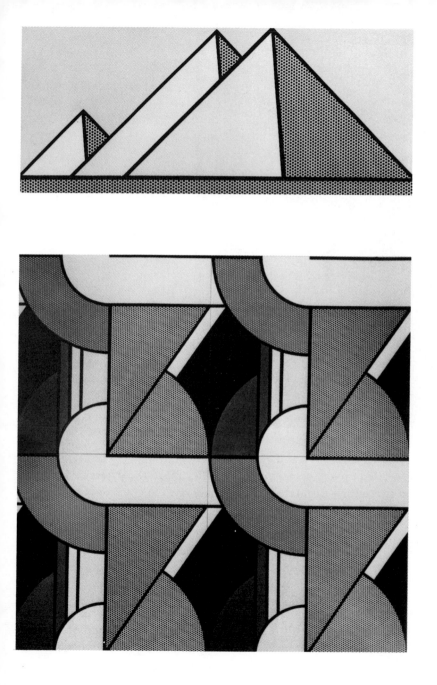

Roy Lichtenstein: *Rouen Cathedral, Set III*. 1969. Oil and magna on canvas. 63″ × 42″. In the collection of the artist. Photograph courtesy of Leo Castelli Gallery, New York.

exercise in funny geometric forms. They make the pyramids look like an overturned ziggurat. Tourists would have to come to New York to see that!

N.C.

Andy Warhol's One-Dimensional Mind

Andy Warhol is undoubtedly the most controversial artist to attain fame in the last decade. Critics seem to be either attracted or repelled by his cool attitude toward his subject matter, which is apt to be

violent death. It is this emotional detachment that prompted the English critic Christopher Finch to view Warhol as a classical painter, comparing his silk-screened *White Car Crash* (1963) with Poussin's *Landscape with Snake.* Easily outdoing the French master in the horror of the scene—an overturned burning automobile and a body hanging from a pole—Warhol rediscovered the dramatic value of including an indifferent spectator, in this case a passerby who continues on his way past the blazing wreck. As Finch pertinently goes on to remark, both painters have resorted to a geometric framework with the difference that with Poussin "geometry is skillfully disguised as naturalism" while "Warhol achieves the same effect through the multiplication of the image on the canvas."[1]

In a lecture Willoughby Sharp claimed that Warhol's compositions of four five-petaled flowers each, derives from Albers' squares. It might be tempting to deduce that Warhol "imitated" Poussin via Albers (rather than via Cézanne). Both Albers and Warhol have a predilection for sets of images and serial imagery; both artists were included in "Serial Imagery" exhibition, with Warhol having the distinction of being the sole figurative contemporary painter included, represented by his *Brillo* (1963–1964), *Campbell's Soup* (1961–1962), *Liz* [Taylor] (1963), *Marilyn Monroe* (1962) series.

John Coplans describes in detail the process used by Warhol to produce his serial works (after he gave up painting identical canvases by hand as in the case of the 1962 Campbell's soup cans, which differ, however, in the label describing the variety of the soup). The transformation of the original photograph into the completed work of art is achieved by means of a number of mechanical processes: a photographic transfer of the image onto the printing screens and the printing of the image on the canvas with synthetic colors and squeegees.[2]

Coplans contends that, although such stars as Marilyn Monroe and

[1] Christopher Finch, *Pop Art* (New York: Studio Vista/Dutton Pictureback, 1968), pp. 146–51.

[2] John Coplans, *Serial Imagery* (Pasadena, Calif.: Pasadena Art Museum, 1963), p. 130.

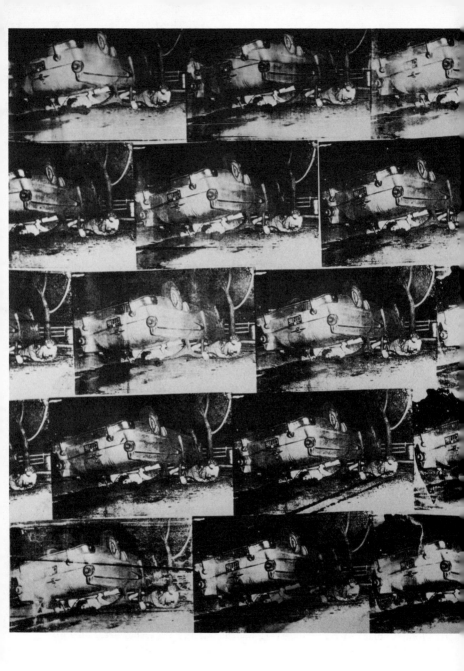

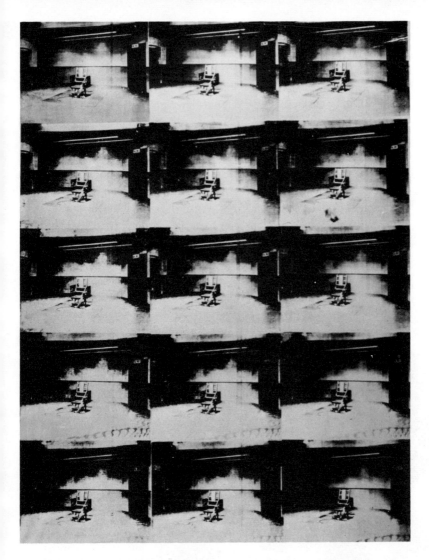

(*Left*) Andy Warhol: *Orange Disaster*. 1963. Silk screen on canvas. 110″ × 82″. Photograph courtesy of Leo Castelli Gallery, New York. (*Above*) Andy Warhol: *Orange Disaster #5*. 1963. Oil on canvas. 106″ × 82″. In the collection of the Harry N. Abrams Family, New York. Photograph courtesy of Harry N. Abrams, Inc., New York.

Liz Taylor are made to look ugly and distasteful in Warhol's presentation, there is beauty in the work that has nothing to do with the physical attributes of the originals but with "human decisions made by Warhol."[3] Certainly one cannot fail to admire Warhol's cleverness, but I for one do not see any beauty in his decisions, nor do I believe that in these images Warhol proves that machine and mechanical processes are no worse nor better than the men who use them. Might not a good photographer take a good photograph with a cheap camera and a bad photographer a bad one with a Leica?

David Antin has claimed that Warhol is "the master of a communication game that elicits the false response." In his analysis of *Cows* (1966), a series of 73 pink cow heads silk-screened on wall-

[3] *Ibid.*

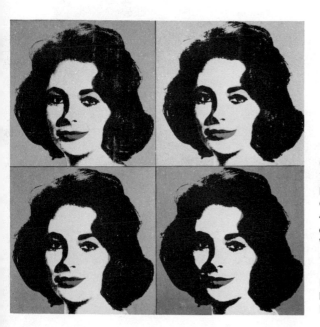

(*Left*) Andy Warhol: *Liz.* 1963. Four separate paintings. Silk screen on canvas. Each canvas: 40″ × 40″. Various owners. (*Right*) Andy Warhol: *Cow Wallpaper.* Silkscreen ink on paper. Each image: 44″ × 30″. Photograph courtesy of Leo Castelli Gallery. New York.

paper, Antin observes that the heads had been magnified to the point where there were insufficient dots to fill in the nose and the horns. Notwithstanding, we recognize Elsie the Borden cow staring blankly out of the wall. However, with a slight change of affect, the same faces become "foolish" faces "enlarged to a painful scale" and "staring at us mournfully": "They are sorrowing clowns."[4] At his best, Warhol gives us an alternative, either to dismiss the vulgar distortions of the printing process and see his pictures in terms of the celebrities evoked, whether human or Elsie the cow, or in terms of the human or animal condition, which is neither beautiful nor secure. For his serial imagery to have an impact, the figures portrayed have to be of public stature. Unlike the propositions of logic, which have to be either true

[4] David Antin, "Warhol: The Silver Tenement," *Art News,* Summer 1966.

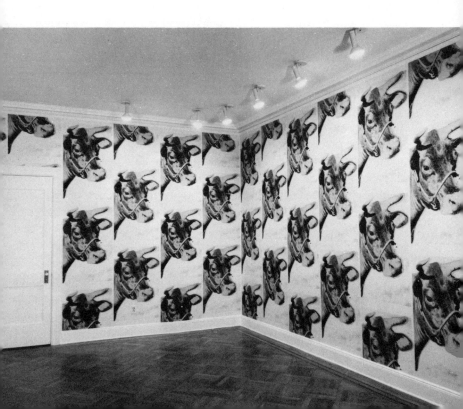

or false, artistic statements are apt to be ambiguous and our final appreciation of a work of modern art has to take into account the factor of ambiguity.

Warhol's stroke of genius was to have projected the machine in terms of ambiguity. Historically, the machine's function was to free man from the pain of labor and the dehumanizing boredom of repetition. Repetition for repetition's sake is absurd, as exemplified by the myth of Sisyphus, who had no choice but to go on repeating his useless labor and whose very existence became the epitome of absurdity. *Homo sapiens* does not necessarily reject the absurd. *"Credo quia absurdum,"* declared the great theologian, Tertullian, who had the alternative of accepting the Church's dogma on the Trinity or repudiating Christianity. With the substitution of doubt for faith—as enunciated by Montaigne—the way was opened for man to assert that existence was absurd. Warhol presents *his* point of view as follows: "Someone said that Bertolt Brecht wanted everybody to think alike. But Brecht wanted to do it through Communism, in a way. Russia is doing it under government. It's happening here by itself without being a strict government, so if it's working without trying, why can't it work without being Communist? Everybody looks alike and acts alike, and we're getting more and more that way. I think that everybody should be a machine."[5] And what about differences in performance between machines? The ultimate goal of mechanization is precision. In a competitive market companies often claim to achieve degrees of precision that are so infinitesimal as to be absurd. It would seem that in Warhol's case his use of mechanical processes or reproduction when he makes sets or serials of repetitive images with minimal differences between them, is at the expense of the avid collector. Warhol himself has complained—true enough, a number of years back—"I have not been able to make every image clear and simple and the same as the first one." Recently, however, he was able to realize his ambition that somebody else do his painting for him.

Warhol treats with equanimity the two forms inherent in machine function: perfect repetition of its appointed task and accidents result-

[5] G. R. Swenson, "Interview with Andy Warhol," *Art News,* November 1963.

ing from malfunction, whether mechanical or human. On the subject
of his *Death* series, Warhol pointed to journalism: not only do news-
papers ostentatiously display on their front pages pictures of plane
crashes but predict holiday-weekend deaths: "Every time you turned
on the radio they said something like, '4 million [*sic*] are going to
die.' "[6] It is not that he is on the side of death, he is simply a witness,
a recorder. He told Swenson that he started his *Liz* series (portraits
of Elizabeth Taylor) when she was so sick that it was thought she was
dying; now that she has recovered, he is repainting it, "putting bright
colors on her lips and eyes."[7]

N.C.

[6] *Ibid.*
[7] *Ibid.*

James Rosenquist's Angular Vista

Cubists fractionalized images to restructure pictures, Surrealists
brought together incompatible objects to reveal a new reality, Rosen-
quist misfits parts to block both the poets metaphors and the adver-
tisers hyperboles. He is the master of the nonimage. He thrusts it
upon us to immunize us against information, the confusion of
tongues, the photographer's parlance, the billboard's vernacular, the
electric message, the phonographic rounds of sound, the cinematic
blow-up, all the noise that makes up Manhattan's Times Square. The
"caustic relationships" (the expression is his) that Rosenquist forces
upon Franco-American spaghetti in its tomato sauce—with the look
of intestines—and the accidental confrontation of a car's bumper
with a girl's profile; the two maladjusted parts of car windows; a comb,
dripping paint, dividing the picture horizontally and slicing an orange
in two; noncommunication between a couple reduced to legs advanc-
ing toward blue blankness; a nose tattooed with IBM perforations. In
World's Fair Mural (1964) Rosenquist spills out of Uncle Sam's
bountiful top hat a bleached-pumpkin moon, sun-kissed marigolds

(*Above*) James Rosenquist: *Painting for the American Negro.* 1962–1963. Oil on canvas. Three panels: 80″ × 210″. In the collection of The National Gallery of Canada, Ottawa. (*Right*) James Rosenquist: *World's Fair Painting.* 1964. Oil on masonite. 216″ × 240″. Photographs courtesy of Leo Castelli Gallery, New York.

and peanuts, the silver spoon, a model's "hams," the glossy car, the status tires—the whole always charged with deadpan presence.

Rosenquist's paintings recall collages of snapshots. Some striking effects depend on blurring derived from shadows and reflections on polished surfaces. The candid camera may have caught a city mood by capturing the weary young man standing before a shoe-polish ad, by surprising us with the two pairs of legs protruding from beneath the Bell System booths; Rosenquist accentuates the incongruity of a photographic situation by substituting an abstract look for a candid one. More recently he compounded the effect of discontinuity by presenting "sequences."

The tripartite painting *For the American Negro* (1963) is held together pictorially by a 1950 Chevy, door open, in the background and a pair of red-rimmed glasses in the middle ground, both overlapping the three sections. This is a painted collage of body parts, sliced, either vertically or horizontally, in which Rosenquist elaborates on misunderstanding in terms of a partial or, as it were, one-eyed view of color: the color of men and color in painting. The red-rimmed glasses

have but one lens—through which one sees the clouded sky—the other is opaque. The glasses provide a clue to the range of misunderstanding based on mis-seeing, mishearing, miscomprehending. On the right a "leg" of the glasses has been plunged knifelike into a man's orange head just above the prominent ear. The face has been sliced off and replaced by a slice of white cake with chocolate frosting: white people, brown people?

In the foreground of the left section, blue-colored legs of basketball players are upended against the backdrop of a green-blue sea, as if plunging headlong into the water. Above the backdrop of the sea, which slices this section horizontally, a swimmer's forehead is visible up to the eyebrows, crowned or oppressed by the headless statue of

James Rosenquist: *Horse Blinders*. 1968–1969. Oil on canvas and aluminum. 120″ × 1014″: 14 panels. (Designed for the four walls of a room, the panels should be viewed in narrative sequence from right to left as they are re-

Lincoln. In the center, in the space formed by the frame of the glasses, there is a black horse's head cropped below the eyes. A young child's open mouth with missing teeth is juxtaposed to the mother's closed-mouth semiprofile perforated by IBM signs, suggesting miscomprehension: the second "leg" of the glasses is plunged between a leg of a basketball player and the mother supposedly talking to the child. The words "darken, normal, light" inscribed next to the lenses of a camera, fuse the theme of color exemplified by Rosenquist's "colored" people with that of reproduced color.

The child's raised face with the disordered mouth seen together with the horse's head bring to mind that famous detail of *Guernica* in which a woman's raised head with anguished mouth approaches that of the bull. With an extraordinary economy of form and the use of but black, white, and gray, Picasso vividly conveys intensity. Picasso's handling of images in epic terms, as well as United States billboards with their childish and crude glamorizations, have had a powerful impact on Rosenquist. Yet, while he succeeded in structuring—in post-Cubist terms—the image in *Marilyn Monroe I* (1962), he encountered difficulties in developing a convincing colored sequence. (Cubism had always sacrificed color to structure.)

A witty variant of his preoccupation with color is to be seen in *Rainbow* (1961). From a frieze composed of portions of a window and its shutters, paint streaks down staining a white house front. Of the two windowpanes, one has been shattered, leaving but jagged

produced across the page spread.) In the collection of Dr. Peter Ludwig, Aachen. Photographs courtesy of Leo Castelli Gallery, New York.

edges of glass (real glass), while the second exhibits the prongs of a "jabbing" (Rosenquist's description) fork. Are those spurting color in lieu of blood?

Rosenquist went on to discover a device to introduce blurring and reflection into a narrative sequence. In his recent and most important work to date, *Horse Blinders* (1968–1969), he abandons his post-Cubist fractionalized angularity in favor of the contrast between images and their reflection upon aluminum surfaces set at right angle to the painted canvas. The great painted panels alternating with smaller reflecting surfaces occupied the entire wall space of the showroom (minus the doorway). The narrative reads counterclockwise. The narrow panel, left of the door, showed a giant finger pointed upwards. Its distorted image is reflected in a panel with which it forms a corner; it is pointed at a brushlike multicolored TT cable painted aslant the panel and pointed in turn at a painted multiple image of a churning spoon. The cable-brush can be viewed as a source of energy, its "juice" running via the electric cable to feed the stove that cooks the foods which feed our energy. The vividly colored TT cable evokes color as giving life to painting. All the cuisine of painting is reflected in the next corner panel, which—like a distorted mirror—gives new life to images. In the fourth panel waves of electric light and circles of moiré waves, supplemented by a grid insert, form new patterns corresponding to the needs of a more abstract composition. Nebulous shapes and new moiré effects merge with the reflection and actual

image of a frying pan with a cube of butter over a stove burner. The metamorphosis of images is being likened to the melting of solid butter and the staining of the polished pan surface with the melted, greasy fluid. A stopwatch aslant against the frying pan is to inform us when the food is ready. The sequence ends with coiled cables. Now that we have turned full circle within the room, we take note that the giant finger points to an acoustic device emitting sound. The room is in fact filled with noise, with "rumor," according to the artist, coming from without. Images, reflections, color streaks, wavering patterns, sounds form a syncopated sequence. Shifts and interruptions act like blinders to force the spectator to a repeated change of vantage point, from frontal to diagonal, back to frontal.

In his kitchen Rosenquist receives the unseen, magically, through sound waves and cables. He is the visionary among those artists who concentrate on the modern vernacular.

Tom Wesselmann's Nudes

Since his early years as a painter, Wesselmann has relied heavily on the use of collage. He has said: "I'm interested in assembling a situation resembling painting, rather than painting." He explained his reason for juxtaposing different kinds of representations: "A painted pack of cigarettes next to a painted apple wasn't enough for me. They were both the same kind of thing. But if one is from a cigarette ad and the other a painted apple, they are two different things and they trade on each other; lots of things—bright strong colors, the qualities of materials, images from art history or advertising—trade on each other."[1] Wesselmann avows that he has learned much from such predecessors as Hans Memling, Matisse, Pollock, and de Kooning. (He admires the latter for his "way of jamming his space to the bursting point and working hard against the edges of his canvas," which Wesselmann felt had a particular influence on his own work.)[2]

[1] Interview with G. R. Swenson, *Art News*, February 1964.
[2] John Rublowsky, *Pop Art* (New York: Basic Books, Inc., 1965), p. 131.

It should be added that in his collage-assemblages of the early sixties, specifically in his famed *The Great American Nude* series, Wesselmann incorporated into his works household articles such as radiators, fans, light fixtures, windows, doors, as well as an intermittently ringing telephone and a working television set. Yet, according to the artist, his primary concern is with abstract compositional problems.

The Flemish masters clearly contributed to the subject matter of Wesselmann's early portrait collages, interiors with a view from a window onto a cityscape beyond. When those small collages evolved into *The Great American Nude* series, the borrowings were not left behind. In one instance, to draw attention to the window, the artist installed a tape recorder just beyond the window with faintly taped street sounds—an improvement on the Flemish! (*Great American Nude No. 54,* 1964.) Other details inspired by the Flemish include Van Eyck's three oranges on a window sill and variations on the flower bouquet of Van Der Goes; we have all those elements in *Great American Nude No. 48* (1963), and in addition a reproduction of a Matisse painting of a vase of flowers. Another source of inspiration may have been overlooked: the Belgian Paul Delvaux, with his receding city vistas. The pose of Wesselmann's *Great American Nude No. 55* (1964), is remarkably like that of Delvaux's *Nude with the Mannequin.* To Modigliani's color-filled eyes and Delvaux's huge, protuberant ones, we juxtapose Wesselmann's eyeless and featureless faces but for the aggressive mouths, faces which might be visualized as a fusion of the billboard's glamour girl and the Surrealist's mannequin.

The sinuous lines and unbroken contours of Matisse and Modigliani nudes have been carefully studied, assimilated and incorporated advisedly into his own vernacular image. Less successful are Wesselmann's occasional attempts to absorb Picasso as in *Great American Nude No. 30* (1962); the sweeping curve of the nude's body is that of Picasso's 1932 models, specifically *Nude on a Black Couch.* Wesselmann's usual vivid colors, red-to-orange, blue, white, have been combined with Picasso's of the period, violet, off-green, black, brown, in an ill-matched union of colors—as well as forms—when he

included in his painting a version of the United States Stars and Stripes, his trademark of the early sixties.

In 1965 Wesselmann introduced his *Great American Nude* into *Seascapes,* sometimes using partly shaped canvases. He portrays but a portion of the body in each work and is most inventive and success-

(*Below*) Tom Wesselmann: *Great American Nude #48.* 1963. Mixed media. 6'9" × 8'10". In the collection of Dayton's Gallery 12, Minneapolis. Photograph courtesy of Sidney Janis Gallery, New York. (*Right above*) Tom Wesselmann: *Great American Nude #55.* 1964. Assemblage. 4' × 5'. In the collection of C. Van Des Bosch, Germany. Photograph courtesy of The Green Gallery, New York. (*Right below*) Paul Delvaux: *Nu au Mannequin.* 1947. Oil. 62" × 90". Photograph courtesy of Staempfli Gallery, New York.

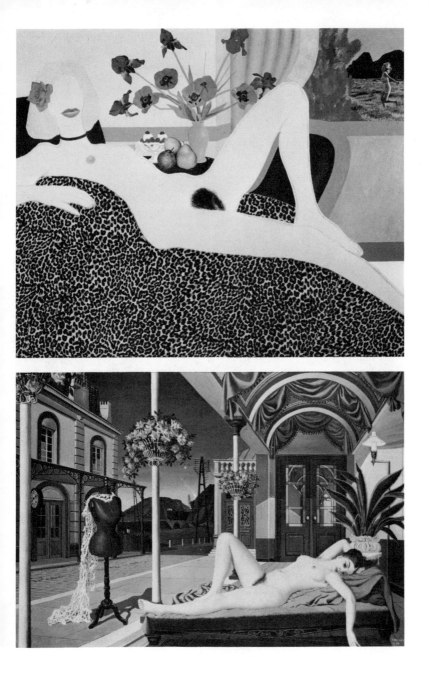

Tom Wesselmann: *Seascape #21.* 1967. Oil on canvas. 108″ × 96″. Photograph courtesy of Sidney Janis Gallery, New York.

ful in incorporating the foot. The foot or feet, the leg or legs are clearly separated from the rest of the body and made one with sea, sky and clouds by abolishing the difference in scale between them. The image becomes almost abstract. Wesselmann went on to isolate the mouth from the face to permit it to form a plastic unit with a dangling cigarette (shaped canvas). The viewing of the leg or mouth

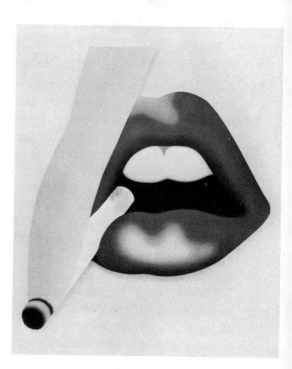

Tom Wesselmann: *Mouth #18 (Smoker #4)*. 1969. Oil on canvas. 88½" × 78". Private collection, New York. Photograph courtesy of Sidney Janis Gallery, New York.

in isolation heightens its fetishistic attraction. In terms of Pop iconology, these body parts are the complementary opposite of both the repetitive and desexualized images of Warhol and the heavily personalized objects of Oldenburg. The giant lips-*cum*-cigarette can also be seen as the imagistic counterpart of the Minimalists' chevrons and circles. Eroticism becomes overt while remaining stylized in *Great American Nude No. 91* (1967), with the genitalia exhibited and a thrust out tongue. The face is still a blank. Wesselmann's recent image of the tongue protruding from a face no longer blank but now fully featured and heavy-lidded is aesthetically offensive: the enormous tongue forces comparisons which tend to make a grotesque of *Face* (No. 3, 76¼" × 45¾"), invalidating the artist's persistent efforts at abstraction through manipulation of scale.

E.C.

Allan D'Arcangelo: Highway to Tension

Allan D'Arcangelo enriched Pop art with the zooming highway, with a landscape in which the driver's and the painter's eye meet at the road's ever-receding vanishing point. Already in the mid-sixties D'Arcangelo began to oppose to the vista of his open, seemingly endless highway in earlier works the image of impassable obstruction, a roadblock set up of varied unmatching barriers as in *Bridge Barrier* (1964). The highway is cropped, reduced by the superimposition of irregular geometrical forms from which no overall pattern emerges. The struggle between imagery and geometry is not yet resolved: what is arresting is the tension arising from the push and pull of antagonistic forces. To quote from an article that discusses his series of works called *Barriers,* D'Arcangelo "weights his pictures with constructions, whether beams of bridges coated in primer orange or warning signs striped white and black or white and red, superimposing an irregular H on a zebraic net over the pictorial space. Cadmium orange or stripes brightened with white lift the monochrome sky out of the background."[1]

While in his earlier one-vantage-point perspectives, the artist presented highways vanishing at the horizon, in his *Landscapes* of 1968–1969 he goes on to reverse the procedure by presenting the viewer with objects thrust forward at an angle with its oblique lines receding slightly to a vanishing point on either side beyond the limits of the picture. The variegated transparent shadows dramatize the illusion of volume and the advance from the picture plane. Against vivid blue, striped boards, so red, yellow and hot, seem set against the sky. But since when are shadows projected against the sky?

An illusionist artist of our day could not have but taken interest in an art that uses abstract patterns as subject matter for the production of fluctuating images, i.e., Op art. Historically, perhaps, the oldest of fluctuations is that between figure and ground. In 1969 D'Arcangelo made a picture composed of three white and black road barriers, two

[1] Nicolas Calas, *Art in the Age of Risk* (New York: E. P. Dutton & Co., 1968), p. 202.

Allan D'Arcangelo: *Guard Rail.* 1963. Acrylic on canvas. 60″ × 70″. In the collection of the Harry N. Abrams Family, New York. Photograph courtesy of Fischbach Gallery, New York.

horizontal and one vertical, placed against a white ground. D'Arcangelo produces fluctuations of images by omitting the line separating the white section of a barrier from the white ground, and the line separating the black section of a barrier from the overlapping black section of another. Now we see white blocks set against a black empty space, then we see angular figures clasping white blocks.

D'Arcangelo's replacement of the tilted views of the vanishing

Allan D'Arcangelo: *Constellation #16.* 1970. Acrylic on canvas. 60″ × 60″.
Photograph courtesy of Marlborough–Gerson Gallery, New York.

point by paraline perspectives results from a fusion of the driver's
fixation of the narrowing vista with the artist's contemplation of a
spreading canvas. The artist's perspectives formed of images of road
barriers symbolically tear asunder the wall blocking the drive toward
vision, a wall euphemistically called "two-dimensional."

N.C.

Lettrism

Paintings based on signs, words, and letters enjoyed considerable success in Europe during the fifties and early sixties. Letters came crowding into art, handwritten and typographic, some real and commonplace, some illegible, fantastic; ancient symbols loaded with magic and characters from undeciphered writings became woven into the pattern of a picture. The advertiser's oversize letters displaced the Flemish master's missal and the Dutch master's love letter; ecclesiastical symbols gave way to highway signs, calligraphy to childish scribblings, celestial maps to the computer's binary arithmetic.

Lettrism is traceable back to Cubism. By introducing newspaper print into their paper-thin planes, Picasso and Braque prompted the viewer to "read" their compositions in structural terms rather than attempt to recognize an image. An indirect effect of Cubism was to start younger artists on pictorial writing. As Thomas Hess has written: "The Cubists, in making the picture independent of a specific environment, were able at the same time to take the act of painting itself and the knowledge and inspiration that goes into it as their theme."[1] When the act of painting does not involve the formation of either images or geometric forms, the artist's oeuvre is most readily understood in terms of a development of a personal style of "handwriting." In antiquity the connection between painting and writing seemed obvious: in ancient Greece the word *"egraphen"* (i.e., written by) was affixed to the artist's signature.

Surrealist automatic writing and Abstract-Expressionist gesturing came to appear as variations on formlessness and read as seismographic charts of violent perturbations. Seeing forms is thus confused with reading signs. Action painting and its European equivalent,

[1] Thomas Hess, *Abstract Painting* (New York: The Viking Press, 1951), p. 41.

Tâchisme, exploded the syntax of art. Parisian Lettrists who exclusively exploit signs and letters, rejecting all other aesthetic considerations, are the most extreme exponents of their art. For them, Schwitters was the revered forerunner of their movement: he alone among the older artists made collages of paper scraps according to plastic effects of letters and words rather than in accordance with geometric and analytic considerations of the Cubists. Conversely, Klee's and Miró's use of signs and letters in conjunction with broader preoccupations with form and color appeared to those extremists as an unforgivable compromise. They stubbornly rejected the ambiguity between seeing and reading that permitted the poem-painting, a genre in which Miró and Magritte excelled.

Since Champollion deciphered Egyptian sacred writing, does it mean that we can no longer see the hieroglyphs as did Plato, as a "garden of letters"? In art, letters blossom in a garden of ambiguity and tensions created by the contradiction seeing-reading. Ambiguity's role is stressed by Dietrich Marlow in his long introductory essay for the catalog to the exhibition "Art and Writing."[2] Marlow examines the field from several angles: the transformation of letters into images, that of texts into images, the tracing of handwriting, imaginative thinking as reflected in writing, inclusion of signs and diagrams. (Oddly enough, musical signs were omitted.)

The above is based on an introduction to an exhibition entitled "According to the Letter," organized by Nicolas Calas in 1963 at the Thibault Gallery. Among the participants were artists as different as Mark Tobey, Cy Twombly, Jim Dine, Chryssa, Jasper Johns, and Oldenburg, whose works in the show could be aesthetically admired without being read or were actually undecipherable. To emphasize this aspect, scores were included by Earl Brown, John Cage, Morton Feldman, and Yanis Xenakis which were only understandable to musicians. In addition, there were paintings by Jensen and Ortman whose very forms are charged with symbolic meaning.

2 Stedelijk Museum, Amsterdam; Staatliche Kunsthalle, Baden-Baden, May–August 1963.

Mark Tobey belongs aesthetically to the interbellum period since his undecipherable characters and tracings float in shallow space as do the signs and characters of Klee, Kandinsky, and Miró.

Alfred Jensen's use of heavy impasto sets his work apart from the spatial abstractions of the French artist Herbin and his followers. Jensen's brushwork serves notice, as it were, that his sensuous colors have a symbolic meaning: he is reinterpreting in idiosyncratic terms

Alfred Jensen: *The Reciprocal Relation of Unity—20.* 1969. Oil on canvas. 50″ × 65″. Photograph courtesy of Cordier and Ekstrom Gallery, New York.

(*Left*) George Ortman: *Blue Diamond*. 1961. Mixed media. 60″ × 48″. Photograph courtesy of Howard Wise Gallery, New York. (*Right*) Cy Twombly: Untitled. 1969. Oil and crayon on canvas. 79″ × 103″. In the collection of the Whitney Museum of American Art, New York. Photograph courtesy of Leo Castelli Gallery, New York.

patterns of numerical order underlying the construction of Sumerian and Greek temples, and of Aztec calendars.

George Ortman conceives the human figure in terms of geometric signs, inducing us to reconsider forms in what might have been the frame of reference of cave dwellers. Unlike the Stone Age hunter who set triangles alongside bisons, Ortman sets in motion a chain reaction of signs and numbers in nonfigurative charts of the human body.

Cy Twombly was wont to insert the scribblings of children, too young to know the difference between writing and drawing, into a space so empty that only a sophisticated adult could fill it with aesthetic speculations. Recently Twombly has been reinterpreting, in white upon gray, scientific blackboard demonstrations accompanied by undecipherable notations of the lecturer.

Robert Rauschenberg produced a unique composition as far back as 1949 in *White Painting with Numbers* when he introduced scribbled numbers—up to five digits—into a pattern whose prototype may have been primitive Melanesian. The irregularity and lightness of tracing common to both Rauschenberg's design and numerals acquire an aesthetic unity, however unlikely the combination.

When Jasper Johns subdivides a monochrome field into squares

Jasper Johns: *Gray Alphabets.*
1956. Encaustic and collage
on canvas. 66″ × 49″. In the
collection of Mr. and Mrs.
John de Menil, New York. Pho-
tograph courtesy of Leo Cas-
telli Gallery, New York.

denoted by letters or numbers, they cease to be of an identical white or gray to become A white or B white, *3* gray or *4* gray. Unlike the white of a printed page, the white in Johns' painting interferes with the reading of the letters, which is why we continue to see the white while reading the characters.

In the wonderland of Claes Oldenburg calendars are objects in which the numerals themselves have become objects (of muslin stuffed with foam rubber). To validate the transformation, Oldenburg set his numerals in a new type, absolutely functional, suited to help us see while reading according to the touch.

Jim Dine designed a series of C-clamps intended to be read also in terms of the letter C, stressing thereby the ambiguity of the sign

Claes Oldenburg: *January Calendar*. 1963. Painted cloth, stuffed. 18⅛″ × 12⅞″ × 9⅜″. In the collection of Miss Eleanor Ward, New York. Photograph courtesy of Sidney Janis Gallery, New York.

rather than the antithesis between sign and pictorial pattern as in the case of Jasper Johns. More recently Dine exhibited two paintings consisting of the names of friends and acquaintances scribbled in his own handwriting against an atmospheric background.

Chryssa has transformed pages of *The New York Times* into darkly Impressionist fields. Not to read according to the letter becomes a subtle exercise in perceiving simultaneously letters that have lost their meaning and a layout that has lost its function.

A most striking example of lettering in the sixties is Robert Watts' reproduction of Matisse's signature in neon lights. To see the great master's elegant handwriting enlarged and illuminated comes as a shock, an intended one, whether it is construed as an homage or a critique.

John Cage, in collaboration with Calvin Sumsion, made a number of silk screens in 1969 composed of apparently random typographic letters. They form delightful multicolored Lettristic firmaments with isolated signs and constellations that revive the shallow-depth effects of an earlier era. Titles such as *not wanting to say anything about Marcel* might be a clue to the puzzle in homage of the unrivaled master of beriddled works, Marcel Duchamp.

Bob Watts: *Henri Matisse.* Undated. Neon lights and plexiglass. 4″ × 5¾″ × 3½″. In the collection of the artist.

d t i ɘ ɿ y

Emmett Williams: *Icon*. 1968.
In the collection of the artist.
Photograph courtesy of the
artist.

From the vantage point of the late sixties, the simplest division of
Lettristic art would be between the undecipherable signs and charac-
ters that Plato called "garden of letters," those in which the meaning
of words is reenforced by the pattern (Indiana), those in which the
meaning of word or words reenforces the pattern of the painting
(Arakawa). (Exemplary for reenforcing the meaning of words by
setting letters and combinations of letters in unexpected patterns are
the exponents of concrete poetry, notably Emmett Williams in this
country.)

It should be added that artists who use the meaning of words as
part of the content of the painting have to rely on the ability of the
viewer to make two types of discrimination, the strictly aesthetic one
of pattern, and the linguistic one needed for the understanding of the
words' meaning. For those unfamiliar with Russian, the Lettrist
compositions of the Constructivist Iliazd are nothing else than a
garden of letters.

N.C.

Robert Indiana and His Injunctions

Indiana has proclaimed himself the American Painter of Signs. Early in his career he was concerned with making variations on such universal symbols as the Crucifix and the yin-yang because "I wish to invest them with a new form." From his loft over the shipyards in lower Manhattan Indiana "saw signs more plentiful than trees," in large part stenciled letterings on old commercial buildings and waterfront warehouses.[1] Enamored with the docks, the epic of the sea, and of shipbuilding, Indiana collected waterfront debris, making crude assemblages of derelict objects and signs, stenciled words on found planks and others of his own devising with brief quotes from Melville and Whitman. He went on to enrich his vocabulary with Indian names, the language of the railroads and, most important, that of the highways. Forms, as well as vocabulary, were taken from pinball and slot machines, the jukebox, the route sign. Indiana's involvement with Americana plus the growing influence of Pop art led the artist to his famed road-sign style of the sixties: the geometry of circles and polygons wedded to stenciled legends and numbers, rendered in pure bright colors, painstakingly applied.

A seminal work of his transitional period is a painting inspired by a Negro spiritual (1961). The rectangular canvas contains (off center) a ring or wheel inscribed with the verse: "GOD IS A LILY OF THE VALLEY. HE CAN DO EVERYTHING BUT FAIL." The wheel, in turn, contains four smaller ones inscribed respectively: "HE IS A TIGER." "HE IS A STAR." "HE IS A RUBY." "HE IS A KING." The same year, Indiana began *The American Dream* series and related paintings. *USA 666* is composed of five diamonds in the shape of an X, each diamond enclosing a circle with two rows of letters. The center one reads USA
666
the four others respectively USA USA USA USA. Indiana's Involve-
EAT HUG ERR DIE
ment with the American Dream embraces its positive and negative

[1] John W. McCoubrey, "Introduction to Exhibition of Robert Indiana" (Philadelphia: University of Pennsylvania Institute of Contemporary Art, 1968), p. 9 ff.

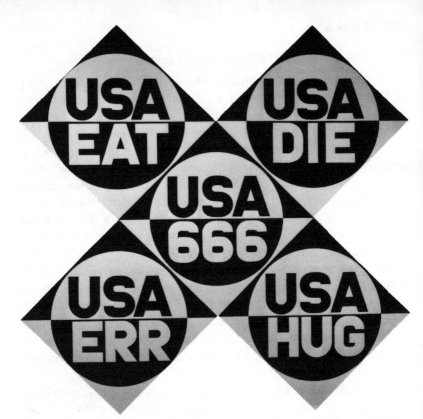

Robert Indiana: *USA 666*. 1964. Oil on canvas. 102″ × 102″. In the collection of the artist. Photograph courtesy of the artist.

I

aspects: easy life, easy love, easy death, for the restless, rootless, optimistic multitudes traveling the highways.

The road sign is Indiana's contribution to Pop art's repertory, but while Pop art centers mostly on the image of an advertised product, gingerly sidesteps social messages, Indiana has chosen to make comments on the American way of life. His road signs with their typographical words are largely in the form of injunctions, to be heeded or not, for better or worse. Are those to be understood as cool references to the moralist's of old interpretation of the Biblical "River of

the Human Race"? In this context it might be remembered that his *Love* series included works with connotations other than that of "easy love," i.e., *God Is Love* and *Love Cross*.

According to Indiana, a painting such as USA has multiple
$$666$$
sources. There is Kerouac's westbound *Route 66* perhaps combined with "Use *666*," a patent cough medicine advertised along highways. More personal associations are with his father, who was born the sixth month of the year, worked for Phillips 66 gas company, whose (then) red and green sign was almost opposite the family home, quit wife and son to go west in search of fortune and thrice-married "having solved the domesticability problem with a house trailer, he was eating breakfast one morning and dropped dead."[2] This would account for the *Eat-Die* series. The role of the car is highlighted in Indiana's unusual double portrait of his parents standing on either side of a Model A Ford, each with a hand on a door, evidently ready to resume their journey. The father wears a high starched collar, a gray felt hat, yet is shoeless and sockless. The mother is the colorful one. She is swathed in a red cloak and wears black stockings and high-heeled shoes. Her shoulders and breasts are bare. She is wistfully, alluringly feminine. Her name had been Carmen and she is a myth. Each parent is encircled by the respective legend "A MOTHER IS A MOTHER," "A FATHER IS A FATHER." It sounds like Gertrude Stein. When some years later Indiana was asked to design the backdrop and costumes for the presentation (Minneapolis, 1967) of Gertrude Stein's and Virgil Thomson's *The Mother of Us All,* he introduced a Model T Ford onto the stage as the main prop, a prop not envisaged by the author or the composer. A banner was attached to the hood of the Ford with the word "Mother." The seductive mother figure, however, had been replaced by the suffragette in a mannish, belted trenchcoat, goggles, and a placard with the word "vote." An American dream come true.

Occasionally the moralist in Indiana resorts to overt critical social comment. The incorporation of the road sign, the inverted Y into his

[2] *Ibid.,* p. 29.

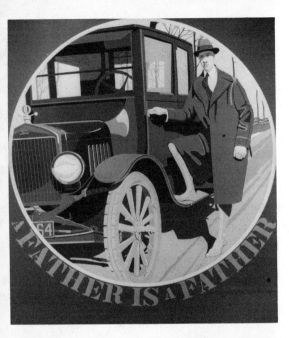

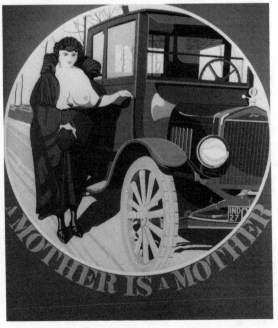

(*Left*) Robert Indiana: *Father.* 1963–1967. Oil on canvas. 72″ × 60″. (*Left below*) Robert Indiana: *Mother.* 1963–1967. Oil on canvas. 72″ × 60″. (*Right*) Robert Indiana: *Exploding Numbers.* 1964–1966. Oil on canvas. Four panels: 12″ × 12″, 34″ × 34″, 36″ × 36″ and 48″ × 48″. All works in the collection of the artist. Photographs courtesy of the artist.

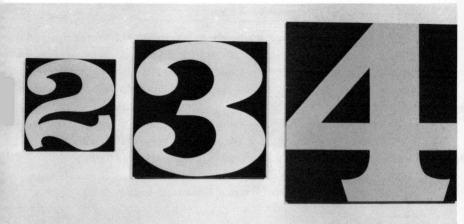

Yield, Brother (1962) was to become an antiwar symbol. His comment on the shameful events in Selma finds vivid expression in his *Alabama* (1965), in which the concentric circles enclosing the map of the state read: "JUST AS IN THE ANATOMY OF MAN EVERY NATION MUST HAVE ITS HIND PART." (The formula was followed for Missouri, Louisiana, Florida.)

Indiana's involvement with numbers, already manifest in his early *American Dream* paintings, has continued through the years. His earlier series, with their squat calendar-like figures might be seen primarily as intimations of the numbered days of our lives. The series of the mid-sixties such as *Cardinal Numbers* (1966) and *Exploding Numbers* (1964–1966), afford an example of his growing interest in experimentation with color and optical effects. The latter work, consisting of four escalating panels which represent numbers 1 through 4, advances with gigantic strides towards the viewer while each numeral remains bound in a formal relationship to the next. Always hard-edge, the numerals, reenforced by vivid color, engage in a tense interplay between figure and ground. Of the silk-screens in *Numbers* (1969) Dieter Honisch wrote: "Often the negative shapes—by the intensity of the colors which fill them—prevail over the positive

shapes to the extent of reversing the relationship between script and ground."[3] The most splendid reversal is displayed in 6: against a blue rectangular background, a circumscribed circle contains a great caterpillar-green 6 which, at first glance, is difficult to visualize as such because of the glow of the red-orange "negative shape." The glowing, throbbing colors of 1 to 9 are suddenly brought to a dead halt by the last number, a zero, fashioned of shades of gray, static, with a tomb-stone-like slab as the oval inscribed in the center of the 0, the zero.

E.C.

[3] Indiana-Creeley, *Numbers* (Stuttgart: Domberger Edition, 1969).

Arakawa's Unexpected Moves

Arakawa views the space common to signs and images as ground for motion rather than as support. He has said: "My medium is the area of perception created, located, and demonstrated by the combining (melting) of language systems into each other into the same moving place."[1] For Arakawa the name is a better substitute for the object than the image: "If I could use words as objects, that would be something."[2] This is because he is more concerned with classes of objects than with a particular object. Thus in *Untitled* (1967–1968) (composed of seven panels) the words include: "HOUSE, CLOUD, POTATO, RADIO, TREE, FISH, AIRPLANE, SHADOW, CHILD, TAXI." In *The Error* (1968–1969) the words read: "FIRE, WORM, SUN, CHAIR, DUST, AIR, MOUNTAIN, SKY, OCEAN, DOG."

Occasionally, as is his two versions of outlines of the human body, Arakawa pairs two nouns by means of dots and arrows to produce pairs of images, body parts, and landscape features. The two most important words to occur in the artist's recent paintings are "place," with its spatial connotations, and "mistake," with behavioristic con-

[1] Shusaku Arakawa, "Notes on My Painting," *Arts Magazine,* November 1969.
[2] *Ibid.*

(*Top*) Arakawa: *The Error*. 1968–1969. Oil on canvas. 48″ × 65″. (*Above*) Arakawa: *Detail of . . .* 1969. Oil on canvas. 4′ × 6′. Photograph courtesy Dwan Gallery, New York.

notations. When sentences are included in the canvases, they are apt to give information on actions either undertaken by the artist or on those expected from the viewers. On one canvas he wrote "I HAVE DECIDED TO/ LEAVE THIS CANVAS/ COMPLETELY BLANK." This statement is patently self-contradictory since the tracing of those words have annulled the blankness. A painting entitled *Shape* (1969) has the word "PLACE" inscribed in a double row of threes above the instruction: "IF POSSIBLE, PLEASE FORGET ABOUT ANY PLACE NOT MARKED PLACE." The instruction obviously cannot be carried out for it requires of the viewer to forget that the painting includes places not marked "place." An attempt to follow the instruction would simultaneously involve its violation since it would be a mistake to ignore the unmarked "places."

Arakawa's "Notes on My Painting" bear as subtitle "What I am mistakenly looking for."[3] Mistakes are related to decisions. In *Natural History* (1969) Arakawa includes the following incomplete sentences: 1. "THE LENGTH OF DECISION/" 2. "NEXT TO THE SELECTION OF A MISTAKE/" 3. "GEOMETRY OF DECISION/" 4. "THE NATURE OF TASTE OR BULLSHIT/" (With this bit of spoof Arakawa places himself at the antipodes of those tasteful geometricians of the Stella-Judd school.) Selection of a mistake? How small a mistake? In *Untitled* (1966) the word "mistake" has an arrow pointed at a minute section of a horizontal line to indicate that it was by error that the line was extended that bit. The word "mistake" in the wittily titled *Still Life* (1967) is stenciled in huge letters and again scribbled marginally by hand. Of his series of works on the theme of "mistake," the most ambitious to date is composed of seven panels, one for each letter. The inscription at the bottom of the painting gives the average height and weight of the letters, which are so presented as to suggest an industrial design for construction of giant illuminated letters. Random words scattered over the canvases and a panel-size color chart could be construed as indicators for billboard displays.

In certain of his recent paintings Arakawa provides information on title and size ordinarily given on the reverse of the canvas. With this

[3] *Ibid.*

Arakawa reinterprets simultaneity of front and back which has haunted some artists—notably Matta—since Duchamp's *Large Glass*. While Matta's topology was derived from the architect's blueprint, Arakawa's is traceable to Wittgenstein's notion of the variety of language games. Arakawa combines different interpretations of space in terms of time: the storytelling time of the Japanese scroll, the reading time of the written page, and the instantaneity of photography. Reaction against pictorial immobility of pure abstract art from Mondrian to Stella, prompts a reexamination of movement. The optical solution is the production of equivocal figures demanding eye movement of the viewer. A theatrical solution suggested by Duchamp's *Large Glass* is a bringing together of objects seen through a transparent surface and the surface imagery. The game solution

Arakawa: *Detail of* . . . 1969. Oil on canvas. 4′ × 6′. Photograph courtesy of Dwan Gallery, New York.

AS YOU DRAW YOUR EYES BACK AND FORTH ACROSS THE CANVAS PLEASE CONNECT THE DOTS INTO WHATEVER LINES YOU WANT.

presupposes the active envolvement of the viewer in the rearrangement of the composition of movable or detachable parts—the most prominent exponent of this method is Öyvind Fahlström. More intellectual is the linguistic solution adopted by Arakawa. His canvases may include polite instructions mentally to rearrange numbers indicated by arrows or to connect rows of vertical dots with lines. The latter instruction reads: "AS YOU DRAW YOUR EYES BACK AND FORTH ACROSS THE CANVAS PLEASE CONNECT THE DOTS INTO WHATEVER LINES YOU WANT."

Mental calculation is manifest in the parsimonious use of color so delicately injected into a word, an outline, a dot, a smudge. Gray and off-white canvases help to dissociate the surface from a printed page. When painting is a language game, it becomes—like all games—a mixture of mistakes and surprises, unexpected moves, minimal variations, and maximal divergences. Arakawa is a brilliant player.

N.C.

Artificial Realism
(Pearlstein, Katz, Estes, Morley, Sleigh, Keller)

Since Cézanne imitation of reality has ceased to be an artistic goal with artists, at best, making paintings that look homologous to reality. While Cubists concentrated on the structure of images of the human figure and objects in the immediate environment, other, equally vanguard artists sacrificed similitude and structure for the sake of expression. A dramatic exhibition, "New Images of Man," devoted to postwar Expressionist interpretations of the image of man, was held at the Museum of Modern Art in 1959. In his introduction to the show, Peter Selz noted most aptly that these works confront us with "what Nietzsche called 'the eternal wounds of existence.' "[1] It is outside the scope of this study to discuss the striking contrasts in viewpoint and style between that memorable show and one of a decade later, entitled "Aspects of a New Realism," held at the Milwaukee Art Center in 1969.

From Cézanne to de Kooning the most interesting portrait and landscape painters stressed the process of painting, i.e., pictorial handwriting, the subject matter being mostly a pretext for a painting. This approach has been avoided in principle by the new Realists, interfering as it does with literal representation. Furthermore, atmospheric effects are ruled out since those are at the expense of precision, plane contrasts, and sharpness of contours. In an introductory essay to the above-mentioned exhibition, Sidney Tillim laments more than once that there is too little agreement among the participants in the representational movement, too much unwelcome diversity, and too often reluctance to shed certain "modernist attitudes." This is fortunate for it has permitted the inclusion in the show of painters who

[1] Peter Selz, *New Images of Man* (New York: Museum of Modern Art, 1959).

have assimilated and now build on the discoveries of their predecessors.[2]

PHILIP PEARLSTEIN

Philip Pearlstein challengingly reappraises the human figure in terms of volume in apparent rebuttal of Pop's aggressive reduction of it to the poster's incorporeal image. Yet, in common with the oversize figures on a poster, Pearlstein's three-dimensional nudes seem too big for the space allotted to them on the canvas. Variations in Pearlstein's composition depend on whether he is depicting one figure or more. In the former case, a combination of foreshortenings and projections is used to emphasize structure. In the latter, especially when working with nudes, he may form a single composite structure, almost fusing a pair of models into one huge bulk as in *Two Seated Models* (1968). The bulk might be seen as assuming a quasipyramidal shape as in *Two Seated Nudes* (1968). An alternate device resorted to by the artist is the bisecting of the picture plane from top to bottom by widely separating the models with an area of empty space between them as in *Standing Male Nude, Seated Female* (1969).

Body parts are interpreted in terms of geometric properties of volumes, not of planes as by the Cubists. Adroitly Pearlstein fosters the illusion of forward thrusts by oversize bent knees, bulging breasts, exaggerated thighs or toes, and fingers as placed in the very foreground of *Crouching Model* (1969). In addition, the artist resorts to anchoring the figure to the edges of the canvas, whether by cropped head, cropped shoulder, or cropped feet. Cropping, a device of Abstractionists such as Noland and Al Held, is used with much effect by Pearlstein, who himself was a figurative artist from the start.

Pearlstein contrasts his massive human forms to minute delineations of design on a rug or a bandanna, warm patches of color and soft folds of draperies to the basically uniform color scheme of the angular limb, head, torso. In his rendition the skin of the nudes is always perfect, but the imperfections of bodily shapes are mercilessly

[2] Sidney Tillim, "Figurative Art 1969: Aspects and Prospect," in *Aspects of a New Realism* (Milwaukee: Milwaukee Art Center, Summer 1969).

exploited for compositional purposes. The skin, aglow with light modulated by shadows, bathes the models in a seemingly excessive reality while deadening all expression of inner life. Equivocation between attractive and repulsive features in the women is handled with calculated detachment. The artist takes full advantage of the breakdown of sexual taboos, but despite the explicitness, intentionally or subconsciously, he keeps eroticism in abeyance.

While regretting Pearlstein's explicitness, i.e., "almost unsavory preoccupation with detail," Tillim, the decade's stern advocate of

(Left) Philip Pearlstein: *Two Seated Female Nudes.* 1968. Oil on canvas. 60″ × 48″. *(Right)* Philip Pearlstein: *Standing Male Nude and Seated Female.* 1969. Oil on canvas. 74″ × 62″. In the collection of Mr. and Mrs. Gilbert Carpenter, Greenborough. Photograph courtesy of Allan Frumkin Gallery, New York.

representational art, gives the artist his due as the most prominent in the movement and "the first to reestablish credible volume in credible space in figurative terms."[3]

ALEX KATZ

Alex Katz invented a genre. In an article entitled "Faces and Flowers" I last wrote on Katz on the occasion of his 1967 exhibition, in which large-scale portraits and flower compositions predominated.[4] We propose now to focus on his cutouts, a medium he has developed through the years. Like many painters and poets of his near generation, Katz was influenced by the rediscovery of Americana, historical and vernacular. Unlike Larry Rivers, who interpreted Americana in Expressionist terms, Katz treated the subject quite objectively: thus, to the former's *Washington Crossing the Delaware,* it is of interest to juxtapose Katz's *British Soldiers* (1962), flat cutouts of wood, painted on both sides, of quasirealistic, doll-like uniformed figures. (They were meant as stage properties for a play, *George Washington Crossing the Delaware,* by the poet Kenneth Koch.) The flat surface treatment of the cutouts—via his wall reliefs of 1964—have certainly influenced Katz's approach to canvas painting. According to the artist himself, the composition of his portraits has been evolved as an alternative to de Kooning's women, structured in terms of the picture plane. Katz, however, has incorporated into his aesthetics the expansive style practiced by the Field painters, handling figures and flowers much the way geometric figures, letters, and signs have been handled by others. Today there is no trace left of the toylike uniform *British Soldiers;* differences in personality traits receive emphasis.

Cutouts and canvases have a striking feature in common: those oversize heads and semitorsos are often cropped in what seems at first glance a totally unexpected and eccentric way. Now sliver-thin because of the substitution of aluminum to wood, the cutouts should be

[3] *Ibid.*
[4] Calas, "Alex Katz," in *Art in the Age of Risk* (New York: E. P. Dutton & Co., Inc., 1968).

Alex Katz: *One Flight Up.* 1968. Oil on aluminum. 67¾" × 15' × 47". Photograph courtesy of Fischbach Gallery, New York.

classified somewhere between the silhouette and a flat sculpture (such as the disks of David Smith); unlike the black silhouette, which tends to contract the image, the cutout expands it due to color contrasts. Using a tabletop for ground, Katz has been grouping the cutouts in a progressively more elaborate composition. In *One Flight Up* (1968) Katz presents some heads-*cum*-torsos frontally, one or two from the back, others depicted in profile. Each unit, highly individualized, was painted directly and separately from a model, in each case a friend or acquaintance of the artists. This emphatically does not imply that the portraiture is not stylized, informed by wit, heightened by light and shadow effects, transformed by his device of simultaneous enlargement and cropping.

In "Faces and Flowers," Katz's croppings were viewed in relation to his canvases. In contrast to the canvases, including his recent very

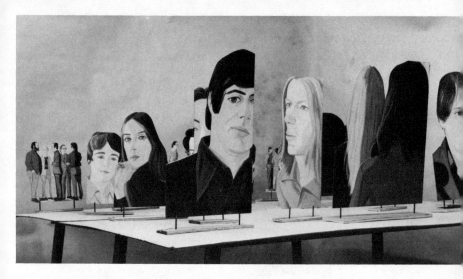

Alex Katz: *The Wedding.* 1969–1970. Oil on aluminum. 74″ × 8′ × 8′. Photograph courtesy of Fischbach Gallery, New York.

large *Private Domain* (1969), in which features are partially concealed by the overlapping of two faces and cropped at the edges of the canvas, his current cutout ensemble, entitled *The Wedding,* includes actual slicings. To wit, the slightly cocked head of a dark young man in left foreground whose face is sliced in a vertical line through the corner of the right eye to the jowl. The objective of the slicing is twofold: to produce from a certain vantage point the illusion that a neighboring figure overlaps the cropped one and, from another vantage point, that the space between the two is so broadened as to produce a formal pattern of full and empty spaces, an objective shared by Katz with many abstract sculptors. The variations in the relationship between spacings and figures permits the viewer "circling" the table to detach and isolate a face from the crowd. Sometimes the eye stops as if to verify a strange phenomenon, Janus-like heads endowed with two faces or their negatives, two back views. At a distance from the table, however, the forest of heads may strike the onlooker as an abstract system humanized.

Katz's wittiest innovation in *The Wedding* is the introduction of intellectual references to true perspective. The busts stationed in the front row are blatantly oversize, the middle rows recede in scale, while the most distant row is comprised of full-length figures in miniature, moreover held in clusters.

RICHARD ESTES

Richard Estes' work is that of an innovator, yet it is useful to view it first from a certain distance. Some of the most spectacular achievements gained by modern art have been made possible by industrial progress, from the production of ready-made paints to that of the minicamera. Since Zervos' famed Cahiers d'Art of the thirties with their superb reproductions of archaic sculpture and architecture, artists learned to see masterpieces through photography. Since the late fifties, artists of Rauschenberg's generation chose to make pictures that corresponded to photographic views of megalopolis and suburbia. With the invention of the minicamera, painters were enabled to substitute colored photographs for the proverbial sketchbook. The possibilities inherent in the 35-mm. color slides prompted Estes to reconstruct in his oils the photographic picture plane, rather than copy it.

Estes is apt to take any number of snapshots of the same spot from different vantage points and then work out the composition using parts of various photographs in his freehand rendition on canvas or Masonite. When viewing the painting of the plate-glass entrance at *Two Broadway* (1969) with its multiple reflections, the realization that some of the objects seen in the glass are only reflections of objects situated back of "the viewer" adds a new mental dimension to the optical three-dimensionality. Estes has developed a technique that might be called the reverse of opticality, since it requires that we correct what we see by what we know.

In *Nedicks* (1970), likewise, Estes resorts to a plate-glass window to combine a dim view of the interior of the diner and its customers at the counter, with the street scene outside, which is partially reflected in the glass and partially seen through it. Accordingly, the

window presents a patchwork of mirrored, i.e., inverted, billboard ads and a forthright notice, "HELP WANTED." Estes dramatizes the scene by the aggressive thrust of harsh reflections of rows of neon lights from within Nedicks against an apartment house across the street, old-fashioned and turreted. While it has been said that Estes' approach could be likened to that of Edward Hopper, it would seem that he has not left untapped the cinematic technique of Goddard in such films as *Week End* and *La Chinoise*.

MALCOLM MORLEY

Dali, the painter of dreams (who has shown interest in Morley's work), once said it was his ambition to make hand-painted photographs. Morley is not concerned with subject matter as such but with facsimiles of reality. He specializes in producing hand-painted enlargements of photos or prints by means of a system of grids. He subdivides his model into a large number of penciled squares. This grid, very much enlarged, is used to subdivide the unpainted canvas as a first step in the transposition. His next step consists in cutting one strip of grids from the model, having, as often as not, inverted it or turned it sideways so as not to be distracted by the subject. With the aid of a magnifying glass, he reproduces by hand the model square by square in Liquetex colors. In so doing he substitutes the print's crude color combinations obtained by superimpositions of four-color plates by the juxtaposition of colors on the canvas aimed at producing retinal commingling. Since Morley "translates" the print square by square, the objective relations within the picture that he ignored while painting, remain unchanged. The first impression upon looking at a Morley transposition is that it is less satisfactory than a

(*Left above*) Richard Estes: *Nedicks*. 1970. Oil on canvas. 48″ × 66″. (*Left*) Richard Estes: *Two Broadway*. 1969. Oil on masonite. 48½″ × 66½″. Photographs courtesy of Allan Stone Gallery, New York.

(*Left*) Malcolm Morley: *Coronation Beach.* 1968. Liquitex on canvas. 89½″ × 90″. Photograph courtesy of Kornblee Gallery, New York. (*Right*) Malcolm Morley: *Racetrack.* 1969–1970. Acrylic on canvas 70″ × 88½″. Photograph courtesy of O. K. Harris Gallery, New York.

print or colored photograph. Only upon close scrutiny of the painting do we realize that it is not a facsimile of a print and are able to understand the artist's undertaking and appreciate the opacity and density which replace the thinness of atmospheric effects and the hollowness of chiaroscuro.

Morley has reworked posters of liners as in *Amsterdam in Front of Rotterdam* (1966), photographs as in *Beach Scene* (1968), commercially reproduced masterpieces as Vermeer's *Portrait of the Artist in His Studio* (1968). Probably his best paintings are the crowded, complex canvases of 1968, *Coronation Beach,* with its splendid interplay of vivid colors, and *Race Track,* with the virtuosity of its display of pseudo-Impressionistic minutiae. Trapped in contradiction, subject matter becomes a mask of reality. Let it be recalled that Morley's basic icon is the grid: might it not bar from sight a repressed image?

south africa

Greyville Race Course—Durban, South Africa

SYLVIA SLEIGH

Sylvia Sleigh is object-oriented, which is not the same as being objective, and nowhere could the mistake between the two viewpoints be more easily made than in portrait painting. The sitter is an object that asserts itself. To find ways of cultivating a person's "objectness" without losing sight of his need to manifest himself requires tact. For the discerning viewer to be touched by a portrait, the artist must retouch the position of a curtain or chair, the direction of a glance, and efface photographic precisionisms that detract the beholder's attention from the metamorphosis of skin into paint, of shadow into colors, of a living room into the structure of a picture plane, and, occasionally, of a photograph into a painting. Artists who have learned, like Miss Sleigh, to look at photographs in color the way the Impressionists looked at a landscape are discovering colors of India in shadows.

Wish You Were Here (1969) is a reconstruction of a familiar scene and situation by means of photographic "texts." The colors in the shadows make a backdrop of the sea and give to the faces an expression that is "photographically" objective. The woman on the left is the recognizable portrait of the artist herself, yet it is not a self-portrait for it is a portrait of the self taken by a camera. In the above painting, as well as in a number of other recent ones, Sylvia Sleigh divides the canvas into three vertical planes. In such paintings as *Lila Katzen, Working at Home, Judy Kardish,* the third plane is a detached and isolated part of the middle ground. In one painting the third section is a reflection in a mirror; in another a rocking chair; in a third a man working at a table, but always treated with a strong emphasis on its relation to the picture plane. Depth is controlled by tightening the parts, by cropping edges, by bridging distances. Sylvia is one of a small but significant group of artists who appear to be following tradition when actually innovating.

HAROLD KELLER

A red Corvair of 1964, a Chevrolet pick-up truck, a Ford tractor, all precisely depicted, are situated in a rural background of groves, barns, and cows in a pasture against the New York skyline; silos touch the George Washington Bridge, the Chrysler Building looms over clusters of trees. Keller takes delight in compressing the imitations of two sets of reality, projecting onto the canvas clusters of images assembled in his mind. He is concerned with structuring what he knows rather with analyzing what he sees. The independent and seemingly unaccountable recessions of specific groupings is deceptively simple, for it is through the interplay between fragments of perspective that the picture plane is stabilized. Technically, one of Keller's most interesting devices consists of breaking up the composition into irregular zones bound by curvilinear triangles or rectangles with emphatically open spaces between them. Keller frequently introduces sets of concentric circles, either whirling in the sky or perhaps

(*Left*) Sylvia Sleigh: *Wish You Were Here*. 1969. Oil on canvas. 48″ × 72″. In the collection of Mr. and Mrs. Saionez, New York. Photograph courtesy of Hemingway Gallery, New York. (*Right*) Harold Keller: *Chevrolet Pickup Truck*. 1968. Oil on canvas. 48″ in diameter. Photograph courtesy of Hemingway Gallery, New York.

outlining winding highways, or embodied in a train coiling around a small wood.

Keller plays white against black so that both might win: white image, black space. Sometimes space is cleverly turned into ground by shadow or reflection: small black and white cows in the cropped foreground or middleground of certain of his dark tondi are held firm by their glossy shadows cast upon obviously solid earth. The paintings are brightened by sudden flashes of color, the yellow of a brand-new truck, the green of a grasshopper-sized airplane, the silver of a tandem disk harrow, streaks and volumes of electric blue. Keller's humor emerges in such pictorial niceties as the parallelogram of a sheet of rain alongside two parallel arcs of bridges (*Local Shower Near Exit 24,* 1969).

Spatial Abstraction

In the fifties, opposition to Abstract Expressionism was not confined to the artistic left, assemblagists, and Pop artists; the Formalists in the name of aesthetic realism condemned gestural painting as too subjective and visually too confused. In abstract art the contradiction between subjectivism and objectivism can be traced back to Kandinsky's pictorial handwriting and Malevich's geometric color forms. From today's point of view, the characteristic common to both those pioneers is composition against a background which is apt to produce the illusion of indeterminate, shallow space. This imprecise space marks the transition between the window space introduced by the Renaissance artists and the open, flat space developed in the fifties.

Historically, first with small-size neo-Impressionist paintings, then more emphatically with Cubism, the framed canvas came to look like a mirage painted on the bottom of a shallow box rather than a view through a window. The first exhibition of paintings without frames was that of El Lissitzky in Hanover in 1925. Frameless pictures came to be seen in relation to their edges. Probably the most dramatic presentation of works without frames was by Frederick Kiesler in his installation of Peggy Guggenheim's Surrealist and Abstract collections in her New York gallery "Art of This Century" in 1942. Frameless, the works were presented as objects protruding about a foot from the walls to create the impression of an environment conceived as a continuum by Kiesler. A few years later, for the exhibition "Bloodflames" (organized by Nicolas Calas at the New York Hugo Gallery), Kiesler placed the paintings at various angles to increase the sensation of an environment. Kiesler's concept of environmental continuity can be traced back to Seurat, who had extended the painted surface to include a frame.

Continuity, conceived as means of overcoming the contradiction

Auguste Herbin: *Lier.* 1958. Oil on canvas. 39″ × 26″. Photograph courtesy of Chalette Gallery, New York.

figure-ground, had been the main preoccupation of the French abstract painter Auguste Herbin. To a construction of forms against a background, he opposed a rhythmic continuity of harmonies and dissonances between nonrepetitive color forms. The term "spatial abstraction," coined by Herbin, is too broad to account for differences in the handling of color forms introduced into abstract art in the course of the sixties. The relation of form to space changes radically according to whether the emphasis is on continuity of field or interplay of pattern.

N.C.

Leon Polk Smith, the Pioneer

Leon Polk Smith ranks among the pioneers of postwar abstract art. Clement Greenberg's disciples are apt to underrate him since he is not

Leon Polk Smith: *Triptik.* 1959. Oil on canvas. Three separate panels: each 80″ × 16″. Photograph courtesy of Chalette Gallery, New York.

an Impressionist. Mondrian, after years of labor, trial and error, revealed the physiognomy of the rectangle. After years of search and experimentation Leon Smith has lately discovered the physiognomy of the circle and its apparented forms, ovals and rounded squares. To the continuity of the field he has always opposed sets of positive and negative relations. Existentially this reflects the ambiguity of a fundamental behavioral either/or situation.

What are the figurative alternatives to Mondrian's rectangles? an artist in the late forties concerned with fundamentals might have

asked. In 1954 Leon Polk Smith was to find the answer, almost accidentally, in a catalog of sports equipment which included drawings of a baseball, football, tennis ball, and basketball.[1] The pattern provided by the stitchings of the ball opened the artist's eyes to a positive-negative relation of curved surfaces. As Alloway points out, an important next step consisted in transposing a curved shape onto a square canvas.[2] As Smith puts it, the problem consisted in forming "a curved space all across the canvas, with only two colors to go by."[3] Smith's next major advance took place in 1966, with a series of paintings called *Correspondence*. One of the two colors may be in the form of a variant of a circle or square, however irregular, set irregularly on a color plane and sometimes touching at one or two points the edge of the canvas. These figures can be visualized either as set over a plane or as framed by a plane. For the Minimalists, Smith's correspondences appear to reintroduce the antithesis figure and ground that field painting claims to have overcome. If so, it overcame it at a price: sacrifice of intensity for the sake of Impressionist flickerings.

In his most recent work Smith both frees the geometric figure from the field, by identifying it with a shaped canvas, and maintains the tension between positive and negative areas, by presenting the two colors as complementary parts of the figure. Thereby he gives to the geometric figures what I am tempted to call a "physiognomy." In contradistinction to field painters, who use geometric patterns to produce Impressionist coloristic effects, Leon Smith uses color to give "skin" to his figures, whether using oils or acrylics. The circular and rounded squares provide the canvas with an elegant contour that seems to capture the appearance of weightlessness we admire in well-curved geometric pottery.

The paintings are grouped in "constellations" which are complete

[1] Lawrence Alloway, "Leon Polk Smith: New Work and Its Origin," *Art International,* April 1963.

[2] Lawrence Alloway, "Introduction to an Exhibition of Leon Polk Smith," Poses Institute of Fine Arts, 1968.

[3] Mimeographed statement by the artist, 1961.

in themselves, touching each other only at one tangential point. They have no top or bottom and may be hung upside down, sideways, diagonally, or any other way. Instead of resting one upon another, they seem to lift themselves and expand. There are ovals, each divided in two-colored areas, converging like baseballs placed nose to nose, blue touching blue; there are sets of staggered squares divided diagonally in two, white touching white; others, combined of different

Leon Polk Smith: *Correspondence Blue—Red*. 1966. Oil on canvas. 68″ × 42″. Photograph courtesy of Chalette Gallery, New York.

Leon Polk Smith: *Constellation.* 1969. Acrylic on canvas. Each oval: 47″ × 31″. Photograph courtesy of Chalette Gallery, New York.

shapes and colors, form irregular expanding clusters. One constellation consists of three horizontally set, identical orange ovals; another of two canvases, a large orange oval and above it a larger blue circle containing, for yoke, the orange oval's twin.

Tangential relations are founded upon the force of attraction and repulsion. Visually Smith's patterns introduce what might be called a "chessman flexibility" into that continuity of space Herbin and his followees achieve by means of variations on the game-board theme. Organization of constellations provide the artist with a stimulating alternative to the monotony of serial order that is currently in vogue.

Illusionism Revisited
(Albers, Vasarely, Held)

Since painting involves the construction of space, changes in attitude toward pictorial space are of paramount significance. When reappraised from the standpoint of the sixties the most striking feature of the art of the interbellum period is not the irreducible contradiction between the endless vistas of the Surrealists and the flat surface of the abstract artists, but the elaboration of an indeterminate shallow space, by Klee and Miró, by Kandinsky and Ernst, by Masson and Mondrian. This is the space that was refined in the forties and fifties by the Abstract Expressionists Gorky, Pollock, de Kooning, Kline, Rothko, and Clyfford Still. This shallow space serves the need equally of those who seek a pictorial equivalent to the elusive spaces of the dreams and of those who wish to escape from physical reality.

The nearest abstract art ever got to the construction of a stable two-dimensional structure was with Mondrian. Mondrian produced the illusion of symmetry in compositions of rectangular units of various sizes by means of "dynamic symmetry" (geometrically a pseudo-symmetry). Symmetry, whether real or illusory, is a "perceptual indicator that speeds the process of visual solutions."[1]

To go beyond Mondrian would mean speeding up illusionistic effects so successfully achieved by industrial designers. André Lhote has traced engineering in painting back to the Italian masters of the true perspective, such as Uccello and Piero della Francesca, and saw in Seurat their modern counterpart. Among twentieth-century artists involved in engineering the most adventurous were Tatlin and Moholy-Nagy and, in graphics, Picabia.

[1] Rene Parola, *Optical Art* (New York: Reinhold Book Company, 1968), p. 27.

Josef Albers: *Structural Constellation: JHC II*. 1963. Engraving on plastic. 25⅞″ × 19¼″. In the collection of Mr. and Mrs. James H. Clark, Dallas. Photograph courtesy of Sidney Janis Gallery, New York.

JOSEF ALBERS

Joseph Albers may have been the first to realize that it was possible to extend the field of dynamic symmetry by substituting the illusion of reversible patterns to stable ones. The prototype of the reversible pattern is the symmetric floor designs of Hellenistic mosaics. In a series of designs Albers provided the illusion of dynamic symmetry by a combined pair of three-sided rectangular boxes. The illusion that the planes are those of real boxes suggests the stability of form that we associate with rectangular solids. Albers' feat was achieved at the expense of figure and ground relationship, for the figure appears to float in space.

VICTOR VASARELY

Vasarely was to take full advantage of the progress achieved in design graphics. Unlike the industrial designer, who plans his projections in terms of an object in space, Vasarely plans his for paintings in which forms and space are both treated as aspects of comple-

(*Above*) Victor Vasarely: Untitled. 1968. Tempera on paper, mounted on board. 6¼″ × 5¾″. (*Above right*) Victor Vasarely: Untitled. 1968. Collage construction. 13″ × 8½″. Both works in the collection of Miss Madeleine Lejwa, New York. Photographs courtesy of Chalette Gallery, New York.

mentary volumes. On the assumption that form is the form of volume, and color the color of form, Vasarely replaces the classical division between form and color by the unit color-form, and to the division between line and color, the antithesis between any two color-forms. He is thus able to oppose the negative volume of so-called space to the positive volume of figures. The interaction of the two could be used to produce illusions either of advancing and receding volumes or of kinetic surface effects. Both alternatives are valid since space is always time-space.

Vasarely's ability to produce extraordinary effects of dynamic symmetry combined with the subtlest interplay of color-forms (painted in tempera) is beyond doubt. What is being questioned, especially in this country, are the aesthetics.

Lucy Lippard dismisses Vasarely's programmatic paintings because his planning "corresponds to the old Greek logic based on syllogism, in which the conclusion is contained in the premise," while "the newer more empirical approach is inductive."[2] Vasarely's pro-

[2] Lucy Lippard, "Perverse Perspectives," in *Changing: Essays in Art Criticism* (New York: E. P. Dutton & Co., Inc., 1971).

grammatic combinations of ellipses and circles, his use of contrasting and complementary colors, of luministic and chiaroscuro effects are as far removed from the reversible floor patterns of the Greek mosaicist as is algebra from Euclidean geometry. What the mirror was to Plato and Leonardo, the prototype of imitation of reality, the paraline representations of planes is to Vasarely, a prototype for establishing relations in an unreal space.

Like de Chirico, Vasarely uses illusionism as an alternative for reality. Irreality, whether of de Chirico or Vasarely, should be apprehended in terms of the cohesion of the parts to the whole. He plays with variations in what is basically a "board game." The squares and circles assume the double role of a ground and of "moves" by pieces on the ground. Further than any other optical artist Vasarely carried the contradiction between the ingenuity of complex calculations and the excitement generated by seemingly endless surface agitation. Calculation and excitement are the main characteristics of an interesting game.

In his exhibition of Optical art, labeled "The Responsive Eye," William Seitz rightly included the Field painters, for by so doing he helped correct the erroneous impression that the latter could be appraised solely in terms of a reaction to the painterly technique of the Abstract Expressionists.

Seitz suggests that the main difference between artists who use optical perspective and those who restrict themselves to illusions of color radiations is that the former are programmatic while the latter are "poetic, even romantic."[3] Radiation of color in abstract art is traceable back to Larionov and Malevich. These two painters are undoubtedly Romantic artists, for they have succeeded in endowing their color-forms with a supreme sense of presence, a quality also achieved by such different artists as Barnett Newman and Alexander Liberman. However, most Field painters restrict radiation effects to the domain of aesthetics: the fuzziness of edges produced by a contrast of colors between image and after-image among elements of their pattern, parallel lines, concentric circles, dots.

[3] William Seitz, *The Responsive Eye* (New York: Museum of Modern Art, 1965).

The basic difference between hard-edge Op art and Field painting is to be found on the level of tactility. In hard-edge Op art we have the illusion of a video-tactile reality, the reality of volume or movement, while in Field painting we tend to discriminate either between flat field and canvas shape, or between stained bands and granulated surface of unstained bands of the unprimed canvas. Vasarely's illusion of tactility contrasts with Stella's emphasis on shape and bulk. To enhance the illusion of volume, Vasarely develops patterns consisting of self-referent color units that appear to contract the outer limits of the painting, while Stella enhances radiation effects to enhance the picture, counteracting weight, suggested by the bulk of the painting's support.

What the game board is to Vasarely, the rose window is to Stella's most successful forms. Stella substitutes the glow of the new industrial colors to the luminosity of the Gothic artist's stained glass. Vasarely replaces the multicolored, intricate geometric patterns of Eastern European folk art with industrial designs in tempera. In the footsteps of Malevich and Mondrian he visualizes art as the plastic expression of the life of a community. For Vasarely "the unlimited space and truth of structures" is a projection of a new dimension, that of crowds, masses, multitudes of human beings."[4] Progressive European artists have accepted structuralism as a positive alternative to the discredited Social Realism. Impressionistic color variations on a Euclidean theme developed by Field painters, Stella in particular, reflect the aesthetic aspirations of a managerial élite, evoking in John Coplans' words "the underlying control systems central to an advanced, 'free-enterprise' technological society."[5] While Vasarely delivers his message with the excitement of a game, Stella demonstrates his argument with an art historian's pedantry.

AL HELD

Ahead of other artists, Al Held is also most unflinching in his zeal to negate the flatness of the pictorial surface.

[4] Vasarely, "Statement," in *Hard Edge* (Paris: Galérie Denise René, 1964).
[5] John Coplans, *Serial Art* (Pasadena, Calif.: Pasadena Art Museum, 1968), p. 18.

Existentially, order is a system of interference that restricts man's freedom of movement. Planning can be challenged in the name of self-expression. This seems to be the significance of Al Held's recent series of paintings that violate the flatness of the pictorial surface with projections of cubes and diverse exahedra. Two-way reading of the individual units never leads to reversible reading of more than one form at a time. As in his earlier work,[6] Held continues to battle in the name of Expressionism against the good gestalt. In his new work, despite the illusionist effects produced by paraline perspectives, he slows down the comprehension of the picture as a self-referent unit. The presence of incomplete forms, especially along the edges of the canvas, tend to counterbalance the contractive effect of illusionistic perspective by thrusts expanding the picture plane in all directions. In *Promised Land* (1969–1970) Held filled certain spaces between prisms with sections of arches, which tend to separate the latter rather

[6] Nicolas Calas, *Art in the Age of Risk* (New York: E. P. Dutton & Co., Inc., 1968), p. 223.

than conjoin them. Al Held is reviving in structural terms that push and pull intensity which we have come sorely to miss, having been fed for so long with Impressionist color variations of geometric forms. Held's black outlines of forms with their obvious imprint of brushstroke is an Expressionist device linking his work directly to Mondrian, who had always refused to do away with this remnant of handwriting.

One is tempted to call Held's recent work "Optical Cubism," for, like Cubism, it is Mannerist, stressing tension over symmetry. Mannerism is to form what Romanticism is to meaning: negation of solution (truth or beauty) in a quest for the impossible.

N.C.

(*Left*) Al Held: *Promised Land.* 1969–1970. Acrylic on canvas. 9′6″ × 20′. (*Right*) Al Held: *Phoenicia X.* 1969. Acrylic on canvas. 8′ × 6′. Photographs courtesy of Andre Emmerich Gallery, New York.

Field Painting

The habit of reading along horizontal lines predisposes Western man to scrutinize pictorial continuity primarily in horizontal terms; hence the tendency of Color-Field painters to widen the field and to stress variations in continuity. Field painting tends to become a landscape in which the monotony of continuity is relieved by intervals. Intervals in a continuum are to Field painting what interruptions are to Expressionism. Intervals are planned while interruptions are improvised and must be executed with skill. Intervals reenforce continuity while interruptions threaten structure. Everything about Field painting is of a reassuring tranquility while nothing looks safe in Abstract Expressionism.

Field painting has been called "nonrelational" on the grounds that the artist is not involved in what "the motif set in one corner of the canvas does to a specific thing in another section of the surface" (Paul Brach). As Al Held, however, pointed out, the artist has to face the fact that as soon as he puts more than one form in any part of the field, an interrelationship develops inevitably.[1]

Prewar abstract painting visualized geometric forms as structures set against a background, while Field painting stresses expanding effects of color juxtaposition. Sidney Tillim has pointed out that field painters often use the luminous colors of the Op artists.[2] However, Op artists use contracting effects of color juxtapositions to produce unstable (kinetic) images.

Variations in the continuum lead to the elaboration of what Lawrence Alloway has called "one image" painting, suggesting "the

[1] Al Held, "The New Abstraction, a Discussion Conducted by Bruce Glaser," *Art International,* February 1966.

[2] Sidney Tillim, "Optical Art, Pending or Ending," *Arts Magazine,* January 1965.

presence of covert or spontaneous iconographic images is basic to abstract art, rather than the purity and pictorial autonomy so often ascribed to it."[3] On the strength of this observation, Alloway challenges critics to "reestablish abstract art's connection with other experiences, without, of course, abandoning the now general sense of art's autonomy."[4] An obvious way of evaluating the significance of mono-images would be to group them according to basic aesthetic categories (Expressionist, Constructivist, Impressionist) and then examine the broad cultural implications.

Clement Greenberg in his *Post-Painterly Abstraction* defined Field painting as Impressionist. The Impressionist looks at his world from a certain distance to focus on changes produced by light, color, or movement, secondary aspects of reality. Impressionism opposes an ephemeral view of reality to a lasting view. Since pure abstraction is concerned with the reality of ideal forms, Impressionism would consist in the elaboration of nonessential qualities of forms, with their light or color. Whether representational or abstract, Impressionism constitutes a mild reaction to a reality, while Expressionism is a forceful and egocentric repudiation of the world.

The champions of field painting differ in their emphasis on its characteristics. Greenberg admires it for its "openness," Michael Fried for its "opticality," John Coplans for its orderliness. These points of view will be discussed in relation to particular aspects of the work of individual artists.

Barnett Newman's Sense of Space

Barnett Newman, back in 1950, presented a new abstract alternative to the Expressionism of gestural painting. The alternative was given in a series of paintings in which the canvas was divided in two by a narrow band of another hue of the same color. Formalistically,

[3] Lawrence Alloway, "Systemic Art," in *Minimal Art,* ed. Gregory Battcock (New York: Dutton Paperbacks, 1968), p. 20.

[4] *Ibid.*

Newman's paintings might be traced back to Mondrian's *Vertical Composition* (1963) and to Kupka's compositions of the early thirties which included a large monochrome rectangle divided by a narrow band of color. Iconically Newman's paintings marked a turning point in the New York School. As I had the occasion to point out at the time (at the Artist's Club on Eighth Street), these were to be read as modern versions of the Parmenidian dictum "The Being is an All in the Now." In contradistinction to the gestural artists, who, in seeking to express the self, reject all not directly connected with the physical act of painting, Newman reduces the representation of the self to a vertical line. For the sake of this reduction Newman repudiated the figure and ground antithesis of the Constructivists, replacing it by line and field relation; he thus initiated a revolutionary change in abstract art. Iconically, however, Newman's statement is a complementary opposite to the Expressionist's, for Newman is just as much committed to the Existentialist manifestation of the self through art as is Pollock.

Surveying the work produced by Barnett Newman during the past twenty years, Lawrence Alloway distinguishes four variants: (1) centered forms, (2) off-center forms, (3) edge forms, (4) forms broad enough to produce the effect of equal adjacent planes.[1]

Clement Greenberg admires the painting of Clyfford Still, Mark Rothko, and Barnett Newman for their effect: "one of an almost literal openness that embraces and absorbs color being created by it."[2] "Openness" would appear to be an outgrowth of an Impressionist view of landscape painting, a trademark of Turner and Monet. But why does Newman cultivate openness if, unlike the atmospheric Rothko and the theatrical Still, he is not a landscape painter? When Greenberg asserts that "openness, and not only in painting, is a quality that seems to most exhilarate the attuned eye of our time," he is pontificating. Why should openness be more exhilarating than, say,

[1] Lawrence Alloway, "Notes on Barnett Newman," *Art International,* Summer 1969.

[2] Clement Greenberg, "After Abstract Expressionism," *Art International,* October 1962.

Barnett Newman: *Shining Forth (To George)*. 1961. Oil on canvas. 9′6″ ×
14′6″. In the collection of Annalee Newman, New York. Photograph courtesy
of the artist.

fantasy, or chance, or expression? And if it is, how does one prove
it?

Unquestionably Barnett Newman's works produce an effect of
openness. What is its significance in Newman's oeuvre? Who, besides
a landscape painter, would need such openness? I would venture the
answer: a poet with a compulsive need to tear asunder the barriers
separating his existence from that of other beings, human or divine.
Openness, in this sense, means communication of the alone with the
alone—an unattainable goal, since to be alive means to be a whole
that is isolated from the world. To aim at this goal is exhilarating; it
has exhilarated mystics and poets through the centuries.

This interpretation of Newman does not run counter to the artist's own undertaking as is made explicit by his *The Stations of the Cross* (1958–1966) and his written statement on the subject.[3] As Alloway phrases it, Newman's works "are visual configurations, displays of colors and forms that become iconographic through internal development and repetition."[4] Newman's sculpture *Presence,* with its three vertical bars viewed in relation to *The Stations of the Cross,* are inevitably associated with Golgotha, while his *Broken Obelisk,* overturned and pinpointed upon the apex of a pyramid, is undoubtedly a funeral monument suggesting the kiss of death.

Newman's openness transcends the openness of the Impressionists, for it is not an end in itself but a means to bring forth light. Since God alone has been identified with light, man can only hope to be enlightened. When a painting evokes light by strictly pictorial means the artist comes near to the impossible. Newman's *Profile of Light* (1967) is exhilarating.

Being enlightened could mean flooded with light; the opposite of seeing an object disappear at the vanishing point. Seduced by the impossible, he struggles to overcome technical obstacles rather than to exploit technical advantages, as does the formalist. Newman has said that when looking at his *Broken Obelisk* he "became intrigued— intrigued is a better word than inspired—with the triangle as a possible format for painting. It was at that moment that I 'saw' paintings on the huge sheets of steel. . . . I must explain that the triangle has no interest for me either as a shape in itself or because it has become stylish to use shaped canvas." Newman wanted to see if he could "overcome the format and at the same time assert it" and "it was only when I realized that the triangle is just a truncated rectangle that I was able to get away from its vanishing points."[5]

In 1969 Newman made two paintings each in the shape of a tri-

[3] Barnett Newman, *The Stations of the Cross* (New York: The Solomon R. Guggenheim Foundation, 1966); and Nicolas Calas, *Art in the Age of Risk* (New York: E. P. Dutton & Co., Inc., 1968), pp. 208–16.

[4] Alloway, *op. cit.*

[5] Barnett Newman, *Art News,* April 1969.

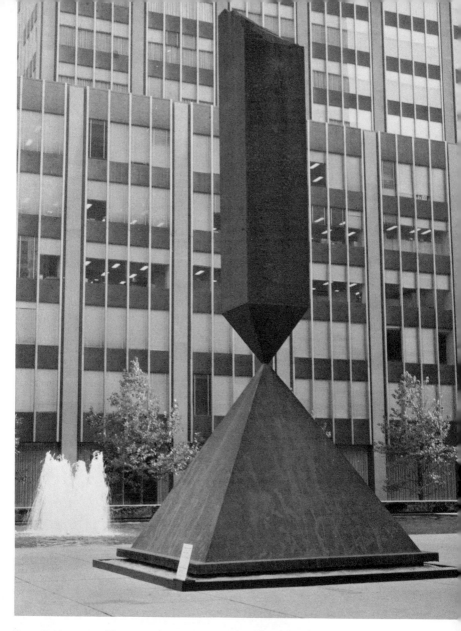

Barnett Newman: *The Broken Obelisk*. 1963–1967. Cor–Ten steel. 26′ × 10′6″ × 10′6″. Photograph courtesy of M. Knoedler & Co., Inc., New York.

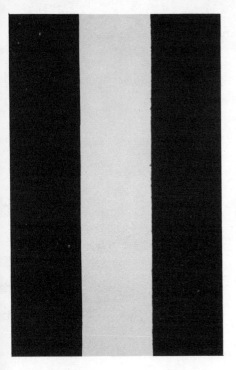

(*Left*) Barnett Newman: *Profile of Light.*
1967. Blue and white paint on raw canvas. 10′ × 6′. (*Below*) Barnett Newman:
Jericho. 1969. Acrylic on canvas.
9′6″ × 8′10″. Photographs courtesy of
M. Knoedler & Co., Inc., New York.

angle, one divided in two by a narrow band ending in a pencil point, the other touching the apex only with the band's left edge. These triangles manifestly represent two different versions of truncated rectangles. Their respective titles are *Chartres* and *Jericho*. Intriguingly Thomas Hess has associated *Jericho* with *Gericault* and the triangle to the *Radeau de la Meduse* of Gericault and its obvious triangle.[6] Whether this was Newman's intention is beyond the point, the reference is provocative.

N.C.

[6] Thomas Hess, "Chartres and Jericho," *Art News,* April 1969.

The Theatrical Morris Louis

Morris Louis (1912–1962) passes as a master of the much vaunted openness. Although he belongs to what has become known as the first generation of the American school, his fame and influence began only in the last years of his life. Most of his paintings resemble "dyed cloth"—Greenberg's expression—for he renounced all tactile feeling associated with the pigments of Expressionist painting for the tactile feeling of canvas. In terms of technique, he is the complementary opposite of Jackson Pollock: while the latter dripped paint onto a canvas spread on the floor, Morris Louis stained the hanging canvas by letting colors gradually soak in and run down. Both artists took advantage of technical innovations, Pollock made use of heavy lead paint while Louis resorted to acrylic paint, highly water-absorbent. Louis often stained and restained the canvas with different colors, producing the effect of layers of transparent multicolored veils. The paintings suggest elegant backdrops for dancers such as Isadora Duncan. The dripping from a wet hanging canvas sometimes resulted in the formation of an overturned triangle bearing a resemblance to a crucifix covered by a transparent colored veil (Veronica's veil?). Owing to the downward pull, the effect is more depressing than exhilarating. The veiled impression links these paintings to Rothko's

Morris Louis: *Beth Kuf.* 1958. Acrylic on canvas. 91¼″ × 133½″. Private collection, New York. Photograph courtesy of Andre Emmerich Gallery, New York.

mists and to the aesthetics of the thirties with their indeterminate shallow spaces.

Louis has none of the formal qualities we find in Rothko, who, at his best, is a master in establishing an exquisite balance between dense and thin areas, heavy and light appearing forms, dark and brighter ones. With Rothko, forms are never the victims of a downward pull, they gracefully defy gravity. Rothko is an accomplished artist who with subtlety profited from the explorations of the Cubist and Orphic painters.

Louis' best paintings are probably the ones in which he uses luminous colors in parallel stripes as in "vertical pillar" series (1961–1962). What is admirable here is the sustained intensity, with each colored stripe reinforcing the brightness of adjoining stripes and producing a truly singing harp of colors. What we admire is the pitch rather than the openness. "Unfurled" series (1959–1960) consists of paintings of sinuous, parallel, oblique stripes, filling but two corners of the canvas and reducing to that extent the stretch of otherwise empty space. In the case of paintings with the two lower corners filled with stripes and thus visually "cut off," the remaining empty space assumes the form of an overturned truncated triangle. It can easily be visualized as an overturned drawn curtain on a stage.

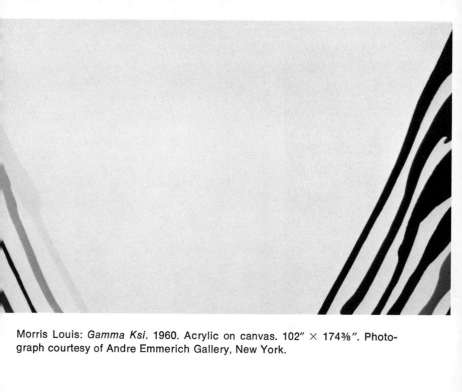

Morris Louis: *Gamma Ksi.* 1960. Acrylic on canvas. 102″ × 174⅜″. Photograph courtesy of Andre Emmerich Gallery, New York.

Aware that Louis' space does not produce that sense of exhilarating openness that Greenberg sees as the prerequisite for post-painterly painting, Michael Fried proposes a new criterion: opticality. By this he means paintings that "address themselves to eyesight alone."[1] Michael Fried considers that, in his best works, Louis achieves a "synthesis of figuration and opticality," transcending "the traditional dualism between line and color."[2] The basic antithesis, however, is between figure and ground: to the clearly delineated figures of Greek vases, of quattrocento paintings, and of geometric figures of Malevich and Albers, we contrast atmospheric effects, of Leonardo, Rembrandt, Monet, Rothko, and Morris Louis (veils).

[1] Michael Fried, *Three American Painters* (Cambridge, Mass.: Fogg Art Museum, 1965), p. 22.
[2] *Ibid.,* p. 20.

Morris Louis: *Moving In.* 1961. Acrylic resin on canvas. 87½″ × 41½″. In the collection of Mr. and Mrs. Andre Emmerich, New York. Photograph courtesy of Andre Emmerich Gallery, New York.

This approach avoids the complication of introducing a term as imprecise as "opticality."

In his article "After Abstract Expressionism" Greenberg is in quest of the "ultimate source of value in art." He believes that the artist arrives at a new conception through inspiration: "Inspiration alone belongs altogether to the individual; anything else, including skill, can now be acquired by anyone. Inspiration remains the only factor in the

creation of a work of art that cannot be copied or imitated."[3] The critic's ultimate task would then be to view the work in terms of revelation, for only in this instance would he be justified in deducing that the artist had been inspired. Since Greenberg has also advocated that each individual art must purify its own elements, inspiration for him is but a handmaiden of purification. Michael Fried with his espousal of opticality proposes as alternative that art be interpreted phenomenologically: an alternative unacceptable from a positivist point of view.

N.C.

[3] Clement Greenberg, "After Abstract Expressionism," *Art International*, October 1965.

Kenneth Noland and the Beauty of Order

Noland is the most eloquent disciple of Morris Louis. While Louis appears to have hesitated to introduce geometric figures into the field from fear of reestablishing the figure-ground antithesis, Noland was able to do so, having found a way of using circles and chevrons as modifiers of the field. By omitting a dish from a group of concentric circles or an angle in a row of chevrons, he asserts, as it were, the presence of the field within the confines of the geometric figure; additionally, by reducing his geometric figures to color bands of unequal width, he establishes the personality of the figure sufficiently for it to serve as an instrument of color variations in the field. To cite an analogy: as a green field becomes an Impressionist painting because of its patches of poppies, so a primed canvas becomes a color field because of its necklace of chevrons. Like the poppies, the chevrons, whether off-center or not, are modifiers, catalyzers of optic effects capable of expanding the painting.

Chevrons are to Noland what squares within squares are to Albers. It is from Albers, undoubtedly, that Noland learned that planes of color need not be separated by lines or empty spaces, for Albers knows how to avoid the optical illusion of advancing or receding

Josef Albers: *Homage to the Square: Broad Call*. 1967. Oil on canvas. 48″ × 48″. Sidney and Harriet Janis Collection. Gift to The Museum of Modern Art, New York. Photograph courtesy of Sidney Janis Gallery, New York.

squares by a clever interplay of colors. However, Joseph Albers succeeded at a price: as his squares grow smaller, they are set lower on the canvas, creating thereby an illusion of weightiness. Structure, as understood since the Cubists, demands the avoidance of the illusion of weight. Noland overcame the hurdle when he replaced the "downgraded" squares of Albers' series with chevron necklaces that look suspended. Noland has, on occasion, identified the triangle with a diamond-shaped canvas ("diamond" series, 1965), multiplying the effect. He has succeeded in sidestepping both Louis' sentimental droopings and the heavy thump of Albers' squares. Some of his shaped canvases, such as *Half Way* (1964), produce a striking effect of directional ambiguity by the contrast between the horizontal axis of the chevrons and the perpendicular one of the diamond.

Painting in Magna colors, as Noland does, holds an important advantage since acrylic paints—unlike oil paints—being water-compatible, do not lose their intensity when diluted. Hence, concentric circles or chevrons maintain that intangible, disembodied, abstract quality which we attribute to ideal forms.

(*Right*) Kenneth Noland: *Air.* 1964. Acrylic resin paint on canvas. 85″ × 89″. (*Below*) Kenneth Noland: *Up Cadmium.* 1965. Acrylic resin paint on canvas. 6′ × 18′ (point to point). Photographs courtesy of Andre Emmerich Gallery, New York.

Noland's chevrons present a wide range of variations: they may be placed well off-center of canvas as in "eccentric chevron" series (1964); they may be separated by off-white bands of canvas; they

may vary sharply in width; they may strike by dramatic color contrasts, such as two red stripes and a black one of graduated width or by a subtle juxtaposition of cool colors, blue, light brown, pink, light green (reminiscent of Kandinsky's late period). Noland has said that he wants his colors to pulsate. They do. But this song of colors is cut short by the epigrammatic simplicity of form. The artist seems to have become aware of this, for in 1967 he gave up geometric figures for a series of parallel bands of color, first in "diamond" series, then concentrating on "horizontal stripes" series (1967–1970). Pulsation is now expressed in terms of broad space and the intensity of contrasts generating grades of luminosity. Vertical pulsations of color serve to blur the edges of the horizontal bands. The effect is quite dazzling and beautiful. The artist conveys the idea that order can produce an impression of beauty.

The ultimate value of art, however, is not to be found in order since we can have order without art. By playing with order in terms of optical pulsations, Abstract Impressionism avoids facing the reality of art much the way Impressionism avoided the issue of physical reality. The reality of art is no more to be found in the "conception alone"[1] than in a renewal of "those of its traditional values that do not pertain directly to representation."[2] In other words, art should concern itself with structure and structure alone. It is art reduced to aesthetics by critics-grammarians. Parenthetically we take note that, writing in praise of Noland's horizontal bars, Fried offers the following tautological "argument": "Noland's bands of color would not be what they are—they would not have the properties here attributed to them—if they were not made of color."[3] Far more enlightening is the following text: "If we look simultaneously upon two stripes of different tones of the same color or upon two stripes of the same tone of different colors placed side by side, if the stripes are not too wide, the eye perceives certain modifications which, in the first place, influence

[1] Clement Greenberg, "After Abstract Expressionism," *Art International*, October 1962.

[2] Michael Fried, *Three American Painters* (Cambridge, Mass.: Fogg Art Museum, 1965), p. 8.

[3] Michael Fried, *Artforum*, Summer 1969.

(*Above*) Kenneth Noland: *Via Blues.* 1967. Acrylic on canvas. 7′6⅛″ × 22′.
(*Below*) Kenneth Noland: *Date Line.* 1967. Acrylic on canvas 107⅞″ × 202″.
Photographs courtesy of Andre Emmerich Gallery, New York.

the intensity of color, and in the second, the optic configuration of the two juxtaposed colors."[4] The above was not written on Noland by a discerning commentator but by the great color grammarian Che-

[4] Michel-Eugène Chevreul, *The Law of Simultaneous Contrast of Colours,* Vol. I, no. 8 (New York: Reinhold Publishing Company, 1967). Reprint from English edition of 1854.

vreul. What higher praise Noland himself could ever expect to receive than to be congratulated on having superbly illustrated Chevreul?

N.C.

Frank Stella, the Theologian

PHILOSOPHER: *I was about to recall to Mr. Galileo some of the wonders of the universe as they are set down for us in the Divine Classics. Remind him of the mystically musical spheres . . . the intoxication of the cycles and epicycles, the integrity of the tables of chords, and the enraptured architecture of the celestial globes.*
. . . May I pose the question: Why should we go out of our way to look for things that can only strike a discord in the ineffable harmony.[1]

Monet saw poppies in a field and painted a field of colors, Barnett Newman made pictorial fields vibrate with continuity, Frank Stella developed variations that threatened the very notion of field. This alarmed certain critics. It was feared that Stella might eventually sacrifice "pictorial reality" for the sake of "artistic reality" and, in the name of the latter, reintroduce illusionistic effects of volume or perspective. So far Stella has limited himself to defining his artistic reality in terms of an antithesis to Jasper Johns. This was an understandable move on his part since his early work was heavily indebted to Johns. Stella's concentric squares (1961) are both pinstripe versions of the stripes of Johns' flags and square versions of Johns' concentric circles. Unlike Johns' early paintings—always homologous to a real flag, target, or map—Stella's pinstripes, whether square, zigzag, or V-shaped, are basically self-referent. In contradistinction to Johns, who often emphasizes process of painting to dissociate the image from the emblem, Stella stresses uniformity of pattern either to

[1] Bertolt Brecht, *Galileo,* English version by Charles Laughton (New York: Grove Press Inc., 1966).

Frank Stella: *Jill*. 1959. Enamel on canvas. 90″ × 78″. In the collection of the Albright-Knox Art Gallery, Buffalo, New York. Gift of Seymour H. Knox. Photograph courtesy of Leo Castelli Gallery, New York.

disguise variations as in sets of concentric squares or to reduce differences as in *Vee* series. Unlike Reinhardt, who develops uniformity to the point where differences all but disappear, Stella reduces monotony by shifts of axes—vertical, horizontal, diagonal—as in *Sangre de Cristo* (1967).

Indeed, many of Stella's works fascinate specifically because of their complicated planning. In *2nd Fluorescent Alkyd* series (1966) one is confronted by a dizzying color variation of purple, orange, and green bands within three zigzagging planes: a rectangular one between two trapezoids, one pointed upwards, the other downwards. This series of paintings offers convincing evidence that since the mid-sixties Stella's work no longer conforms to Greenberg's definition of post-painterly painting as being the product, ultimately, of inspiration; rather, Stella's is the outcome of calculation. (In his *Eccentric Shaped Canvas* series, 1964, Stella elaborated the pattern of Albers' *Kinetic* series, 1945. Eccentrically shaped they certainly are: they

rather create the impression of mass-produced cardboard boxes waiting to be folded into polygons of glowing colors.)

Stella's attitude toward Johns' painting was explicitly stated in a diptych consisting of two sets of concentric squares entitled *Jasper's Dilemma* (1962–1963). This painting is one of a series in which Stella worked on the theme of the color chart. In *Jasper's Dilemma,* one consists of eleven graduated hues and the other of nine grisailles ranging from black to white. As Robert Rosenblum pointed out, this is a reference to "Johns' own problem of color versus grisaille. . . ."[2] Each of the two sets of concentric squares is divided into four sections by diagonals which do not cross each other, since one of them zigzags to bypass the irregularly-shaped center quadrangle. (This is

[2] Robert Rosenblum, "Frank Stella," *Artforum,* March 1965.

Frank Stella: *Jasper's Dilemma.* 1962–1963. Alkyd on canvas. 77″ × 154″. In the collection of Alan Power, London. Photograph courtesy of Leo Castelli Gallery, New York.

undoubtedly an allusion to the concentric circles of the *First Disc,* 1912, by Delaunay with its four quarters divided by two diameters crossing each other within a circle subdivided by color intensity.) Quite evidently, Johns prefers to cultivate dilemmas in contradistinction to Stella, who is intent on solving riddles.

With his *Jasper's Dilemma* Stella, as it were, served notice that he was ready to provide a solution to the problem of the disk, superior to Delaunay's. Delaunay's contribution was to reassemble the elements of the prism within the shape of a disk, often using color dissonances which, he discovered, are the peculiarity of lunar reflections of light. Apollinaire considered this type of painting "pure art" for it provides "pure aesthetic pleasure by means of a structure which is self-evident, and a sublime meaning that is the subject. . . ."[3] Stella stresses the object quality of his paintings—using supports which hold the canvas three inches off the wall.

Undoubtedly his most successful variations on the circle theme are the tondi of the *Sinjerli Variations* (1967–1968), especially numbers 3 and 4. In structure they appear to be simpler than is the case, this is part of their unquestionable charm. Both tondi are formed of three concentric circles with the upper and lower halves in contrasting colors. Each half thus appears divided into two concentric "protractors." Furthermore, the whole disk is subdivided by sectors of four sets of concentric circles, each set having for its center one of the four corners of an ideal square into which the circle would be inscribed. *Sinjerli Variation III* has the peculiarity that, in one sector, these concentric circles are missing.

In a work of his most recent series, *River of Ponds III* (1969), Stella makes combinations of circles and squares, basing himself on two concentric squares combined with reversed sections of arcs in lieu of diameter. The color effect is startling. Each square is divided into two color areas, the outer square dark green and pink, the inner square pale green and dark blue.

Indeed, coloristically as well as thematically, Stella is indebted to Delaunay, with the difference that the latter strove for the sublime.

[3] Guillaume Apollinaire, *The Cubist Painters* (New York: Wittenborn, 1944).

(*Left*) Robert Delaunay: *First Disc.* 1912. In the collection of Mr. and Mrs. Burton Tremaine, Meriden. (*Below*) Frank Stella: *Sinjerli Variation III.* 1968. Fluorescent acrylic on canvas. 120″ diameter. Private collection, New York. Photograph courtesy of Charles Uht. (*Right*) Frank Stella: *Sinjerli Variation IV.* 1968. Fluorescent acrylic on canvas. 120″ diameter. In the collection of Mr. and Mrs. Burton Tremaine, Meriden. Photograph courtesy of Leo Castelli Gallery, New York.

With the color wheel ever in mind Stella forms triads of colors by using a compass instead of a ruler. In *Sinjerli Variation III,* he seems to take into consideration contrasts between earth and sky, night and day, since the upper half is keyed to violet and the lower to brown. The effect is stunning and most agreeable.

Viewed as objects, Stella's disks are more satisfactory than those produced by either Robert Delaunay, Sonia Delaunay, or Kupka. For Stella accomplishes what he sets out to do, to make an object that is a finished painting. Delaunay's disks are apt to be as incomplete as Cézanne's landscapes. Stella omits geometric figures whose absence is indicated by the presence of their parts. His omissions might mislead the orientalizing Westerner to mistake his tondi for Yogi disks, beautifully elaborated in Tantra art. Upon close study, however, the semblance of mystery vanishes for the statement is explicit and the picture can be admired as a brilliant exercise.

Frank Stella: *River of Ponds III*. 1969. Fluorescent acrylic on canvas. 120″ × 120″. In the collection of Mr. and Mrs. Robert Mayer, Chicago. Photograph courtesy of Leo Castelli Gallery, New York.

Stella is the most prestigious among those artists who have turned abstract art into a self-relying system. He is a theologian, theology being a self-referent system of belief whose ultimate function is to eliminate mystery in order to discourage, and whenever possible forbid, any ineffable communication of the alone to the alone.

A critic has compared Stella's recent work to the fugues of Bach. Perhaps it would have been more correct to compare them to the

score; for enjoyment of a piece of music consists in following the process by means of which a period of time is filled with movement registered by sound. In contradistinction, the appreciation of the score itself provides us only with a foretaste of what is to come. In abstract painting all the elements of a pattern are viewed synchronically (not in succession, as in music). Since Stella's paintings develop a complicated system of self-reference, a still more apt comparison would be with mathematical puzzles.

Stella emerges from the Metropolitan Museum's exhibition of "New York Painting and Sculpture: 1940–1970," as the strongest post-Abstract-Expressionist painter. This show, presented with impeccable taste by Henry Geldzahler, is style-oriented. The serious drawbacks of this approach are evidenced upon reading the catalog's essay on Arshile Gorky. As an example of Gorky's stylistic indebtedness to Miró, William Rubin reproduces a detail of his *The Betrothal II* together with Miró's *Fratellini*. If Mr. Rubin had not been carried away by his stylistic preoccupations, he might have realized that Gorky's *The Betrothal II,* as the title hints, is primarily a reinterpretation of forms used by Duchamp in his *Bride*. In contrast to theologians, Duchamp was interested in posing enigmas. Gorky was aware of this, as is Jasper Johns. What the Metropolitan Museum's emphasis on style detracts from, too, is the recognition that Johns' *Studio* (1964), is both a comment on Duchamp's *Big Glass* and on the zigzag canvases of Stella.

That Duchamp and Delaunay were good friends is hardly a reason for not admiring one more than the other, the impure rather than the pure, the imagist rather than the stylist, Johns rather than Stella.

N.C.

Ellsworth Kelly: Dialogue Between Painter and Sculptor

In the mid-fifties, Ellsworth Kelly, as well as Youngerman and Krushenick, followed the lead of Leon Polk Smith in trying to overcome the contradiction between figure and ground by the juxtaposi-

tion of positive and negative forms. Kelly's basic forms at the time were biomorphic, largely derived from Hans Arp. His endeavor turned out to be self-defeating, since shapes derived from plants, associated as they are with leaves and flowers, detract attention from the required abstract character of the positive-negative situation. Aware of this difficulty, Kelly gave up biomorphic forms for geometric ones. Furthermore, to free himself from Smith's influence, he placed his forms upon a solid monochrome surface, which, because of its color intensity, had to be visualized as a field rather than as background. In 1964 Kelly made a red painting that contained two parallel elongated figures, one blue, one green. In an attempt to preserve the unity of the field, he rounded the blue and green figures to keep them from quite touching the upper and lower edges of the canvas, thus from slicing it; additionally, the curved edges helped to do away with any association with a banner. Despite the broad critical acclaim for the intensity of color and its hard-edge application, this painting cannot be considered successful: it is still too heavily indebted to Leon Smith's set of three elongated "rounded rectangles" of *Triptik* (1959). Also, Kelly's figures are so broad that they neutralize the effect of openness achieved by Newman's more subtle verticals, an openness which is a prerequisite of Field painting.

Kelly came into his own with his 1966 series of paintings which consisted of pairs of adjacent rectangular canvases, each canvas flatly painted from edge to edge in a single strong color. Those works included panels of identical size such as *Black and White;* two or three panels unequal in format, such as *Blue Yellow Red* and *2 Panels: White over Black.* Within a year, a shaped canvas made its appearance, an L containing a square, *Green White* (1967). This was followed by shaped canvases of triangles, parallelograms, trapezoids, etc., as well as projections of cubes and various polyhedra. Color contrasts in projections of solids are reducible to light and shadow: this is dramatized by Kelly in terms of the contrast between light and dark colors, in such words as *White Brown* and *Green Black* (both 1968).

While still in his biomorphic period, Kelly produced a bewitching

Ellsworth Kelly: *2 Panels: White over Black.* 1966. Oil on canvas. 86″ × 80″. Photograph courtesy of Sidney Janis Gallery, New York.

Ellsworth Kelly: *Yellow Orange and Yellow Black.* 1968. Oil on canvas. 62″ × 62″ / 92″ × 116″. Photograph courtesy of Sidney Janis Gallery, New York.

Ellsworth Kelly: *Green Blue.* 1968. Painted aluminum. 8′7″ × 9′4½″ × 5′8½″. The Museum of Modern Art, New York, Susan Morse Hilles Fund.

sculpture suggestive of a water lily. It is made of two identical white oval metal disks rising at a shallow angle from the floor and crossing one another lightly at a single indentation they have in common (*Whites,* 1963). By 1966, Kelly had translated his experiments with volume projections into sculpture. His early free-standing *White Angle* and *Blue White Angle* (both epoxy on aluminum) are formed of two planes set at a right angle in a floor-wall relationship. His most brilliant achievement to date is probably his *Untitled* painted steel (1968). Seen from the front, it consists of two adjacent triangles, a blue one pointed upwards and an overturned green one. A rear view of the sculpture reveals a very different configuration: a metal sheet, painted white, is folded into three triangles, one flat on the ground supporting the two vertical ones. Upon study, the sculpture can be identified as a section of a right-triangular prism.

The simplicity and ease with which Kelly reinterprets solids in terms of color is both an enchantment to the eyes and a delight to the mind.

Jo Baer

To the openness of the color field advocated by Greenberg, Jo Baer opposes an empty canvas framed by painted lines, often just a black strip coupled with a thin, vibrating green, yellow, or purple line. As Amy Goldin pertinently remarked, "The brilliant black-and-white contrast immediately sends the eye to the frame where it follows the line round and round like the trapped animal on a treadmill."[1] More recently Miss Baer reduced the "frame" to two "posts" guarding the entrance to an empty field. Sometimes these "posts" form a corner clasping the edge of the canvas, adding thereby narrow profiles to the front view. According to a formalist critic, Jo Baer's "seemingly

[1] Amy Goldin, "In the Galleries," *Arts Magazine,* April 1966.

Jo Baer: *Tiered Horizontals.* 1968. Oil with lucite on canvas. 5′ × 7′. Photograph courtesy of Goldowsky Gallery, New York.

empty canvases opt for marginal preoccupations."[2] This is a round-about way of saying that her painting is the pictorial equivalent of a decorative page devoid of text.

N.C.

[2] Robert Pincus-Witten, "New York," *Artforum,* February 1969.

Jules Olitski: Atmospheric Effects

One can admire a Bellini madonna without believing in God, but it is difficult to wax enthusiastic about Olitski without accepting the importance of the principle of opticality. Olitski, we are told, "addresses himself to the eyesight alone," which means that the opticality of his painting "is grounded chiefly in the handling of color."[1] Michael Fried views Olitski as a "modernist" counterpart of van Eyck for he is primarily concerned with "visual time": "What the paintings of van Eyck and Olitski have in common is a mode of pictorial organization that does not present the beholder with an instantaneously apprehensible unity."[2] Works whose unity is not immediately apparent undoubtedly include the Utrecht Psalter illustrations, Duchamp's *Large Glass,* Max Ernst's collages, most of Rauschenberg's paintings. The difference between a van Eyck and an Olitski is that it takes considerable time to become aware of the complexity of *Wedding Portrait of Giovanni Arnolfini,* apparently a simple enough portrait, while it requires only a few minutes of attention to discover the rhythmic expansions and condensations of Olitski's abstract landscapes. In contradistinction to what is being claimed for Olitski, one may safely claim that in van Eyck there is more than meets the eye.

What we see in Olitski's paintings is an artful handling of sprayed colors producing a dreamy, Impressionist glow. Wishing to avoid Rothko's post-Cubist plane construction, Olitski freed his "atmospheric" effects from all association with volume. In the early sixties he tended to adopt the vertical narrow rectangle characteristic of early Newman and, like Newman, occasionally introduced a band of color or a "tear" at the edge of a canvas.

In 1967 Olitski exhibited a series of light, bright broad-field paintings. In *High a Yellow* (1967) he limits the glow to a hazy red in the very lower left corner with color imperceptibly turning high yellow

[1] Michael Fried, *Three American Painters* (Cambridge, Mass.: Fogg Art Museum, 1965), p. 37.

[2] *Ibid.,* p. 35.

over the vast expanse of canvas (89½″ × 150″). As counterpoint in the upper right corner there is a loosely formed angle of brushstrokes, flowing streaks of greens, red, yellow, purple, clamped down by a blob of white. In this and other works of the period, such as *Pink Drift* or *Green Goes Around,* streaks, blobs, and splatterings run a gamut of density, on occasion even being sprayed over.

In the long horizontal *Shake Out* (1968) the artist sprayed a shower of particles (synthetic polymer paint), mostly yellow and orange, over a purple field, flooding the upper section and lightly sprinkling the lower one. The first impression might be that of a

Jules Olitski: *High A Yellow.* 1967. Acrylic on canvas. 92½″ × 150″. In the collection of the Whitney Museum of American Art, New York. Photograph courtesy of Andre Emmerich Gallery, New York.

Jules Olitski: *Shake Out*. 1968. Acrylic on canvas. 47″ × 218″. Photograph courtesy of Andre Emmerich Gallery, New York.

golden glow illuminating the horizon while purple darkness still covers the earth. One rejects the association almost immediately since the narrow bands of color placed along some of the edges neutralize all atmospheric effects. The bands of color, brushstrokes in pink, turquoise, brick, green, yellow, partially sprayed over, provide us with the artist's "palette" and draw attention to the sprayed field as such. What we actually do see in the picture is a texture of lovely coloring, purple sprinkled with light dots, and a subtle gradation from darkness to brightness. Are we expected to admire a picture for its texture as we admire fine cloth?

Critics who discuss Olitski's work in terms of opticality clearly do not think so. Their assumption is: what colors do to our eyes is more relevant than what thoughts are stimulated by looking at a painting. This approach reduces a picture to a stimulus of optical sensations. Paintings are made to be seen by persons who think while looking and if they see but texture, the mind is hardly stimulated.

Larry Poons and His Puzzles

Larry Poons' monochrome fields blossoming with precise bright dots have enchanted gallery-goers since his first exhibition in 1963. When close scrutiny discloses how the dots pop in and out of a barely

visible grid of squares and their diagonals, added pleasure is found in rediscovering the strategy which determined their position. Poons' elliptic dots are musical notes progressively freed from the narrow confines of the pentagram to play independently of any score. Poons' fascination with musical notation goes back to the early fifties, when, as a student at the Boston Conservatory of Music, he was prompted by Mondrian's and van Doesburg's interest in music to begin investigating the possibilities of using musical structures for plastic purposes. By the mid-sixties, however, Poons felt that "analogies with music were irrelevant."[1]

More relevant to the understanding of Poons' musical dots, as well as his recent "cracked earth" paintings, is perhaps a book by Hugo Steinhaus entitled *Mathematical Snapshots*.[2] In relation to Poons, it is interesting to take note that the book's *puzzle 76* makes use of the musical scale, *puzzle 77* shows a polygon on a lattice of tiny circles, *puzzle 81* shows large, slightly irregular elliptoid disks against a lattice of dots, while *puzzle 82* is accompanied by a diagram showing the position of a hop pole and its circular projections on a lattice of dots. *Puzzle 69* deals with the seemingly irregular patterns that we observe on the shore of a river when the mud has dried up.

The variations in the position of dots in Poons' complicated patterns of 1966–1967 can be accounted for in terms of an underlying structure. *Stewball* (1966), analyzed in detail by Lucy Lippard, consists of three types of dots: small dots placed in small squares; small ovals placed in rhomboids double the size of the squares and slanting left to right; and, lastly, large ovals set in vertical rectangles twice the area of the small squares and slanting to the left or to the right. In this musical-note period Poons is at his best in a painting such as *Nixes' Mate* (1964), in which green ovals with their blue mates dance with brightness before our eyes against a static monochrome red field spotted with silent pink dots. Some critics have compared these paintings to Pollock's, but the resemblance is purely

[1] Lucy R. Lippard, "Larry Poons, The Illusion of Disorder," in *Changing: Essays in Art Criticism* (New York: Dutton Paperbacks, 1971).
[2] New York: Oxford Press, 1950.

Larry Poons: *Nixes' Mate*. 1964. Acrylic on canvas. 70″ × 112″. In the collection of Mr. and Mrs. Robert C. Scull, New York. Photograph courtesy of Leo Castelli Gallery, New York.

superficial. To appreciate Pollock's paintings we have to scan the surface and bridge gaps, but in Poons' figures and their respective positions and omissions, however complex, are planned.

By 1968 there is a striking reversal of process, grid is abandoned and the dots become clear brushstrokes. In 1969 Poons shifted to what might be called "cracked-earth landscapes." He provokes accidents by precipitating the drying of fatty synthetic paints. While Max Ernst and Pollock with frottages and drippings exploit accidents, Poons produces accidental effects of irregularities, evocative only of mud in riverbeds (one of the paintings is called *Yang Tze*), of canyons, while others suggest eruptions of volcanoes vomiting pretty

Larry Poons: *Stewball*. 1966. Acrylic on canvas. 125″ × 90″. In the collection of David Mirvish, Toronto. Photograph courtesy of Leo Castelli Gallery, New York.

Larry Poons: *Ode.* 1969.
Acrylic on canvas.
88¼″ × 55″. In the col-
lection of S. I. New-
house, Jr., New York.
Photograph courtesy of
Lawrence Rubin Gallery,
New York.

acrylic colors. At close range the flowing lava looks more like melting
fudge, to the touch, however, it feels like chewing gum. Seen at a
distance the pleasant colors and charming variations in this imag-
inary yet never startling landscape are picturesque versions of cata-
clysms.

The Problem of Invisibility
(Ad Reinhardt, Paul Brach, Agnes Martin)

AD REINHARDT

From the early fifties it was apparent that Reinhardt had chosen van Doesburg and Albers for his masters, both devotees of the square. Through a series of experimental eliminations during the sixties, Reinhardt reduced color differences to degrees of dark tones which strike the viewer as variations in quasi-blackness. The distinctive trait of these "monochromes" is their division into three rows of three squares or "trisection" (the artist's term). Lucy Lippard has claimed that Reinhardt's trisection is to be viewed as armature, not form.[1] If this indeed is the case, his work would mark a return to pre-Impressionist painting, since Impressionism's great technical achievement was to have freed painting from the armature. As for the Cubists and Constructivists, their contribution was to have made structure their primary concern. Reinhardt's peculiarity is to have freed painting from armature. As for the Cubists and Constructivists, their contribution was to have reduced the visibility of structure to the point where differences between squares all but vanish while the differences between colors are so restricted as to produce an illusion of monochrome. It might have been rewarding to study the paintings at very close range for their tonalities were it not for the intrusion of the delineated trisections, which, as armature, supposedly should have been concealed. It seems to me that Reinhardt failed where Albers succeeded, i.e., in producing a proper balance between structure and color.

Evasion of the problem of form in Reinhardt's work is helpful to those critics who chose to see the latter as a forerunner of Olitski. It does not account for Reinhardt's own position: why would an artist have persevered for over two decades with manipulations of squares

[1] Lucy Lippard, "Introduction" to catalog of Ad Reinhardt's exhibition, Jewish Museum, N.Y., 1967.

unless he was convinced that an order of squares was necessary to the effects he sought? Each square provides color information distinct from that given by adjacent squares. To "forget" his squares is to assume that the sum total of information could be given adequately without recourse to squares. Revealingly enough, Reinhardt used a similar mode of expression in certain of his writings: the poetic quality of his *Art-As-Art Dogma* is not in his enunciated truths but in the structuring, the permutations in the order of positive and negative statements which replace variations between his squares.

> *Order in art is not order.*
> *Chaos in art is chaos.*
> *Symmetry in art is not symmetry.*
> *Asymmetry in art is asymmetry.*
> *A square in art is not a square.*
> *A circle in art is a circle.*
> *A triangle in art is a triangle.*
> *A trisection in art is not a trisection.*
>
> *Simplicity in art is not simplicity.*
> *Less in art is not less.*
> *More in art is not more.*
> *Too little in art is not too little.*
> *Too large in art is too large.*
> *Too much in art is too much.*
> *Chance in art is not chance.*[2]

Reinhardt can more plausibly be viewed as a forerunner of artists who make of a system the subject matter of their art.

Reinhardt's system involves playing hide and seek with invisibility. His black paintings—generally considered his best—are like board games reduced to three rows of three squares, the hue of each unit's blackness, as it were, differently seasoned. The interplay of figure and ground assumes, according to some, the shape of a cross. Statements

[2] "Writings" by Ad Reinhardt in *The New Art,* ed. Gregory Battcock (New York: Dutton Paperbacks, 1966), p. 199.

Ad Reinhardt: Untitled (Black). 1960–1966. Oil on canvas. 60″ × 60″. Photograph courtesy of The Jewish Museum, New York.

reiterating the wonders of silence and invisibility ought to be interpreted in a religious context. Reinhardt's last paintings have become icons for agnostics who prefer veils covering the obvious to signs indicating the presence of an enigma.

PAUL BRACH

Clement Greenberg probably never foresaw that his theory of reduction of each art to its essential elements might be construed to

mean that painting could dispense with visibility. Leo Steinberg identifies four modes of invisibility: invisibility by disappearance; by extinction of light; invisibility due to dim vision; and a fourth, which encompasses the others, invisibility of undifferentiated homogeneity.[3] Steinberg wrote the above on the occasion of Paul Brach's exhibition (1964) of his large gray-blue canvases which contained a barely discernible figure.

In the broader context of postwar abstraction, Reinhardt and Brach are part of a movement attempting to overcome the contradiction between figure and ground through homogeneity in space. Brach is free of Reinhardt's compulsion to resort to a chesslike pattern; the homogeneity of his work in the middle sixties depends on an interplay between the canvas' color field and a geometric figure, circle, or concave square carried to the threshold of visibility.

Steinberg is charmed by those "solitary" paintings, cerulean and white, slightly tinged with added violet or umber and varying in "the pigment's density and the pressure of buried color below." He eloquently evokes ". . . the stately conversion dance of his circles: ashen disks in a strafing dance, then hollows or portholes in a dark field as you change position."[4]

In his recent paintings Brach undertakes to solve the problem of "figure-ground differential" (Steinberg's expression) in a novel way: the almost imperceptible emergence of dots on an otherwise blank canvas. As we explore the seemingly empty surface of the picture, pointillist-like dots—pink, yellow, gold—begin to come into view, first, perhaps, one by one, then gaining momentum and crowding a section of the canvas to form an arc or a circle. Two variants are present: there are instances when the emergence of the dots is such a gradual process that we perceive their grouping as a change in the color of the ground before recognizing the formation of a figure; in other instances, with color less pale or dots more concentrated, the figure gains in visibility, if not in meaning.

[3] Leo Steinberg, "Paul Brach's Pictures," in *The New Art, op. cit.,* p. 226.
[4] *Ibid.,* p. 228.

AGNES MARTIN

Agnes Martin is known for her matlike monochrome canvases subdivided into tidy small rectangles of spidery delicacy.[5] Some critics have associated Miss Martin's impression of impressions with the art of redundancy. Annette Michelson in a close scrutiny of

[5] Michael Benedikt, "New York Letter," *Art International,* December 1966.

Agnes Martin: *Trumpet.* 1967. Acrylic on canvas. 72″ × 72″. Photograph courtesy of Robert Elkon Gallery, New York.

Martin's paintings notes with finesse that "one reaches for a tape measure only to relinquish it, knowing that the verification of the rationale will in no way account for the interest of the work."[6] More recently, in a painting such as *Trumpet,* Agnes Martin produces atmospheric effects with "intangible" brushstrokes.

[6] Annette Michelson, "Agnes Martin," *Artforum,* January 1967.

Art and Strategy

To judge from an exhibition which originated at the Pasadena Art Museum and later moved to the Santa Barbara Museum of Art,[1] emphasis shifted from the oversize to the long series. Monet, with his cathedrals and haystacks, is presented as the forerunner of serialization and Albers, with his squares, as the father of modern serialization. The new masters of the genre are undoubtedly Reinhardt, Morris Louis, Kenneth Noland, Ellsworth Kelly, Stella, and the sculptor Larry Bell. The exhibition of "Serial Imagery" includes a *Marilyn Monroe* and a *Brillo Box* series of Andy Warhol; as well as a Buddha-blue series of Yves Klein.

In a thoughtful introductory essay to the catalog, John Coplans traces Serialism back to the Dedekind-Cantor theory of variables. With Serial art, Coplans points out: "the masterpiece concept is abandoned. Consequently each work within the series is of equal value; it is part of a whole; its qualities are significantly more emphatic when seen in context than when seen in isolation."[2] Barnett Newman was excluded on the grounds that his *Fourteen Stations* follow a narrative rather than a serial order.

Doing away with the notion of a masterpiece sounds very democratic, while serialization, as such, would appeal to the art scholar who tends to view works of the past in terms of the rise and fall of styles. Unlike an evolutionary series which has a beginning and an end-in-view, Serial imagery is treated as a continuum having neither a first nor a last element. It is to be comprehended as a macrostructure with variables, such as rhythmic variations of shapes and intervals,

[1] John Coplans, *Serial Imagery* (Pasadena, Calif.: The Pasadena Art Museum, 1968).
[2] *Ibid.,* p. 11.

combinations of verticals with horizontal and diagonal directions. (Also excluded from the exhibition were works of Herbin, Vasarely, and Domela, since the variations and permutations in their "game board" paintings occupy a fixed position in a system, not a variable one in a series.)

From Coplans' text we deduce that Stella is the brightest star of the Serial microfirmament, for he alone explores Serial imagery "both vertically and horizontally, by altering the parameters within each successive series."[3] Stella is furthermore credited with having discovered "that permutations—the typical, possible distributions, which are strategically central to Serial order—can be varied at will." Absence of limiting rules to this strategy is "reminiscent of Wittgenstein's remark 'Language is a game the rules of which we have to make as we go along.' " How misleading! Surely, the variables resorted to by Stella or Noland are much too limited to permit a comparison with the variables of natural language. Diametrically opposed to Coplans' view of serialization in art is that of the late Anton Ehrenzweig. In "The Hidden Art of Order" this author interpreted serialization in music—initiated by Schoenberg—as an intellectual attempt to challenge, in the name of a more profound meaning, the good gestalt elaborated by melody. Ehrenzweig saw that serialization is originally prelogical and traceable back to a scanning process. I would like to add that it is through the intervals in a series that John Cage permitted noise to be introduced into the musical structure. With Cage noise becomes an event in the series. Its counterpart in painting is the pictorial accident—unexpected image or bad gestalt. Expressionism wants to exploit such effects. Of Expressionism in art it could be said that it is a game "the rules of which we have to make up as we go along." The Expressionist artist forms images or develops a writing by serializing microelements. The more a work looks like writing, the more we will be tempted to read it; the more it looks geometric, the more tempted we will be to explain its order.

Coplans points out with satisfaction that American Serial imagery evokes "the underlying control systems central to an advanced, 'free-

[3] *Ibid.,* p. 14.

enterprise,' technological society."[4] An analogous claim is made by European Constructivists in the name of Socialism, advocating planning in art as an alternative to the much discredited Social Realism. A humanist can hardly accept impersonal planning, with or without computers, nor macrostructural serializations which involve repression of unconscious desires. What else is "strategy" as meant by Coplans but a substitute for the post-Romantic notion that art is for art's sake?

If strategy were to become the criterion for appraising macrostructure, the variations, within and between series, would have to be calculated much the way players calculate moves in a game of chess. By implication, art would no longer be viewed as a language whose rules are invented as we go along, but as a game whose moves we make in accordance to the situation confronting us. Not all games are comparable to language. Unlike natural language, the purpose of a game is not to transmit information, but to change a given situation through correct moves.

In games, strategy consists of planning a series of moves against an opponent that are not forbidden by the rules of the game. Since the Serial artist is not planning moves against any opponent, real or fictitious, his series can have no strategic value but only didactic value, presenting examples that may be followed if certain effects are to be achieved.

While dismissing the notion of the masterpiece, Coplans does not question the validity of scale. It seems to me that the enjoyment of following a series of macrostructural variations has no relevance to the size of the canvas and can be had more comfortably in confrontation with a medium format portfolio. Reduction in scale would certainly have an adverse effect upon neo-Impressionist abstractions. By forcing green to clash with red, and blue with white, Ellsworth Kelly makes his color fields vibrate with luminosity; by a vertical interplay of luminous tensions Noland tightens his grip over his horizontal bands and neutralizes the pull of serialization. Space calls for light,

[4] *Ibid.*, p. 18.

hence the presence of light in a given area becomes an event interrupting the silence of time.

According to Coplans, Serial imagery evokes "the underlying control systems central to an advanced, 'free-enterprise,' technological society." This is alarming for it implies that Serial imagery serves to reenforce the system of control that managerial order wishes to impose on both our actions and the expression of our ideas and emotions. I, on the contrary, believe that to the precision of controls, the artist should oppose the disturbing ambiguities of expression. To the order of good gestalt the tension of bad gestalt. To the logic of serialization the shock of surprise. To the eloquence of exposition, the challenge of double meanings.

N.C.

3D Structures

David Smith, The Painters' Sculptor

Openness, a characteristic of Impressionist painting, whether representational or abstract, was difficult to introduce into sculpture. Both Rodin and Boccioni were Impressionists when they exposed modulated surfaces to an interplay of light and shadows. To achieve their Impressionist effects, these sculptors found themselves obliged to emphasize mass at the expense of form. Cubists, viewing sculpture as a reaction to Impressionism, substituted the cutout space to open space. Initiated by Archipenko, the cutout space reached its high with Gonzalez. The latter went on to present silhouetted figures, their incomplete forms completed by open space, i.e., using open space as material (the artist's expression). David Smith misinterpreted Gonzalez's open space and showed his complete delineated abstract silhouettes *against* open space, a step back from Cubism, as well as Constructivism, Gabo having used open space to complete structure.

In 1961 David Smith began resorting to the use of the circle with an early piece titled *Noland's Blues* (a reference to the stained canvases of concentric circles by his friend, the painter Kenneth Noland). Smith's *Circles* (1962), consisting of a set of three polychromed steel disks, have been concisely described (in part) by Edward Fry: "Each of the three units is basically a simple circle with an open circular core; the inner and outer diameters vary among the three."[1] Thus the three are primarily studies in the relationships of an inner circular space to a circular rim or frame.

Through the years Smith had also included in his compositions small rectangular linear frames as in *Oculus* (1947), but usually

[1] Edward Fry, *David Smith* (New York: The Solomon R. Guggenheim Foundation, 1969), p. 129.

pictorial elements were held within the frames which grew progressively larger; i.e. *The Banquet* (1951). In Fry's estimation, Smith's final achievement consisted in banning all figuration from within the frame and the presentation of the frame itself as *the* whole sculpture. Commenting on the monumental *Cubi XXVII* (polished stainless steel ⅜" × 87¾" × 34"), Fry says: ". . . The frame could be massive enough to permit a spatial articulation of its component parts sufficient to overcome the visual power of a central open space."[2] The component parts of the giant asymmetrical frame are irregularly placed cubes of varying dimensions, plus one cylinder, which together form the two verticals of the structure, while rectangular beams define it horizontally. The "articulation" of the component parts does not overcome the impression that the sculpture is but a variation on the window-frame theme.

Smith is basically a painter's sculptor who has often been intent on translating into sculpture problems preoccupying the Field painters. The latter, when successful, sustained the continuity of the field despite the presence of geometric forms. To produce analogous effects in sculpture, Smith should have developed a three-dimensional continuity, the way Laurens produced a continuity of cubistic facets and Vantongerloo a continuity of solid cubes. Smith inserts his hollow cubes, cylinders, and beams into an essentially frontal two-dimensional image, the frame. An emphatic exception to this is provided by a composition of two years earlier, *Cubi XVII* (1963), a three-dimensional assemblage of cubes and beams on a raised platform supported by a tall cylinder resting on a base at an angle to the platform.

His vertical structures are probably the most successful, especially his virtuoso *Cubi I* (1963). A totem pole of dazzlingly polished stainless-steel cubes, zigzagging vertically and somewhat tilted forward, it amazes by the precariousness of its balance. Technically Smith's great contribution was to have found a way to make constructions of hollow steel forms welded together. As in *Cubi I,* he obtains his most startling effects by joining cubes tangentially, edge to edge.

[2] *Ibid.,* p. 162.

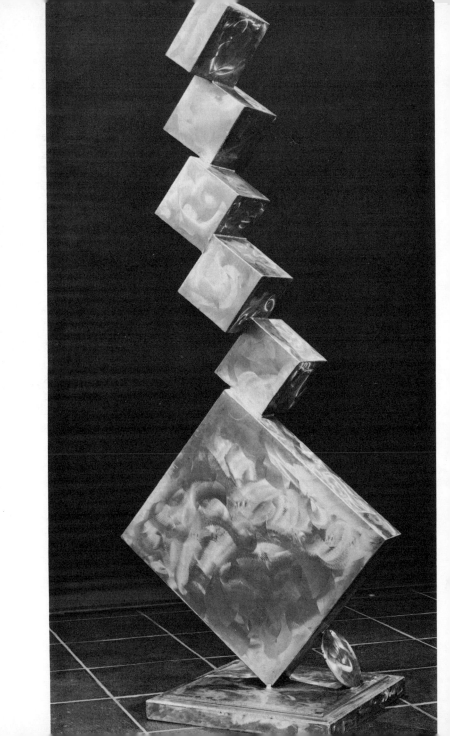

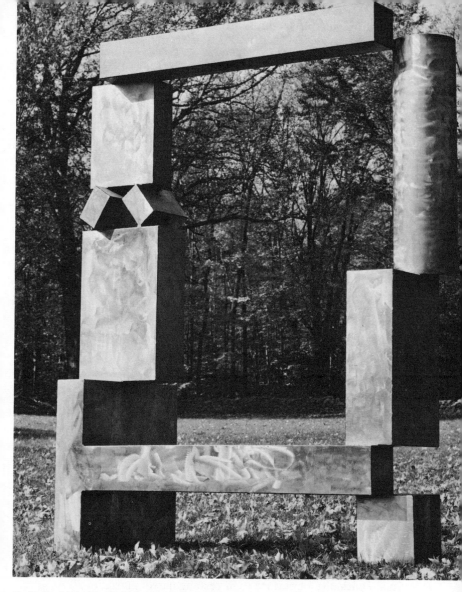

(*Left*) David Smith: *Cubi I*. 1963. Stainless steel. Height: 360″. Photograph courtesy of The Detroit Institute of Arts, Detroit. (*Above*) David Smith: *Cubi XXVII*. 1965. Polished stainless steel. 111⅜″ × 87¾″ × 34″. Photograph courtesy of The Solomon R. Guggenheim Museum, New York.

Naturally enough, such asymmetric verticality would be inconceivable without welding and with solid bodies.

The significance of David Smith's later works transcends aesthetics. Historically those works became the impetus for new, valid experimentation with geometric forms, having induced the younger generation of sculptors to reexamine Constructivism. Both Smith's polychromes (in which he was influenced by Alexander Calder's use of color) and the polished-steel cubi are to be viewed as elaborations of patterns traceable back to sketches of Lissitzky and Moholy-Nagy. Smith's emphasis is on silhouetting his constructions against a visual field. It was left to the English sculptor Anthony Caro, who at one time worked with Smith, to realize that the three-dimensional counterpart to field painting requires that the ground become the field along which the artist composes his sculpture horizontally.

Tony Smith's Spaces, Solid and Empty

From the work of Mondrian one may draw the conclusion that contemporary man prefers regularity to symmetry. If regularity is to avoid becoming boring, the "order" should remain somewhat hidden. Mondrian saw to it that the secret of his system should not be totally revealed even to himself, leaving adjustments to the inspiration of the moment. We get the impression that Tony Smith does likewise, which is one reason his system of regularity continues to fascinate.

Although Smith's compositions are based on polyhedra, they are not cubistic, since the works are not built around a central axis. Smith's important innovation is to have built certain of his solids in relation to the axes of a space-lattice made up of polyhedra. Such an organization, according to Smith, "allows for greater flexibility and visual continuity of surface than rectangular organization."[1]

[1] Tony Smith, "Remarks on Modules" in *Two Exhibitions of Sculpture,* Wadsworth Atheneum, Hartford, and The Institute of Contemporary Art, University of Pennsylvania, 1966.

Visual continuity dictates such structurally valid novel forms as those of the sculpture titled *Amaryllis* (1965). Basically it consists of two truncated prisms linked at a crazily tilted angle. While the front view is that of a pair of oblique parallelepipeds held in precarious balance, at a three-quarter angle it resembles gaping jaws, and from the rear a mammoth bent in two. These iconic associations are not contrary to the spirit of his work, for Smith named one of his Z-shaped sculptures *The Snake Is Out* (1962). Another twisted form is *Cigarette,* which owes its name to Smith's discovery upon its completion that it looks like "a cigarette from which one puff had been taken before it was ground out in the ashtray."[2]

Smith's rectangular constructions could be mistaken for reconstructions of portions of edifices of bygone civilizations. *Free Ride* (first mock-up, 1962) is in the shape of a Z with one of its rectangular beams vertical and the two horizontal ones at an angle to each other. It is evocative of a jamb and salient angle of a wall of a Near Eastern palace. This is valid only as long as we view the piece as a "reconstructed portion" for the eye expects the vertical to double in size the two horizontals, whereas Smith is forcing upon the viewer the unexpected juxtaposition of an angle formed by two horizontals each 6'8" to a vertical 6'8".

In contrast to such rectangular structures as *Night, Marriage, Playground* (difficult to date because of the lapse of time between their conception in blueprint, through cardboard models and plywood mock-ups to metal and their ultimate realization), Smith produced a most irregular and odd-looking construction, *Willy* (1962), a composite monster with three unmatching limbs. Smith explains that the model had been made from parts of other models, including those of *Snake,* adding: "I tried to put these components together as arbitrarily as possible. Again the basis was determined only at the last. The monstrous result reduced *Snake* to a tame little dragon. It was a crawling thing that had not been designed for crawling."[3] Tony Smith's tendency to joke about his work is refreshing, especially

[2] *Ibid.*
[3] *Ibid.*

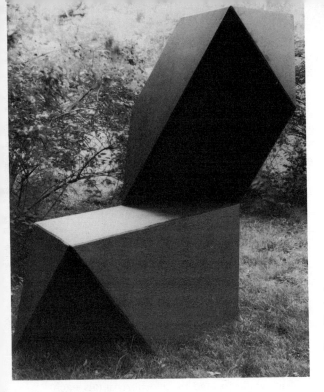

Tony Smith: *Amaryllis.*
1965. Steel (wood
mockup). Front view.
11'6" × 7'6" × 11'6".
Photograph courtesy of
M. Knoedler & Co., Inc.,
New York.

today when a younger generation of sculptors speaks of its work with
the dryness and pomposity of third-rate art historians. Despite their
frivolous titles, no one should be misled into thinking that *Cigarette*
or *Willy* is anything but a serious work. Like most of his structures,
Willy can be seen as a variation on an architectural theme: it consists
of three weirdly unmatching slanted pillars and two openings or
passageways, one rectangular, one triangular. (It must be remembered
that Smith worked for many years as an architect.)

The interplay between solid forms and empty spaces is intended to
be seen as a continuous space grid, the voids forming negative vol-
umes. When Smith's sculptures were on exhibit in New York's Bryant
Park in 1967, they acted as aesthetic catalizers, shaming the sur-
rounding skyscrapers' rigidity and formlessness. Smith's sculpture

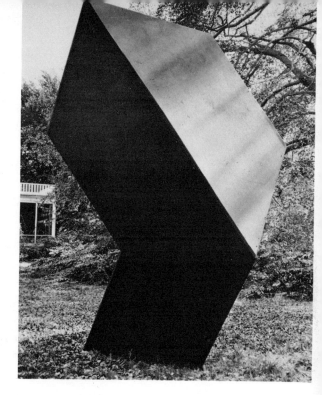

Tony Smith: *Amaryllis.*
1965. Steel (wood
mockup). Side view.
11′6″ × 7′6″ × 11′6″.
Photograph courtesy of
M. Knoedler & Co., Inc.,
New York.

could have the same beneficial effect on future urban planning as
Mondrian's painting has had on architecture. A preview of what
might be done is offered by *Wandering Rocks* (1967) when set in
landscaped surroundings. If we translate these structures into edifices,
we get an idea how radically the dreary orthogonal cityscape could be
changed. *Wandering Rocks* is composed of five irregular and dissimi-
lar parallelepipeds spaced at a distance from each other. With sun-
light reflecting upon the steel surfaces and casting sharp shadows on
the ground, a simultaneous view of the five units multiplies the
difficulty of identifying the true form of each, adding an element of
enchantment.

Designed for interior space and built at the Corcoran Gallery from
a small-scale cardboard model is the atypical *Smoke* (1967). It is an

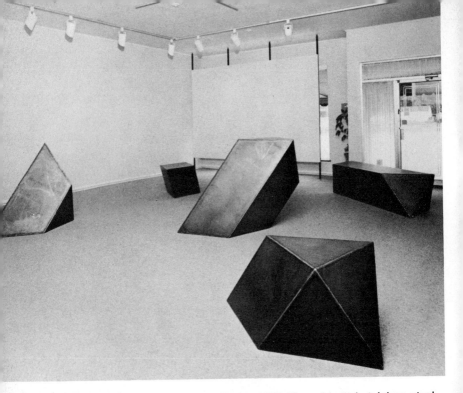

(*Above*) Tony Smith: *Wandering Rocks.* 1967. Vapor-blasted stainless steel. *Crocus* (left), 45″ × 27″ × 47″; *Smohawk* (background), 22½″ × 27½ × 47″; *Slide* (middleground), 22½″ × 27½″ × 6′4″; *Shaft* (foreground), 45½″ × 27½″ × 6′; *Dud* (right), 22½″ × 31½″ × 8′2″. Photograph courtesy of M. Knoedler & Co., Inc., New York. (*Right*) Tony Smith: *Smoke.* 1967. Painted plywood to be made in steel. 24′ × 34′ × 48′. Photograph courtesy of of M. Knoedler & Co., Inc., New York.

immense open construction, a network of flowing spaces, held together primarily by tension. Built of plywood, it consists of two superimposed rows of polyhedric pillars and arches. It has been written of it: "A paradox of spaces within spaces is set up making the voids as vital to the work as the positive forms."[4]

[4] Eleanor Green, "Scale as Content," The Corcoran Gallery of Art catalog, October 1967.

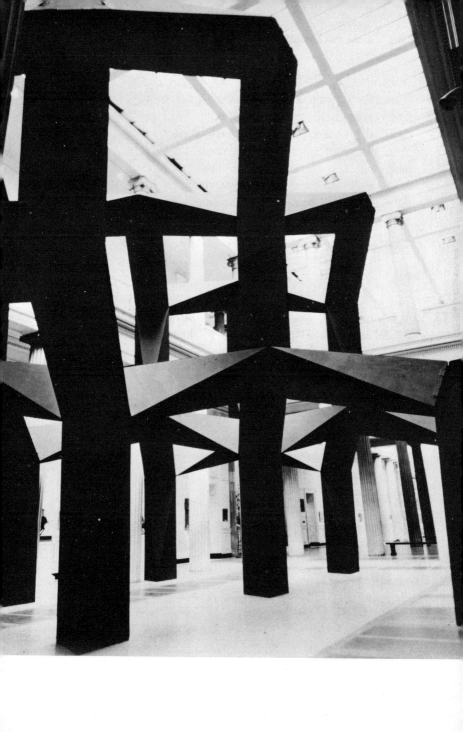

Grosvenor's Illusionist Sculpture

Grosvenor's defiance of gravity is spectacularly embodied in two remarkable cantilevered structures made in 1965. *Tapanga* is composed of a square plywood post which rises vertically over nine feet high, abruptly folding over to a slant at a 60-degree angle and stopping some feet above the floor. This feat is made possible by steel cables concealed within the post which, bolted to the floor, uphold the great slanted beam.[1] Its complementary opposite, *Transoxiana,* is an angled beam sweeping down from the ceiling and suspended by

[1] David Bourdon, "The Cantilevered Rainbow," *Art News,* Summer 1967.

Robert Grosvenor: *Tapanga.* 1965. Wood, polyester, and steel. 9' × 21' × 3'4". Photograph courtesy of Paula Cooper Gallery, New York.

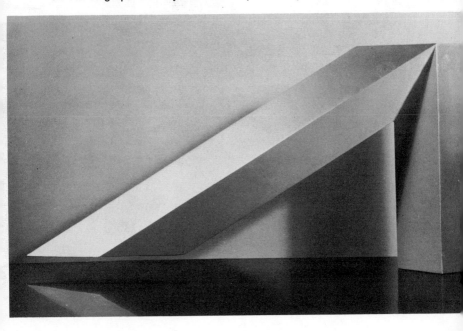

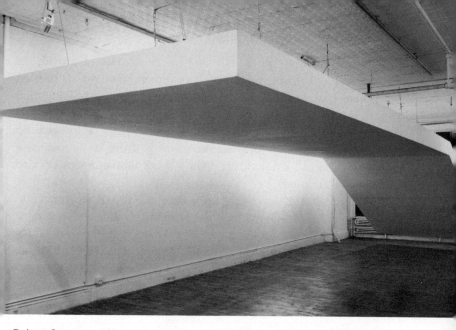

Robert Grosvenor: Untitled. 1970. Steel and wood painted white. 10′ × 40′.
Photograph courtesy of Paula Cooper Gallery, New York.

channels, "teasingly missing the floor by inches."[2] While Bourdon is
in admiration of the appearance of effortless sweep of the cantilevers
"engineered with clean precise lines," Burnham finds that *Trans-
oxiana*'s "switch of gravitational orientation destroys not only the
base, but the spectator's sense of 'up' and 'down.' " Why not?

Barbara Reise's contention that the constructions of Grosvenor
and Bladen are less rich "conceptually" than those of Judd, Flavin,
Morris, Andre and LeWitt[3] prompted Grosvenor's admirers to a
redefinition of him as a "perceptual" artist. This, however, is not a
satisfactory alternative.

Grosvenor was undoubtedly inspired by illustrations of so-called

[2] Jack Burnham, *Beyond Modern Sculpture* (New York: George Braziller,
1968), p. 431.

[3] Barbara Reise, " 'Untitled 1969': A Footnote on Art and Minimal-Style-
hood," *Studio International,* April 1969.

impossible triangular figures. His impossible cantilevers provide us with information obtained from the two-dimensional world. Illusion in sculpture has existed since the Greeks represented a walking man by posing him with one foot in front of the other. The question remains: Are the L-shaped beams of Robert Morris, which give no information that cannot be obtained directly from a three-dimensional world, richer conceptually than a work that provides us with additional information?

The prerequisite of a work of art is uniqueness, not self-reference. For a work to be considered "absolutely modern" means that it must inform modern man (not the ancients). By reappraising the controversy between illusionist and self-referent art in terms of information, we rid ourselves of difficulties arising from the belief that abstract art can be validly subdivided into conceptual and perceptual art.

N.C.

Ronald Bladen's Dramatic Expressionism

Ronald Bladen, along with George Sugarman, David Weinrib, and the painters Al Held and Knox Martin, participated in an important show labeled "Concrete Expressionism," held in 1965 at the Loeb Student Center of New York University. According to Irving Sandler, who organized the exhibition, these artists express themselves in terms of structural lucidity derived from Stuart Davis and Fernand Léger and the Cubist-oriented geometric abstraction of the thirties.[1] Since the more recent work of Bladen achieves a high degree of iconic lucidity, my own preference would be to account for his expressionism in terms of the geometric figures he has been constructing. Bladen uses forms to act upon the environment, much the way a character acts upon a stage. His expressionism tends to be dramatic. With

[1] Irving Sandler, *Concrete Expressionism* (New York: New York University Press, 1965).

Barnett Newman and Tony Smith, Bladen was included in an otherwise excellent show which, unfortunately in my opinion, was keyed to the idea of "Scale as Content," held at Washington's Corcoran Gallery of Art in 1967. A more apt title would have been "Dramatic Abstraction" or "Dramatic Expressionism." By emphasizing scale, attention is concentrated on the inter-reaction of figure and environment. As the preface to the exhibition has it: "The kind of scale that acts as content is not simply a matter of size and proportion, it is a function of the way the forms appear to expand and continue beyond their physical limitations, acting aggressively on the space around them and compressing it."[2]

Bladen has said in an interview: ". . . What I am after is to create a drama out of a minimal experience—to make use of it in terms of geometrical construction." What is he after? "Space, dramatic relationships, excitement."[3] Contemplating a huge, precariously poised sculptpure of Bladen, one may well ask oneself: How did he do it? As of 1967, Bladen gave the answer: "I try not to make the inside of the sculpture known. . . . The rods and weights, the column and the buttress—all those parts that hold the work up—were necessary for just that." As Eleanor Green so pertinently and vividly puts it in her comment on *X,* which, "hovering slightly off the floor, is built in an absurd, impossible defiance of architectural principles." She sees it as a "hypnotic piece" which from within the structure "is a place of shelter with the aura of a dolmen, from without the arms soar into the air, extending beyond their own length to fill the space of the atrium."[4] The Corcoran catalog included a comprehensive photograph of the armature of the structure of *X* with its interlaced and bolted parts, to be covered eventually by a plywood skin. Bladen, it appears, enjoyed constructing works that "eventually would become a hidden private sculpture."

[2] Eleanor Green, "Scale as Content," The Corcoran Gallery of Art catalog, October 1967.

[3] Bill Berkson, "Ronald Bladen: Sculpture and Where We Stand," *Art and Literature,* Spring 1967.

[4] Green, *op. cit.*

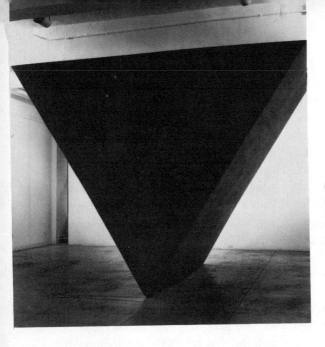

(*Left*) Ronald Bladen: *Black Triangle.* 1966. Painted wood (to be made in metal). 9′4″ × 10′ × 13′ across top. (*Right*) Ronald Bladen: *X.* 1967. Wood. 22′8″ × 24′6″ × 12′6″. Photograph courtesy of Fischbach Gallery, New York.

Bladen's aesthetics run counter to the prevailing purist view which requires that all constituent parts of a sculpture be exposed. A most attractive feature of old Russian wooden churches was in the fitting of logs together without benefit of nails. Would the purists of today consider that Greek temples are inferior to the log churches when their marble joints have been strengthened by metal cramps?

The three oblique parallelepipeds spaced regularly back of one another (*Untitled,* 1965) manifestly defy gravity. The ambiguity of form is startlingly exemplified in *Black Triangle* (1966). Frontally it is an overturned triangle, seemingly a side of a pyramid posed on its vertex. Moving sideways, one perceives a rhomboid plane and recognizes the solid as being not a pyramid but a prism. To the challenge presented by gravity and form must be added that of space. In *X* (1967), his most dynamic work to date, the opposite thrusts of the two triangles are camouflaged by a common rectangular trunk. When focusing on the trunk, the form suddenly appears as a figure with

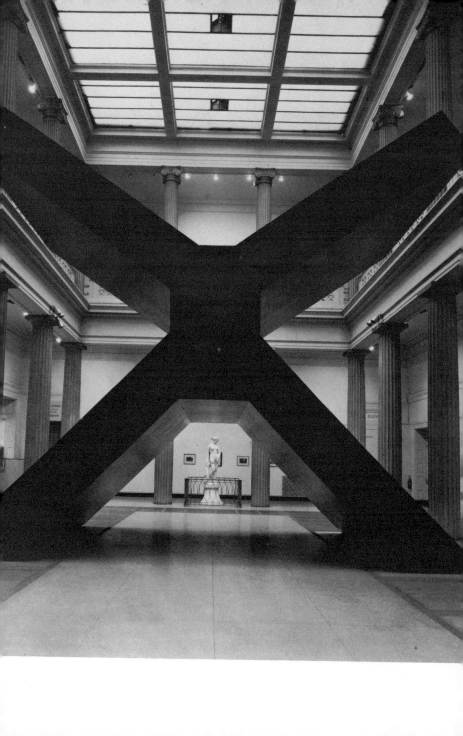

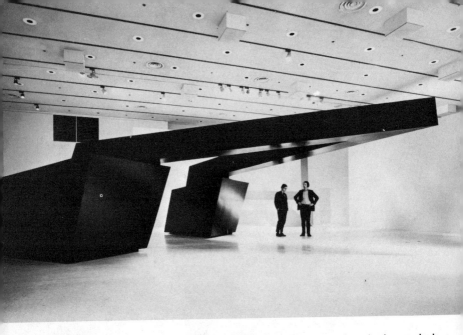

Ronald Bladen: *The Cathedral Evening.* 1969. Wood mockup (to be made in steel). 10′ × 29′ × 24′. Photograph courtesy of Fischbach Gallery, New York.

limbs forcefully thrust out. As shown in the great hall at the Corcoran, it evoked Samson shaking the pillars of the temple.

<div align="right">N.C.</div>

Liberman's Many Faces of the Cylinder

Sculpture reduced to a flat plane is but a constructed picture plane. As has been known since the Renaissance, optically the picture plane is a section of the visual cone. Seeking to avoid a picture-plane effect, Caro substituted the horizontal axis for the vertical one, but got bogged down in the problem of perspective as in his *Homage to David Smith*. To escape these twin pitfalls inherent in Constructivism, the artist must construct "cubistically" by coordinating four different viewpoints.

It is not a coincidence that the painter-sculptor who solved the problem in the most satisfactory way should also be an outstanding photographer. It seems to me that Liberman's first attempts to free the picture plane from being viewed as a section of the visual cone of a single eye can be traced back to a painting made in 1952, *Exchange*. This work is indebted to Malevich, more specifically to *Suprematist Composition: Red Square and Black Square*, which consists of two dissimilar squares set at a slight angle to each other and clearly intended to be seen as a synthesis. Liberman, on the contrary, resorts to juxtaposition, implicitly dividing the painting in half vertically by means of the two disks and horizontally by means of the two dots set between the disks. It follows that each of the disks tends to be seen as a distinct image, corresponding to a section of the visual cone of each eye of the viewer. In *Continuous on Red* (1960) the

Alexander Liberman:
Continuous on Red.
1960. Oil on canvas.
Tondo 80″ diameter.
Photograph courtesy of
Andre Emmerich Gal-
lery, New York.

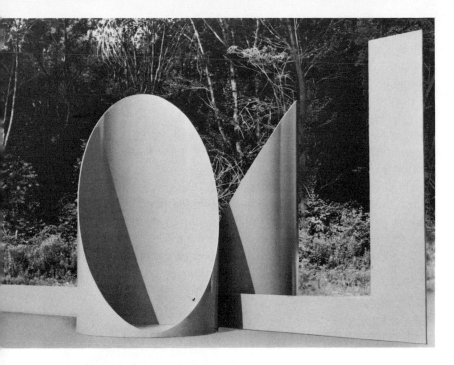

Alexander Liberman: *Bond.* 1969. Painted steel. 7′7″ × 8′5″ × 18′6″. Photograph courtesy of Andre Emmerich Gallery, New York.

problem is presented in a tondo. Two disks, one black, one blue, each with a satellite, are pulled by the satellites in opposite directions, one northwest, one southeast, along parallel chords.

The application of this principle to sculpture was satisfactorily carried out by Liberman in his 1969 constructions based on the cylinder. Earlier he had used a disk as a vertical plane in conjunction with a great coiling tube abutting at the disk. By mentally retracing the sinuous path of the tube to and from the disk, the viewer's eyes move back and forth, instead of merely regarding the sculpture frontally as in the case of David Smith's disks. Suddenly realizing that the disk and the tube could be replaced by the cylinder and its sections, Liberman went on to construct superbly articulated sculpture.

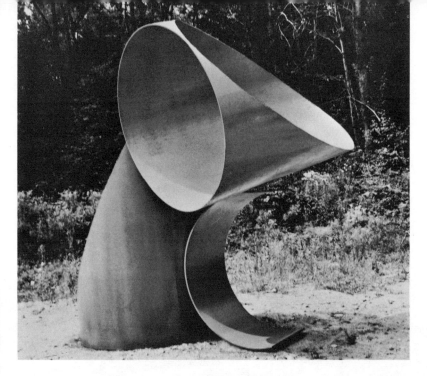

Alexander Liberman: *Free*. 1969. Painted steel. 7'7" × 8' × 7'7". Photograph courtesy of Andre Emmerich Gallery, New York.

In *Bond* (1969) two identical cylinders with slanting ellipses are presented jointly, front to profile, bolted to a horizontal section of an L passed between them. The four sides of the sculpture can be mentally reconstructed from any vantage point since each cylinder is recognized as the pregnant form of the other. To the parallactic view of Renaissance sculpture, Liberman substitutes what I am tempted to call a "diachronic" view of the four sides. *Free* (1969) is composed of two cylinders with slanting ellipses and the curved band of a third one. The crescent-shaped band stands back to back with the vertical cylinder supporting at a convex angle the horizontally placed second elliptical cylinder. Thus, from one vantage point, the viewer can see simultaneously a crescent, an ellipse, a circle, and deduce the pres-

ence of the second ellipse. *Eros* (1969) includes both integral and elliptical cylinders, its name calling attention to basic complementary images suggested by the two variants.

The interplay between solids and space is most felicitously achieved in the graceful and compact *Free*. All three structures are entirely original although built of familiar geometric elements and make manifest the superiority of Liberman's solution over plane and perspective approaches.

N.C.

Alexander Liberman: *Eros*. 1969. Painted steel. 91″ × 144″ × 138″. Photograph courtesy of Andre Emmerich Gallery, New York.

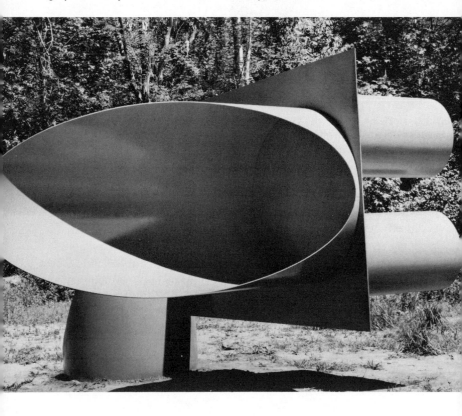

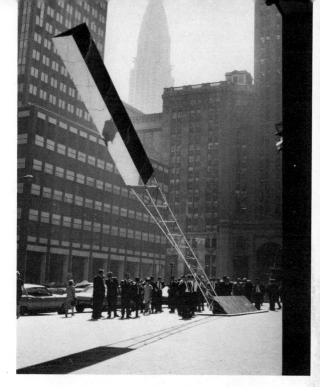

David von Schlegell: Untitled. 1966. Aluminum and stainless steel. 43′ × 4′ × 16′. In the collection of Larry Aldrich, Ridgefield. Photograph courtesy of the artist.

David von Schlegell's Projections in Motion

In contrast to Tony Smith, who likes to give names to his sculptures that encourage whimsical associations, von Schlegell rejects the notion that his forms resemble concrete objects, natural or man-made. The artist sees certain of his forms as "projections in motions," apt to challenge gravity.

It is hard to believe that his *Twisted Column* (1963), made of industrial maple plates riveted together, maintains balance, as it does, without the aid of armature. The curvilinear column is projected into space while held up at an extreme point of its base by a metal channel connected to an overturned L-shaped ground piece, unexpectedly small. From one vantage point, the oddly angular column displays its S-shaped body with the grace of a Mannerist sculpture.

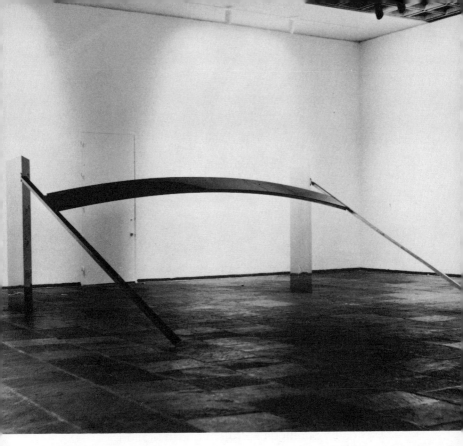

David von Schlegell: Untitled. 1967. Stainless steel. 17′ × 16′ × 7′. In the collection of the Whitney Museum of American Art, New York. Photograph courtesy of the artist.

More unexpected is his slanted triangular, seemingly top heavy metal column, somewhat twisted at its base. It cuts the field of vision diagonally. When exhibited on Park Avenue in New York City it introduced into the cityscape that note of tension which we generally associate with a functioning crane. But von Schlegell is a poet and his column sings a silent defiance of gravity.

Structurally minimal is the skeletal stainless steel of 1967, some-

what reminiscent of a hangar. The sides are outlined by two orthogonal triangles joined by a narrow arched band which unifies the structure by spanning the distance between the parallel hypotenuses. Von Schlegell has sought to achieve an aesthetic effect which overrides functionalism: by placing the arched band somewhat below the apex of the triangles and raising the verticals above the hypotenuses, von Schlegell erected a structure of compelling unity while preserving the visual autonomy of its geometric parts: triangles, parallel verticals, parallel obliques, arc.

Kenneth Snelson's Stress Structures

Snelson should be distinguished from Constructivist sculptors in that he concentrates on the tension-compression which holds a structure together. In Snelson's terms, the main interest presented by the pyramid is that it is held together by the pull of gravity while that of the balloon lies in the balance between gas expansion and the container's compression. With the mass production of cables and aluminum tubing, Snelson found at his disposal materials solid and light enough to construct free-standing structures, networks of tension-compression. (The bicycle wheel with its network of wires has been suggested as a forerunner.) Snelson was the first to expose a stress-structure for aesthetic appreciation.

One of his simplest yet entirely effective pieces is *Untitled* of 1967. It is made of four hollow tubes of equal size connected by cables to the ends of the tubular poles. Three of the poles stand at the corners of an ideal triangle: instead of converging to form the apex of a pyramid, they diverge, two pointing southward, one northward, to form a larger and complementary opposite triangle at the top. The structure is bolstered by the fourth pole, set horizontally and supported by cable and one pole, supporting in its turn the two parallel poles which rest against it.

Cable and tubes outline various polyhedra which are apt to be visually contradictory, making the structure agreeably perplexing.

Kenneth Snelson: Untitled. 1967. Stainless steel. 10'6" × 8'. In the collection of the Whitney Museum of American Art, New York. Photograph courtesy of Dwan Gallery, New York.

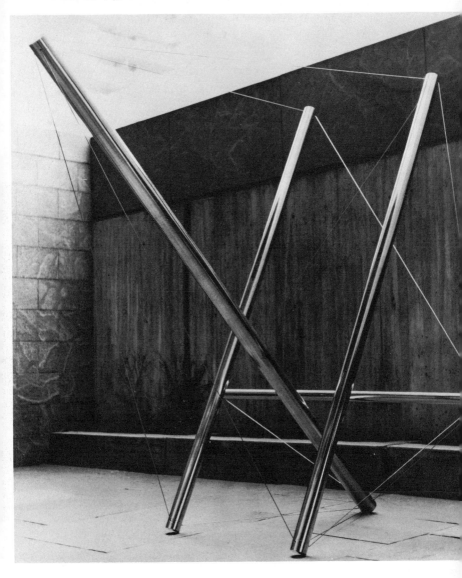

Certain pieces are of sufficient complexity to cause the viewer to lose track of the configurations. At first sight a work such as *Fair Leda* (1968) may strike us as delightfully airborne but difficult for the eye to unravel. The composition acquires focus when we come to realize that it is formed of the skeletons of four kites, each consisting of two crossed sticks and a wire frame, and, additionally, a single pole suspended in midair. Of the four kites, only one is actually completely

Kenneth Snelson: *Fair Leda*. 1968. Aluminum and stainless steel. 12′8½″ × 18′5″ × 10′10½″. Private collection, New York. Photograph courtesy of Charles Uht.

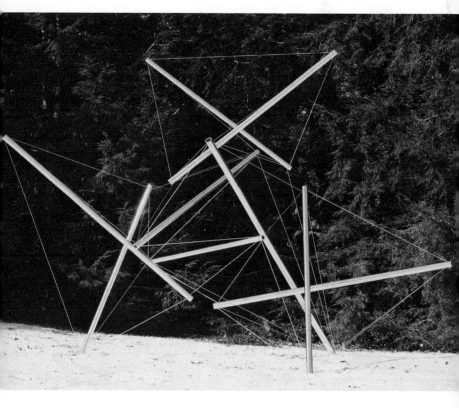

off the ground. The mental image of a cluster of kites incapable of rising challenges our first impression of lightness. Are we expected to overlook the contradiction by visualizing the sculpture as capturing space in a field of tension?

Explaining that his true disposition is that of a Romantic, Snelson has recently undertaken to do away with the modular continuum system, replacing its obviousness with an Expressionist irregularity of structure.

The Phenomenological Approach

Joseph Albers' famous dictum that it is more difficult to see in two-dimensional terms than in three misleads by implying we can obtain direct information about things by looking at a picture plane. Through perception we obtain information about objects and events.[1] Information received through perceiving a design on a wall or a canvas comprises only one feature of a three-dimensional object. Likewise, information obtained from perceiving a carved stone or the layout of a metal sculpture is only information about the shape of a three-dimensional object. The aesthetic value of the information acquired from the study of a pattern, a patch of color, or a heap of objects can be appraised only after we are able to include it in a given frame of reference, such as that of degrees of order or disorder. This is equivalent to saying that a recognized pattern is an image of a certain category of order. Since we obtain only indirect information about objects through images, an artwork, whether or not limited to providing us with information about a category of order, should not be confused with an object from which we can obtain information about itself, through direct perception. Furthermore, as images of order or disorder may induce pleasant or unpleasant effects, it is as arbitrary to declare that a work of art can be appraised without taking into consideration emotional reactions, as it is to claim that the work of art is a self-referent object.

When Georges Vantongerloo writes that "to create means to materialize, hence to arrive at ONE,"[2] he is viewing the work of art in strictly structural terms. In abstract art Vantongerloo explains,

[1] James J. Gibson, "New Reasons for Realism," *Synthèse,* June 1967.

[2] Georges Vantongerloo, *Painting, Sculptures, Reflections* (New York: Wittenborn, Schultz, Inc., 1948), p. 16.

"The principle of unity consists in finding the elements of some geometric form or algebraic equation and creating a new geometrical form which has (sic) the elementary form as the basis of its unity."[3] Yet, for Vantongerloo, creation is not reduced to mathematics, for he adds "the greater one's knowledge of geometry, the greater one's possibility of creative invention." From this artist's point of view it would follow that a known primary form, such as a cube or a sphere or its subdivision into sections, would not be a work of art.

Unlike Vantongerloo or Max Bill, American sculptors such as Robert Morris or Donald Judd believe that artists should construct elementary forms rather than derive new ones from them. To the sculpture of the Cubists and the Constructivists Robert Morris opposes a new kind that "takes relationships out of the work and makes them a function of space, light, and the viewer's field of vision."[4] For Morris the work is "autonomous in the sense of being a self-contained unit for the formation of the gestalt." He qualifies this by saying "the major aesthetic terms are not in but depend upon this autonomous object, "adding that these major aesthetic terms "find their specific definition in the particular space and light and physical viewpoint of the spectator." Morris believes that through this change of aesthetic point of view the object does not become "less important" but "less *self*-important." To the structure of the Cubists he opposes placement in a setting: "For example, in much of the new work in which forms have been held unitary, placement becomes critical as it never was before in establishing the particular quality of the work. A beam on its end is not the same as the same beam on its side."[5]

Since information received through perception of the object cannot be limited to perception of its form, the difference between the perception of a beam on its side and a beam on its end is a difference

[3] Vantongerloo, *op. cit.*, p. 20.

[4] Robert Morris, "Notes on Sculpture," in *Minimal Art,* ed. Gregory Battcock (New York: Dutton Paperbacks, 1968), p. 232.

[5] Morris, *op. cit.*, p. 235.

between two events that happen to a beam. Events that can happen to a beam or a cube may be of theatrical interest, but they are not, strictly speaking, of sculptural interest. Instead of going beyond Cubism Morris and his friends simply abandon sculpture to develop a new type of Happening.

Theoretically, Morris avoids the issue by examining objects in terms of "the viewer's field of vision." Morris and his friends expect their works to be comprehended in terms of scientific myths that avoid telling us what we see or how things we see are made, in order to explain how our field of vision is structured. Structural analysis is now substituted for a stylistic one, the latter being considered too instrumentalist, too obsessed with craftsmanship and with the handling of the artist's tools, his stylus, brush, or chisel. In the name of thingness, illusionistic effects are banned to enable the object to "assert its own existence," to quote Donald Judd. However, according to Rosalind Krauss, Judd's own sculpture cannot be fully appreciated "by means of a list of its physical properties, no matter how complete."[6] We should not draw the conclusion from this that Miss Krauss is against a strict structural analysis; being a phenomenologist she replaces the structure of the object by the structure of the phenomenon. Her task was made easier by Merleau-Ponty's "Primacy of Perception." From him Rosalind Krauss learned that perception "is given as the infinite sum of an indefinite series of perspectival views in each of which the object is given, but in none of which it is given exhaustively." Miss Krauss believes that she can account for Donald Judd in phenomenological terms. In a study of one of his wall-piece sculptures she notes that before she realized that its short violet bars supported the continuous aluminum one she thought that it was the larger bar that supported the smaller ones. What she is actually saying, without perhaps realizing it, is that she had at first made a mistake. Her error is similar to the one made by a beholder who mistook a round platter held in a tilted position for an elliptic one. As

[6] Rosalind Krauss, "Allusion and Illusion in Donald Judd," *Artforum,* May 1966.

Gilbert Ryle has pointed out in his devastating criticism of phenomenology: "When someone looks at a plate, tilted away from him and sees it as elliptical, all that he is doing is seeing a plate that has an elliptic look."[7] Ryle concludes that there are not two kinds of elliptical objects, namely some platters and some looks, just as when we say that someone has a pedantic appearance we do not mean that there are two kinds of pedantic beings.

Unlike Rosalind Krauss, Barbara Rose seems to adopt Judd's view of object art for she says that an "object" should be considered as "nothing more than the total series of assertions that it is this or that shape and takes so much space and is painted such a color and made of such material." As for the present writer, he always thought that what distinguishes a being from an object is that the former can assert whilst the latter cannot! If Barbara Rose means that it is the artist or the viewer who asserts, then the object asserts nothing and her statement is meaningless.

In contradistinction to the artist, the believer, when alluding to the supernatural power attributed to a magnet or a cross, is justified in saying about the object that "it manifests itself." Likewise, speaking of the exceptional qualities of a particular diamond the connoisseur may rightly claim that it manifests the brightness that is required from such stones. The objects made by the Minimalists not only cannot be compared to either crosses or diamonds—for they are neither magical nor exceptional—but also cannot be identified with those mathematical objects that scientists construct to demonstrate the properties of lines and planes projective geometry discovered in forms such as cones or dodecahedrons. The latter are intended to be viewed as models of forms rather than as objects in themselves. The objects of either Minimalists or Maximalists remain objects, regardless of whether they are homologous to nudes or cubes. They have been made to be included in the world, not just to transmit information about forms discovered to exist in the world (as are the constructions devised by mathematicians or biologists).

[7] Gilbert Ryle, *The Concept of the Mind* (New York: Barnes and Noble, Inc., 1959) Ch. 7, No. 3.

In a recent article[8] John Chandler defends redundancy in the name of phenomenology. As an example of the genre he reproduces a work by Eva Hesse, consisting of 12 parallel rows of 12 hemispheres forming a square set in a slightly larger square sheet of latex. From a phenomenological point of view, says Chandler, a sentence repeated over and over again may still be meaningful although it conveys no new information in repetition. He therefore must dismiss the case when the repetition many times over of a unit, sentence, paragraph, series of shapes, figures, or sound is a unit transmitting information about a structure that includes elements of redundancy, as is the case in poetry, in modern French novels, in paintings, and in music. But if redundancy is to be isolated and examined as a total in itself, analysis will at some point discover differences between objects and their sequence for the simple reason that no two things or two moments are ever identical. If the discovery of the differences is so minute that it cannot be discerned by our eyes or ears, the redundant unit should be dismissed as unworthy of attention. To like redundancy for redundancy's sake is tantamount to preferring sameness to difference and boredom to surprise.

What Morris is actually doing when, inspired by an example though not by the teaching of Wittgenstein, he constructs the projection of a cube, is to indicate by association that his trapezoid stands for a cube since this is how a cube is represented in painting. When he inserts a neon light into the narrow space separating two planes, he is transforming the demarcation line into a source of light. In the second instance it could be said that the artist inserted his assertion into an object.

The historically minded critic might be led to believe that Merleau-Ponty's theory of the primacy of perspective is to our time what the doctrine of the true perspective was to the Renaissance. Alberti provided his contemporaries with a method for measuring the ratio of increase and decrease in size according to distance. From the standpoint of Masaccio the weakness of his predecessors was a lack of

[8] John Chandler, "Art in the Electric Age," *Art International*, February, 1969.

awareness of the relation of perception to object. In their faith in the primacy of perception phenomenologists failed to realize that "there is no unique and central problem of perception."[9]

In contradistinction to the object-artist, Braque, when he tilts a round table, does not do so to make us believe that it is elliptical, he does it to reduce the semblance of distance between the table and the back wall. When Marcel Duchamp on his *Glass* draws a cube rather than a trapezoid projection of a cube, he expects us to include what we see behind the glass in our view of the objects depicted upon the glass. Like Cézanne, Braque and Duchamp do not make objects, but works homologous to reality. Actually, these no more help explain Cézanne's work than the supposition that El Greco suffered from astigmatism was relevant to the latter's.

Cézanne criticized Monet for neglecting the solid aspect of the landscape, while in our day Robbe-Grillet avoids describing the secondary qualities of objects such as color and light in order to concentrate all his attention on the structural elements of the events that he is reporting. In contradistinction to Cézanne and the phenomenological-minded Robbe-Grillet, the object-minded artists are not constructing a view that is homologous to that of real objects but are constructing real objects. From Rosalind Krauss' description we deduce that Judd's wall sculpture differs from its architectural prototype in that the artist undertook to mislead the observer. Rosalind Krauss suggests that Judd deceives with subtlety, for she says about his hanging sculpture that "the assumption that the apparently more dense metallic bar relates to the startling sensuous, almost voluptuous lower bars as a support from which they are suspended, is an architectural one, a notion taken from one's previous encounters with constructed objects and applied to this case." In other words, Miss Krauss came to believe that the small bars were suspended from the big one because she was so fascinated by the fact that they looked voluptuous that she did not notice that it was they which actually supported the big bar. Apparently what made these bars look so voluptuous was their color, first referred to as translucent violet, then

[9] Ryle, *op. cit.,* Ch. 8, no. 4.

as purple. From a structural point of view such as Cézanne's, color is a secondary quality. When the object sculptor relies upon color or light to produce his best effects he is reviving Impressionist methods. In contradistinction to Monet, who escapes from reality to sing a song of colors, the object sculptors use color and light to mislead us in our appraisal of the object.

In the name of the primacy of perception, Robert Morris claims that unformed objects could potentially be used as well as perfect cubes and that rags can have as much value as bars of stainless steel. This theory was put into practice in a much publicized exhibition of Anti-form art, held in a Castelli Gallery warehouse, a painter splashed liquid lead over a section of the edge formed by floor and back wall. Only a naïve visitor could attribute this stain to an accident, for the room was filled with things carefully isolated from each other. Viewed as an object, the stain of lead interrupted the continuity of the clear line separating floor from wall. But, when reexamined in terms of an artist's work, this same stain could be compared to an oral ejaculation that, by its suddenness, interrupts a speech. Unless the oral interruption is followed by a statement, its effect remains ephemeral. The "floor piece" of another artist consisted of a soft material that could serve as a doormat, as a wall piece, or could be folded in two or four parts or rolled up and carried away. When an object, stain, or rag is not comprehended in terms of structure, it is usually envisaged as material that eventually could be structured, the way clay is when the sculptor molds it, or stone is when he hews it. To claim that this raw material is itself an art object is like asserting that the ink in a bottle is a poem. One might as well declare that the plot of the unwritten novel is in itself a work of art and that the space devoted to a statue is a masterpiece. The trouble with this version of the emperor who wore no clothes is not that he was naked but that the naked man was not an emperor.

Historically Monet's greatness lies in having freed art from the structure of the good gestalt Manet had fought to preserve. Abstract Impressionism is reduced to the interpretation of forms, whether good or bad. But wherein lies the interest?

Understanding of objects is achieved by gathering information about their structure; this is a scientific procedure. Unlike the scientist, the artist is fascinated by the mystery of the object. He interrogates it and conveys his uncertainties about it by means of a deeper structure that serves to transmit his message. It remains for the inquiring viewer to interpret it.

Constructivist artists delude themselves when they claim that by reducing art to structure they have carried the pioneer work of Cézanne to the heights of musical abstraction. There are no such summits. Music is to gesture what painting is to the image. When Rauschenberg replaced the serial order of images with a random assemblage, he did for imagist painting what John Cage did for music, he interrupted the series with noise. But interruption, *per se* (split liquids or dropped materials), is not comprehended artistically in terms of structures. Anti-form art is not a new art game of sculptors but a new hunting game that could eventually lead to the use of new material for a new type of sculpture.

The structural concreteness of an art nonhomologous to a reality, real or fantastic, will be but a false concreteness unless it conforms to the artist's emotions and can be interpreted as a structured expression of his attitude.

We should not deduce from this that the construction of basic geometric or biomorphic forms, the spreading of monochrome effects over the whole canvas, and the repetition of monotonous patterns reflects mysticism, as some critics believe. To the extent that mysticism aims at establishing a direct system of communication between the individual being and the Universal Principle, the artistic work of the mystic is a negation of an attempt at mystic communion, for it is an assertion of the being's individuality at the expense of the annihilation of his self before the Absolute. For the union to be mystic the poet must be silent and the icon invisible. Mystic interpretations of the work of Reinhardt, Stella, Robert Morris, and their followers are aesthetically meaningless, as were earlier attempts (often encouraged by some of the artists themselves) at explaining the work of Kandinsky, Malevich, Mondrian, and Arp in a similar frame of reference.

What is contrary to an evolutionary view of history is the endeavor to revive in our time the antiquated faith in universals of occidental and oriental mystics.

N.C.

An Impressionist Approach to Geometric Forms
(Morris and Judd)

In the sixties the cube became for sculptors what concentric circles were to field painters, an archetypal icon. Boxes in modern art are traceable back to Marcel Duchamp's *Green Box*. Cornell's boxes were influenced by Man Ray and Max Ernst. Sculptors such as Tony Smith and Isamu Noguchi were held in high esteem, the former for his steel *Black Box* (1962), the latter for his *Life of a Cube* (1962). The Minimalist Walter De Maria has payed homage to Joseph Cornell's boxes with one of his own, entitled *Blue Glass for Cornell* (1966). Warhol's *Brillo* boxes were honored as cubes (Stable Gallery, 1964), while the square units of Carl Andre's floor pieces have been described as flattened cubes by at least one critic.

Wittgenstein pointed out that the two ways of seeing the projection of a cube in a drawing correspond to two different facts: the perception of the four interrelated parts in terms of either the back view or the front view. On the basis of the above, a sculptor could draw attention to the two or more ways of seeing an actual cube by introducing "facts" which accentuate the difference between its constituent parts. With Wittgenstein's explanation, we are able to cut through the maze of difficulties ensnaring critics who discuss the new sculpture either in terms of phenomenology (Merleau-Ponty) or structural analysis.[1]

ROBERT MORRIS

Robert Morris is by far the most ingenious sculptor of elementary forms. A clue to the understanding of his thinking in the early sixties is provided by a small wood sculpture which features three yardsticks, all uniformly gray, one slightly differing in length from the two

[1] Marcellin Pleynet, "Peinture et Structuralisme," *Art International,* November 1968, pp. 29–32.

others. Our difficulty in recognizing the true measure from the false stirs our curiosity. In *Document* (1963) of the same period, Morris includes a notarized statement in which he declares that he withdraws all aesthetic quality and content from a certain earlier work. Morris thus establishes a difference between an artist's repudiation of a work and a disavowal of its aesthetic qualities. Since this disavowal is presented as an oeuvre in its own right, we are confronted with a more intricate version of the problem posed by the *Three Rulers* (1963).[2]

Both *Three Rulers* and *Document* were inspired by Marcel Duchamp: the former by *Standard Measure,* the latter by *Check to Tsanck* (rhyming with "junk"). Morris' delightful box titled *Heart* (1963), which contains a frail pulsating mechanism, surely echoes Duchamp's *Secret Noise.* Morris' *I-Box* (1963), opening to reveal the artist fully naked, is neo-Dada in spirit; but to the aggressivity of the Dadaists it substitutes the narcissism typical of the Rivers-Rauschenberg generation.

The most revealing of Morris's narcissistic manifestations was the dance that he choreographed and performed with dancer Yvonne Rainer in which the naked pair, pressed against each other, walked at a snail's pace along narrow wooden tracks.[3] In his penetrating article on Robert Morris, David Antin points out "the fact of their being pressed together, concealing each other, and the simulated danger of falling from the tracks renders them naked."[4] In other words, nakedness is but anticipated by spectators, for while the two dance, they are in that state of aesthetic grace called "nudity." Thus, had they in fact fallen from the tracks, spectators would in retrospect view them as naked all along since by falling they proved themselves incompetent performers incapable of transforming nakedness into nudity. A complementary opposite of nakedness is secretiveness. Better than any other artist of our century, Duchamp knew the importance of making a work enigmatic: enigma is the outward or aesthetic form of a secret.

[2] Nicolas Calas and Elena Calas, Introduction to "Hard Center," group exhibition at Thibaut Gallery, New York, 1963.

[3] First produced at the Judson Church, New York, 1966.

[4] David Antin, "Art and Information, 1 Grey Paint, Robert Morris," *Art News,* April 1966.

By the mid-sixties Robert Morris was concentrating on exposing the nakedness of his objects. Plastics and synthetic paints enabled the artist to expose the geometric nakedness of solid forms more precisely and sharply than ever before. In reference to Morris' 1965 ensemble of four fiber-glass polyhedra, painted dull gray, David Antin held that, since the pieces were of plastic and had no joints, there was no visible point at which the coat of paint left off and the material began. Likewise, when Morris introduces fluorescent light into gaps between solids, split rings or parallel polyhedra, he is able to expose narrow cracks that heretofore had been left in shadow.

Among Morris' most curious cubes are four low-standing mirror boxes; being of lead, the cubes themselves were barely visible at their exhibition but their reflection of the surroundings displayed the inter-

Robert Morris: Untitled. 1965. Gray fiberglass and light. 24″ × 96″ in diameter. In the collection of John Powers, Aspen. Photograph courtesy of Leo Castelli Gallery, New York.

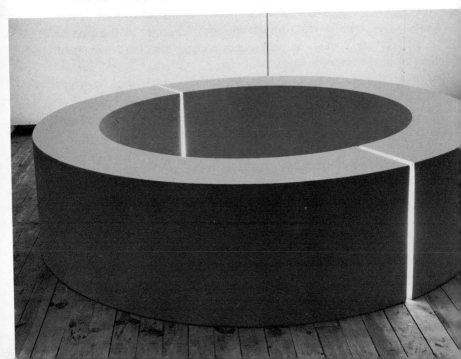

Robert Morris: Untitled. 1967. Steel. 31″ × 109″ × 109″. In the collection of Burt Kleiner, Los Angeles. Photograph courtesy of Leo Castelli Gallery, New York.

dependence between object and environment illustrative of Morris' contention that one should not seek for "major aesthetic terms in the object itself for these exist "in a particular space and light."⁵ This interdependence was expressed quite differently but equally eloquently in the concave and convex structures of steel mesh (1966–1967). Due to the high shine of the mesh's links, especially those of the concave sculpture, quasi-Impressionist refractions of light cannot fail but to delight one. Structurally the more interesting sculpture is the one that might be referred to as the "lobster trap," a combination of two "boxes," an inner square one without lid or bottom, and an outer closed one with convex sides curving to join the edges of the inner square. Through the mesh one admires the elegant outline of the corner triangles with their convex hypotenuses, bands which hold the parts together.

Mesh served the versatile artist as transition between hard and soft

⁵ *Ibid.*

Robert Morris: Untitled. 1968. Felt (tan). Ten strips, each 6″ × 12″. Photograph courtesy of Leo Castelli Gallery, New York.

forms. Ever since Greek maidens were draped in peplums and Baroque saints robed in satins, soft forms have fascinated sculptors. The historical importance of works such as Max Bill's *Endless Ribbon* (1935) and *Monoangulated Surface in Space* (1959) is to have replaced a garment's bronze folds by geometric curvature. In contradistinction to Bill, Morris is not concerned with topology and the geometric variations of pliable forms. Morris may well have consulted books of mathematical puzzles such as Steinhaus' *Mathematical Snapshots* with illustrations of raised pliable angles and curves formed by webbed surfaces, cords, and ribbons. Morris' soft sculptures of felt or earth are apt to be neat but are at times ostentatiously messy. His *Earthwork* (1968) is composed of ten different materials: earth, peat, brick, steel, copper, felt, aluminum, brass, zinc, grease,

gathered in a formless heap. In contrast, in a number of his felt pieces, strips of felt, identical in length, width, and color (untitled, 1967–1968), are hung from the wall and allowed to fall—more or less naturally—to the ground or are piled curling on the floor; in each case the felt strips are kept well within bounds.

Formalistically such works are without interest. Structuring implies subjecting material or mass to a recognizable and stable order; whenever the order is not recognizable, the work cannot be self-referent. Morris' soft objects are best described as samples of material (felt) or mass (earth). While his geometric sculptures give information on

Robert Morris: *Earthwork.* 1968. Earth, peat, brick, steel, copper, felt, aluminum, brass, zinc, and grease. Approximate size: 2′ × 5′ × 7′. Photograph courtesy of Leo Castelli Gallery, New York.

what happens to the image of a polyhedron when painted plastic has been made to comply to the structural requirements of a given order, his felt pieces only indicate the type of curves and folds characteristic of the material of which they are a sample. Morris no more forms a new order than does the salesman when elegantly unfolding some yards of goods before a customer.

To MOMA's end-of-the-year fun show entitled "Spaces" (1969) Morris contributed a "cubicle" enclosing four large metal cubes surmounted at the viewer's eye level by upward-rising triangular beds of earth or peat, planted with tiny spruces in regular rows as in a nursery. The cubes fill the four corners of the cube-shaped space, leaving just enough room for a crossroad. This walk is paved with metal, emphasizing the fact that in this artificial land, with light as hard as steel, earth is aboveground. Morris has a strong urge to contradict, in this case, quite probably De Maria, who brought a gallery down to earth by covering its floor with earth. The neat rows of spruces—with their needles—may well spoof system sculpture, specifically De Maria's steel *Bed of Spikes* (1969). In the process Morris seems also to have tidied up Hans Haacke's *Grass Cube* (acrylic plastic, soil, grass; 1967) and his *Grass Mound* (soil, grass; 1969).

Morris emerges as a theatrical personality, albeit a dancer of minimal steps on the floor as well as in theory. A most memorable performance of his was one in which he imitated the stance of an art historian behind the podium while his tape-recorded voice read an analysis by Panofsky which parallels his own thinking on concentration by isolation.

DONALD JUDD

Donald Judd renewed the image of the hexahedron with boxes of iron, steel, aluminum, Plexiglas, or a combination of some of these industrial materials. We note the subtlety of his variations by comparing three horizontal sleeve boxes, all three untitled, 1968. In one (anodized aluminum, 48″ × 61″ × 108″) Judd contrasts the rectangular open ends to the broad closed horizontal sides, the darkness

Donald Judd: Untitled. 1968. Anodized aluminum. 48″ × 61″ × 108″. Photograph courtesy of Leo Castelli Gallery, New York.

of the interior to the clarity of the outer surfaces. Notable in the second is the flatness of the twin boxes with a three-inch space between them, the width of the open sides and the relative thickness of the frames (anodized aluminum, 48″ × 120″ × 120″). The third consists of a steel box contained within a yellow Plexiglas box, yet forming but one sleeve unit, sealed as they are together at the frame (stainless steel, Plexiglas, 36″ × 84″ × 48″).

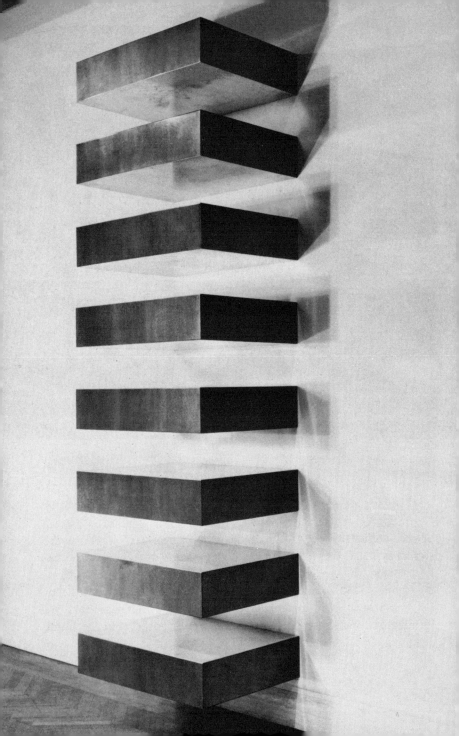

In yet another version Judd lines the bottom of the open box with a mirror. It would seem to be a mistaken idea: the role of the mirror is to provide information about objects it reflects, thereby deflecting attention from the object of which it forms a part, an object, in this case which is intended to be perceived in self-referent terms. Judd's series of identical stacked boxes, whether with sides of galvanized iron or of steel, with lids and bottoms of colored Plexiglas, vary in

(*Left*) Donald Judd: Untitled. 1966. Galvanized iron. Each unit: 9″ × 40″ × 30″. (*Below*) Donald Judd: Untitled. 1968. Anodized aluminum. 48″ × 120″ × 120″. (3″ between). Photographs courtesy of Leo Castelli Gallery, New York.

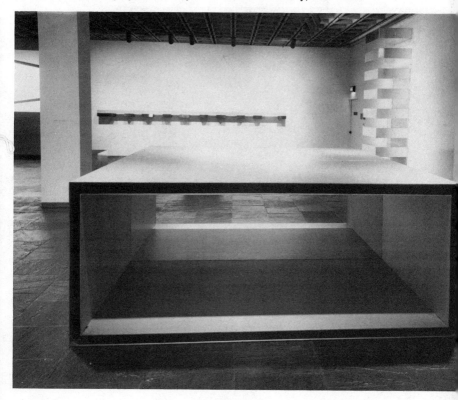

number of units and in the width of the interval between each unit. Barbara Reise aptly notes that "their light-sensitized transparency and reflective properties act as a visual dissolution of these volumes. . . ."[6] As with the mirror-lined box, the stacked sets thus cease to be self-referent, geometrically structured works and, in this instance, are likely to remind one of elegant Art Deco lampshades.

Prominent among the box makers are Sol LeWitt and Larry Bell. LeWitt's contribution is the open square frame; these multiple skele-

[6] Barbara Reise, " 'Untitled 1969': A Footnote on Art and Minimal Stylehood," *Studio International,* April 1969.

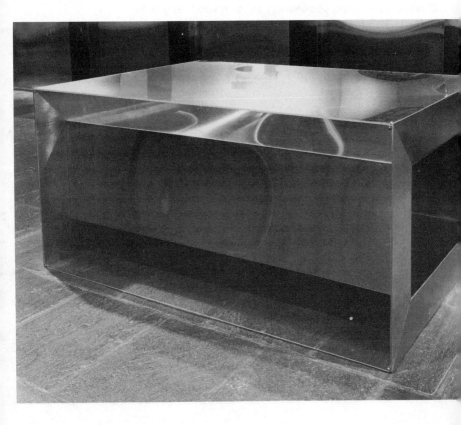

tal forms, combined or not with solid cubes, are characteristically of painted aluminum. According to John Coplans, Bell's metal-framed glass boxes-cubes "seem capable of absorbing light-energy indefinitely without reaching a saturation point."[7]

When an artist wishes to emphasize the originality of his repre-

[7] Coplans, *Serial Imagery* (Pasadena, Calif.: Pasadena Art Museum, 1963), p. 60.

(*Left*) Donald Judd: Untitled. 1968. Stainless steel and plexiglass (amber). 36″ × 84″ × 48″. In the collection of the Whitney Museum of American Art, New York. Photograph courtesy of Leo Castelli Gallery, New York. (*Right*) Larry Bell: Untitled (Terminal Series). 1968. Mineral coated glass with metal binding. 20″ × 20″ × 20″. Photograph courtesy of Pace Gallery, New York.

sentation of a geometric figure, he has to limit himself to elementary forms so as to make it possible for his public to recognize where the originality of his structure lies. While some commentators have interpreted the renewed interest in geometric figures as tinged by mysticism, the artists involved are in fact pragmatic individuals unconcerned with ideal forms or proportions (thus the contrary of Mondrian). The uniqueness of their versions of solids depends on the rendition of a geometric figure in a given industrial material. Judd's steel and plastic cubes have a closer affinity to Warhol's Brillo boxes than to a mathematician's cube. The latter is a presentation of a perfect form, while Judd's is a reconstruction of a geometric form in an industrial material, homologous to the model cube. The emphasis here is on qualities introduced into the object, not on the structure of the object as is the case with the Constructivists. Surface effects are to these artists what color was to the Impressionists while good gestalt is substituted for Chevreul's color theories. Yet there is a striking similarity between today's geometric sculptors and the Impressionist painters: both deal with secondary qualities pertaining to the objects of their attention. Barbara Reise had this in mind when she said of Judd's sculptures: "Their highly polished surfaces, saturated colors and translucence do act more optically than tangibly, ironically dematerializing the material."[8] There is little doubt that the material is as dematerialized as Monet's water lily. John Coplans goes so far as to contend that a single translucent box of Larry Bell achieves the effect equal to that of Monet's series of 20 paintings of the Cathedral of Rouen.

Robert Morris, Donald Judd, Sol LeWitt, and Larry Bell are basically Impressionist artists.

<div align="right">N.C.</div>

[8] Reise, *op. cit.,*

Systems Elementary and Complex
(LeWitt, De Maria, Andre, Vollmer, Robert Mallary)

Contemporary geometric sculpture falls into two basic categories, one embodying geometric figures, the other numerical systems. In the latter category a further distinction should be made between systems wherein each unit occupies a distinct position and those in which positions of units are interchangeable to a greater or lesser degree. Various reasons have been given in justification of the use of systems in abstract art. According to John Chandler, the common denominator between all systems whether constructed by contemporary artists or by philosophers such as Aquinas, Spinoza, Hobbes, or Descartes, is beauty.[1] Chandler himself would undoubtedly find it strange were a man to undertake to read these philosophers just for their beauty! What else is beauty but the recognition of the aesthetic value of a system?

When a system becomes the subject matter of art, what is the criterion for appraising its value? Most provocative is the theory according to which "aesthetic experience consists in the closed systems of the universe being disturbed by the introduction of something unknown."[2] For those who believe that the content of experience is limited to the awareness of pleasure and pain, the above statement could be reinterpreted in more concrete terms to mean that interruptions of a given system produce a shock, provided, of course, the interruption concerns a system whose order we value. The interruption of the daily cycle by an eclipse frightened early societies but leave modern man undisturbed. Pythagoreans who counted with pebbles or by segregating dots were disturbed by the realization that the numbers 3, 6, 10, 15 were denoted by dots forming a triangle,

[1] John Chandler, "Tony Smith and Sol LeWitt: Mutations and Permutations," *Art International,* September 1968.

[2] C. Blok, "Minimal Art at The Hague," *Art International,* May 1968.

while the numbers 2, 4, 9, 16, 45 formed quadrangles of dots. Today what interest would a sculpture present consisting of two sets of steel pillars, a set of triangular ones, another of quadrangular ones, in which the order was interrupted by an inclusion of a pillar of the alternate set?

SOL LEWITT

Somewhat more complicated is Sol LeWitt's *47 three-part variations on three different kinds of cubes: solid cube, open-side cube, sleeve cube.*[3] LeWitt stacks them vertically in units of three, combining them in such a way as to eliminate repetition of their order. His *ABCD 2* (1967) is a sculpture consisting of four square horizontal flat platforms, each with a rectangular box in the center, each of the four with characteristics different from the others: (1) skeletal box on open grid (platform), (2) closed box on open grid, (3) skeletal box on platform, (4) closed box on platform. This sculpture's only modern element is the material from which it is made: enameled aluminum. Yet aluminum no more modernizes a Pythagorean game of numbers than plastic chessmen modernize chess. Since we know that numerical series of permutations can be mathematically calculated, LeWitt's system is too easily solved to hold interest. Hence, if his pieces were destroyed with no record kept of his system, man would suffer no loss. One rather assumes that those viewers who find the Pythagorean system more intriguing than the sophisticated permutations of artists such as Vasarely are attracted by the video-tactile aspect of works which are but variations on the counting board.

In 1969 LeWitt presented a series of huge drawings extending the length of the (Dwan) gallery walls. The *East Wall* drawing consisted of four horizontal rows of 16 squares each. The squares presented four variants of three superimposed lines. The order of the variation within the square was imperceptible to the naked eye. Scanning the wall, we begin to see that certain combinations of squares (such as: A B) produce a faint image of concentric diamonds.
 B C

[3] Schematic drawing reproduced in *Art International*, September 1968.

Sol LeWitt: *4-Part Set ABCD 2.* 1968. Baked enamel on steel. Squares: 9 cm. × 9 cm. Base: 145 cm. × 145 cm. In the collection of the Hans Lange Museum, Krefeld. Photograph courtesy of Dwan Gallery, New York.

Unlike Reinhardt, who made a simple pattern vanish under monochrome effects, LeWitt has permitted a secondary pattern to emerge through his system of superposition. This is by far his most interesting work to date, for he successfully overcame the boredom of repetition by generating illusionism.

WALTER DE MARIA

De Maria's numerical system has been developing since 1967 when he first exhibited two parallel rows of stainless-steel columns set in nine groups, each consisting of three columns; each triad provided a variation on 4/6/8; i.e., square, hexagonal, and octagonal columns.[4] His *Bed of Spikes* (1969) is composed of five "beds" of needle-sharp obelisks, a foot high. The beds of equal size differ in the number of

[4] Nicolas Calas, "Review of Exhibition," *Arts Magazine,* January 1967.

Walter De Maria: *Bed of Spikes*. 1969. Stainless steel—progression nine across. 15″ × 3′6″ × 7′. Photograph courtesy of Dwan Gallery, New York.

their spikes, graphically visualized as a progression of 1/3/5/7/9. The sharpness of the spikes plays on the ambiguity "to touch or not to touch" and frustrates the urge to count the spikes by hand. Counting units of equal rank by touching or even pointing is video-tactile. It is by audio-tactile means, the vibration of instrumental cords, that the Pythagoreans discovered the relation of musical notes to numbers. Taction can enhance visual pleasure: stroking a marble statue confirms, as it were, what had been assumed by our eyes. Unwarranted is the deduction that permutations in visual arts are as valid as permutations in music by Bach, Stockhausen, Boulez. Once a simplistic system has been understood, interest is unavoidably shifted from aesthetic appreciation to a verification of the system. This objection does not apply to works in which permutations cannot be grasped simultaneously. Music apart, this occurs in painting whenever variations are too numerous or complicated to be perceived synchronically as with Vasarely.

CARL ANDRE

Carl Andre is credited with flattening the cube to a point where his works are easily mistaken for pavements, all the more so as his materials run to bricks, cement blocks, and Styrofoam planks: "Their

common denominators are rigidity, opacity, uniformity of composition, and roughly geometric shapes."[5] Andre's art consists in arranging the units "on an orthogonal grid by use of simple arithmetic means." Cohesion is based on gravity: "the results of another *a priori:* The use of no adhesives or complicated joints." With Andre, this necessitated leaving his blocks on ground level. Commenting on his *Lever* (1965), a brick causeway consisting of 139 unjoined firebricks running for some 34 feet, Andre has said: "All I'm doing is

[5] Mel Bochner, "Serial Art," in *Minimal Art,* ed. Gregory Battcock (New York: Dutton Paperbacks, 1968).

Carl Andre: *Cuts.* 1967. Concrete sculpture. 2″ × 30′ × 42′. Photograph courtesy of Dwan Gallery, New York.

putting Brancusi's *Endless Column* on the ground instead of in the sky."[6] On the ground Andre's arrangements are meant for a specific site and are wont to be dismantled.

Naturally enough, arithmetic calculations vary with each work. In 1967 his arrangement of concrete blocks covered the whole floor of his gallery, its title, *Cuts,* being a reference to "eight voids created by removing combinations of blocks in various shapes, but always totalling thirty blocks. . . . Some voids were created by removing combinations of blocks of 2×15, 3×10 and 5×6, each combination with two complementary possibilities."[7] Andre's stand is the most extreme among the systematists. He has often voiced rejection of the need for quality and the notion of the uniqueness of a work of art, accepting with equanimity the dismantling of his "sites" when exhibitions are over.

Elaboration of systems for aesthetic purposes leads, oddly enough, to the repudiation of the qualitative aspect of the object. Instead of the work being viewed as an icon, it becomes the exposition of a system. Andre's, LeWitt's, and De Maria's predilection for bygone systems, such as the Pythagorean, probably stems from a need to challenge the present by seeking refuge in the order of an irrevocable past. This past's order, however, has lost most of its fascination since Bertrand Russell exploded the notion that there is mystery in the relation of numbers.

Wittgenstein's concept of art as a language game implies that there are alternative ways of reading the work. Thus Sol Le Witt's *4-Part Set ABCD,* usually comprehended structurally in terms of variations on a set of permutations, can just as well be visualized as a model of an architectural unit; likewise, Vasarely's post-Euclidean sets of variations of color-forms can also be visualized as a lively pattern.

RUTH VOLLMER

A very different order of options is provided by an artist such as Ruth Vollmer, who has used mathematical models as the structure

[6] David Bourdon, "The Razed Sites of Carl Andre," *ibid.*
[7] Kurt von Meier, Los Angeles Letter, *Art International,* April 1967.

Ruth Vollmer: *Steiner Surface.*
1970. Gray transparent acrylic.
12″. Photograph courtesy of
the artist.

for sculptures. Vollmer has most successfully reinterpreted hepta-
hedrons: the so-called *Steiner Surface* (a closed surface into which the
heptahedron is deformed by curves) becomes a subtle transparent
gray object; a heptahedron, consisting of three squares alternating
with four cut-away triangles, by means of contrast between mat and
polished surfaces, is transformed into a lovely plastic object of inner
and outer monochrome surfaces.

If a head of Julius Caesar is admired as a marble object, a plastic
object by Vollmer can be appreciated as a mathematical statue. Like
the human head, the mathematical object has to be both sufficiently
clear and complex to be considered as a statue. Spheres, cubes, and
simple polyhedra are too basic to produce the effect of statues, while
biomorphic forms, such as shell-like spirals, tend to seem as models
of natural forms rather than as self-sustaining works of art.

ROBERT MALLARY

If an artist believes that recourse to a system is essential to his
work, why should he not experiment with modern systems made
available by the computer? Robert Mallary's sculpture has shown
that the cybernetic system does not have to result in cold mechanical

Robert Mallary: *Quad III*. 1968. TRAN2 computer sculpture in laminated veneer. Height: 60″. Photograph courtesy of the artist.

structures. Quite the contrary, his pieces elaborate a morphology that, curiously enough, is somewhat reminiscent of the biomorphic forms of Hans Arp. We are told he achieved his effect by means of a most complicated fusion of forms. Thus his *Quad III,* made of laminated veneer, is an assemblage on a vertical axis of 48 contour slices derived from an input of four profiles together with segments of four ellipses.[8] One has the distinct impression that this sculpture is to the Age of Cybernetics what Doric pottery was to the Iron Age, the perfect expression of a need to rationalize in geometric forms.

Structurally, *Quad* III is far more original so far than the productions of artists working in plastics. It might be argued that its biomorphic contour and its vertical stance do not correspond to the prevailing taste of the sixties. It may well be that Mallary is aesthetically of a somewhat conservative disposition, for he looks forward to the day when, in partnership with the computer, "an optimum creative situation" will have been established. He conceives of it as "taking into consideration both human and technological imperatives and the need, both from the individual and social point of view, of achieving a *healthy balance* between the two" (italics not in text). This is an adaptation to the needs of the age of the computer of the *mens sana in corpore sano* of the Ancients. Such a harmonious balance between individual and social aspirations, between form and image, occur but in periods of classicism. If, as I believe, the historical significance of Romanticism was to have indicated that tension due to alienation is for our industrial era more important than adaptation to established values, then faith in the "creative" contribution of cybernetics is a substitute for loss of faith in the individual's ability to exploit his sense of himself. To the healthy balance between man and computer one could contrast the use of the computer as an instrument for the production of unexpected effects, as does Nam June Paik with his "arranged" television sets.

N.C.

[8] Robert Mallary, "Computer Sculpture: Six Levels of Cybernetics," *Artforum,* May 1969.

Kinetics
(Gabo and Moholy-Nagy, Calder, Rickey, Lye, Takis,
Wen Ying Tsai, Bury, Breer, Castro-Cid, Haacke)

When the dimension of motion was introduced into sculpture, the possibility arose that representation of motion by the depiction of appropriate gestures, whether of a Laocoön or a prancing horse, would become obsolete. Some drew the naïve conclusion that the days of immobile sculpture were numbered. In her introduction to an exhibition of the works of her husband, Sibyl Moholy-Nagy aptly points out: "To the historian the simultaneity of traditional and innovative visual means seems as natural and as inevitable as books and television, ships and space rockets, scholars and computers. Easel painting will always remain. . . ."[1]

Motion in sculpture has been traced back to the eighteenth-century automata, more specifically Vaucanson's famous *Duck,* in which all the organic functions, including defecation, had been simulated mechanically. However, it should not be overlooked that the makers of these works were not concerned with the aesthetics of the mechanism but with simulation of organic motion by a machine within a zoomorphic or anthropomorphic container. (Unlike these automata, clocks demonstrate the precision with which a machine is capable of structuring a period of time.)

NAUM GABO AND LASZLO MOHOLY-NAGY

Gabo and Moholy-Nagy are the great pioneers of kinetic sculpture. According to Gabo, kinetics provide the rhythm to a line and space unit freed of volume and mass. This principle was illustrated in his famous piece *Kinetic Sculpture* (1920), which, when set in motion by a motor, traced the trajectory of a rod to produce an illusionary

[1] Sibyl Moholy-Nagy, "Laszlo Moholy-Nagy" (Chicago: Museum of Contemporary Art, 1969).

Alexander Calder: *The White Spray. Ca.* 1960. Standing mobile: metal. 21″ × 35½″. Photograph courtesy of Perls Gallery, New York.

geometric form. Illusionistic effects were the concern of Marcel Duchamp in his rotating disks, although the illusion was pictorial rather than sculptural. Moholy-Nagy's most important contribution was to have demonstrated the role of light and color in kinetic sculpture. Man Ray should be counted among the forerunners of kineticism, for his freely hanging paper objects such as *Lampshade* (1919) are the immediate antecedents of Alexander Calder's mobiles.

ALEXANDER CALDER

Calder's mobiles since 1932 shifted the emphasis from motion to balance. Calder conceives structure as a support for coordinating individual parts suspended like leaves from a branch. The aesthetic quality of his mobiles, whether hanging from the ceiling or rising from the ground, lies in the delightful variations of a ballet: graceful rods, flexible stems, metal leaves of Miróesque planes are set in motion when touched by the hand or a breeze. The forms and movements evoke schools of darting fish, birds in flight, dancing snowflakes. Calder brought to sculpture the wit and playfulness the Surrealists had introduced into painting of the interbellum period. With his emphasis on balance, Calder liberated kineticism from its obses-

sion with the machine (although he resorted to motorization in his earlier works). His influence spread beyond kineticism: his method of bolting metal plates in his mobiles and stabiles were taken over by sculptors as different as David Smith and Nakian. Imagistically, Calder's *The Whale* (1937) is as expressive as any work by Brancusi and Arp. For originality, inventiveness, and skill, Calder is the greatest American sculptor.

GEORGE RICKEY

George Rickey's mobiles look austere when compared to Calder's, their balanced movement is strictly controlled and reduced to the trajectory of a pendulum. The swinging of the blades suggests both the irregular crossing of spears and cutting scissors widening and narrowing space between the blades. Unlike Calder's mobiles, which are limited to circumscribing their orbit, Rickey's giant blades, pointing outwards as they do, force the eye to follow them as they threateningly slice into the sky.

In more recent works Rickey shifted from a vertical thrust to a horizontal stance. He sometimes retains his blades, although in minia-

(*Left*) George Rickey: *Peristyle—Four Lines.* 1963–1964. Stainless steel. 100″ high. In the collection of the Art Gallery of Toronto, Toronto. (*Right*) George Rickey: *6 Squares 1 Rectangle.* 1967. Stainless steel. 32″ × 16″. In the collection of Mr. and Mrs. David M. Winton, Wayzata. Photographs courtesy of Staempfli Gallery, New York.

ture, which now fall and rise to break and reconstruct a plane as in *Four Lines Horizontal* (1964–1968). He mostly resorts to flat stainless-steel squares and rectangles balanced on a standing rod or hanging. He calls these interrelated, seemingly buoyant squares "planes." One four-plane unit suggests flower petals, drawing attention to the vulnerability of a geometric form. His *6 Squares, 1 Rectangle* (1967) establishes a delicate imbalance of form, movement, and light reflection, disturbing rhythm and good gestalt. *Column of Four Planes* (1967) maintains an eccentric equilibrium with an escalating rod of support.

LEN LYE

A New Zealander who first came to Europe at twenty-five, Len Lye is haunted by magic practices of primitive peoples, more interested in producing a modern counterpart of the kinesthetic effects of tribal dances and rituals than in deriving purely aesthetic effects from the movements of motorized parts. In contrast to Gabo, whose motorized wire constructions generated the illusion of a familiar geometric form, Lye, in his earlier works, sought to generate eccentric forms. Unlike Calder, whose playfulness found full expression in his *Circus,* Lye is theatrical even when performing with a single metal loop. Tinguely produces convulsions in his screaching machines, Lye directs convulsions of light-forms. We feel we are witnessing an extraordinary event, emphasized by the circumstance that the demonstration—with the artist at the controls—is apt to be limited to a single performance.

In the course of the last decade, Lye's sculptures underwent transformations, progressively growing larger, noisier, speedier, more frenetic, and, lastly, formless. He has continued to concentrate on the bodily movement of a given metal piece: a ribbon of steel, a springy loop, slender rods, chains of polished balls, aluminum sheets—all highly flexible, capable of gyrating, leaping, arching, swaying, undulating, at desired and varying tempos.

Lye's first full-scale exhibition at the Museum of Modern Art, entitled "Tangible Motion Sculpture," was accompanied by a recital

Len Lye: *Loop.* 1965.
Polished steel. 22″ strip.
Photograph courtesy of
Howard Wise Gallery,
New York.

(April 5, 1961). John Canaday's review includes the description of the pieces and the effects produced. Of *Ring* (1961) Canaday wrote: *"Ring* is a ring of polished silvery metal suspended from a gibbet, nothing more, until a motor yanks and twists its suspending cord so that the bouncing metal is dematerialized as an intermeshing of gleaming planes, lambent shifting volumes and glowing linear tracings."[2] Two of the constructions already incorporate sound, albeit very timid, *Grass* (1965) "sends out a singing whispering sound" while *Round-head's* (1961) concentric rings "occasionally emit a few small chirps."[3]

By 1965 Len Lye's works had become electronically controlled and programmed and performances could take place daily and continuously.[4] His series entitled *Bounding Steel Sculptures,* included *The Loop* (1965), which was to become perhaps his best-known piece, fascinating in its simplicity of means. It is a strip of polished steel shaped into a band, standing on a magnetized field. When the

[2] John Canaday, *The New York Times,* April 6, 1961.
[3] *Ibid.*
[4] Howard Wise Gallery, New York; Albright-Knox Art Gallery, Buffalo.

charged magnets go into action, the steel loop is pulled downwards, then suddenly released. The spectator watches it struggling to resume its natural shape while it "bounds upwards and lurches from end to end with simultaneous leaping and rocking motions, orbiting powerful reflections . . . and emitting fanciful musical tones which pulsate in rhythm with the Loop. Occasionally as the bounding Loop reaches its greatest height, it strikes a suspended ball, causing it to emit a different yet harmonious musical note, and so it dances to a weird quavering composition of its own making."[5] Steel elements supercharged with electricity writhe, twist, bound, and convulse, reaching an ever more frenzied pace in the effort to discharge the energy until a climax is reached and the tremulous collapse; the self-generated music, whether by drums, bells, or a "cascade of thundering sound," quickens with the intensity of the movement and dies away when the energy is withdrawn.

In 1969, the largest to date and most thunderous construction of aluminium and steel was exhibited and performed. Entitled *Storm,* it consists of a long steel ribbon (9′8″ in height) and two hammering projections sparring with it on "the principle of reciprocity"; this unit, *Storm,* is set up against *Thunder Sheets,* aluminum wall hangings, one black, one white. When the piece goes into action, it builds up to convey a formidable crashing of thunder while the steel ribbon convulses in flashing zigzags. According to Lye, this is but a small part of an ensemble he plans which would include 24 Sky Snakes, six Twisters, Lightning Bolts, and the necessary sounding wells. As Lye stresses, the performance of such a programmed composition is meant to convey some semblance of the power generated by a great storm.

Emphatically Len Lye is at the antipodes of art that claims to be self-referent. Release of energy in itself in no way constitutes a work of art and it is only energized form that is an object of our visual perception. In *Storm,* however, Len Lye makes it practically impossible to follow movement in terms of mobile forms for the interchanges are so rapid and spasmodic that the spectator is com-

[5] Len Lye, catalog to exhibition, Howard Wise, Gallery, April 1965.

Len Lye: *Storm* (comprising *Storm King* and *Thundersheet*). 1969. 9′8″ high.
Photograph courtesy of Howard Wise Gallery.

pelled to react as to a succession of shocks. Lye's art is not one for aesthetes.

<div align="right">E.C.</div>

TAKIS

Takis' early mobiles are vertical—long-stemmed flowers of metal parts, stalks of flexible rods, thistle-like heads of radio condensators, pistils of copper. This flora evokes the arid landscape of Attica with its railtracks and train signals with their awesome power of control. From signals Takis moved on to the magnet, that "stone" which Greek philosophers of Magnesia had identified with the force of nature. Takis became preoccupied with electromagnetized signals, needles, and lights; random movement is produced in space and time. Simultaneously the unpredictable sequences of flicker fascinate with their floral version of airport lights. Takis has become preoccupied with acoustic signals. In some works an electromagnetized needle

Takis: *Magnetron #II.* 1966. Metal, magnets, nylon, and needle. 9″ × 20½″ × 6″. Photograph courtesy of Howard Wise Gallery, New York.

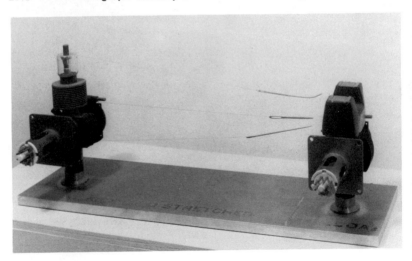

Takis: *Indicator Time-to-go.* 1969. Plexiglass and magnets. 11″ × 11″ × 4″. Photograph courtesy of Howard Wise Gallery, New York.

strikes randomly a musical cord stretched over hollow wood, producing thereby sound effects that could be well included in concerts of aleatory music. Another object points to an interest in games without rules. It consists of a large sphere oscillating over signals compelling them to move in disorderly fashion. What could be more unsettling than a magnetic pendulum marking time over a set of ubiquitous compasses trembling in the circle of nowhere? In *Time-to-go,* a magnetic indicator of a multiple of one hundred copies, we follow the random movement of a rotating disk produced by two complementary magnetic fields, operating separately from one another and in combination with the pull of gravity. Let there be a scientific explanation of magnetism, art requires that knowledge's assurance be suspended while anxiety awakens our sensitivity to the invisible.

Takis' newest work is based on observations made some ten years ago in Venice when he became fascinated by the up and down oscillation of the sea. In the spring of 1968 he was invited as Fellow to M.I.T. Center for Advanced Visual Studies where, with the assistance of scientists, he was able to complete his experiments. In collaboration

with Professor Ain Sonin, Takis produced a working model of a floating sculpture entitled *The Perpetual Moving Bicycle Wheel of Marcel Duchamp* (1968). Robert Rheinhold, who saw it in the exhibition of Takis' work at M.I.T.'s Hayden Gallery, describes it as follows: "It consists of a float that moves a lever up and down. The motion of the water lifts the float, which stretches a spring. The spring, in turn, rotates the bicycle wheel for power."[6] Summing up, Rheinhold, who is himself a scientist, says that Takis' work is more sophisticated than most of the works shown at the Brooklyn Museum under the auspices of Experiments in Art and Technology.

Depending on whether the movement is rapid or slow, regular or irregular, with or without lights or sound, the kineticist must strive to achieve a noncumbersome and eloquent style. Instead of transmitting signals to train, plane, or ship, he is exhibiting signals to an audience not overly interested in means of communication but intent on the artist's presentation. To understand the rules according to which an artist is playing we must see several of his works. It was therefore unwise of the organizer of the Machine show at the Museum of Modern Art to include but a single piece by Takis. But then why include Takis at all since he is not interested in the machine itself?

Takis explains his interest in magnetic attractions in terms of the Platonic theory of the creator. In a catalog to a one-man show of his in 1964, Takis quoted the passage in which Diotima, in her famous dissertation on love, explains to Socrates that we have creation whenever there is a passage from nonbeing to being, although, she hastens to add, the term *poietes* (creator) is reserved for the creations of the *poietes* (poet) (*Symposium,* 205, b). Plato here has succumbed to the naturalistic fallacy: i.e., the poet speaks and makes, he does not create. Takis' signals and magnets have been constructed and stylized to express significant aspects of a natural power, or energy—magnetism. Obviously sculpture concerned with energy offers more than just aesthetic pleasure for energy as such, being invisible, can produce effects that surprise and mystify.

It is useful to view kinetic sculpture of the sixties as falling into

6 Robert Rheinhold, *The New York Times,* December 13, 1968.

two basic categories. The first would include works of those who, like Takis, Tsai, Haacke, and a few others, dramatize the mystery of invisible energy by means of an appropriate stylization of structure; the second includes quantities of artists who seek to produce startling effects without regard to stylistic considerations of structure. Thanks to the Center for Advanced Visual Studies, artists belonging to the first group are able to realize some of their most ambitious projects.

The exploration of natural phenomena is also to be sharply differentiated from the subtle optical effects obtained by Morris, Judd, and Don Flavin through constructions of volumes or displays of object or mass. The former, fascinated by energy, are Expressionists. The latter, concerned with phenomenology, are Impressionists. The Expressionists confront conflicts, the Impressionists avoid them; the former are poets, the latter aesthetes.

No wonder Takis' work was first and best understood by poets, by Allen Ginsberg, William Burroughs, and the Frenchman Alain Jouffroy. Diotima would certainly have been proud to count Takis among her admirers.

N.C.

WEN YING TSAI

Wen Ying Tsai (American born in China) is intent on creating illusionistic effects: Duchamp's rotating disks inspired his *Multi-Kinetics,* a work which from a distance resembles a chessboard with revolving spheres, the latter consisting of concentric rings each equipped with a separate motor, each following its own trajectory. In his essay introducing Tsai's *Multi-Kinetics* (1965), Willoughby Sharp wrote that each of the 32 units "contains a configuration of multicolored gyroscopic forms" and that "by controlling the time sequence of each unit and skillfully composing them, Tsai has used engineering principles to achieve aesthetic ends."[7] To the viewer, the engineering feat (Tsai is an engineer by training) was more impressive than the aesthetic effect for the number of variables distracted from the unity of the composition.

[7] Willoughby Sharp, "Multi-Kinetics" (New York: Amel Gallery, 1965).

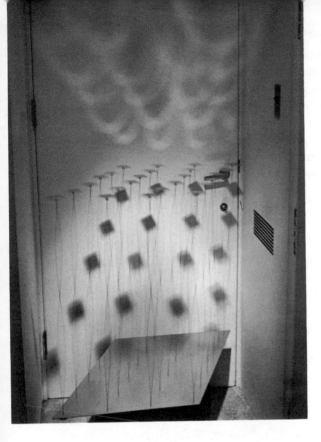

Tsai: *Cybernetic Sculpture*. 1968. Aluminum, stainless steel rods, vibrating and strobe light. 42″ × 34″ × 24″. Photograph courtesy of Howard Wise Gallery, New York.

A few years later Tsai was to achieve a happy fusion of technology and art in his cybernetic sculptures employing numbers of stainless-steel rods, oscillators, stroboscopic lights, electronic equipment. In some of his most recent sculptures the oscillating rods have been metamorphosed into long-stemmed metallic flowers that oscillate and undulate harmoniously under the spell of high-frequency stroboscopic lights. As the lights react to sound, the viewer can entertain the illusion that his voice has brought into motion an enchanted garden.[8]

[8] *Cybernetic Sculpture,* Museum of Modern Art exhibition, "The Machine," Fall 1968.

POL BURY

Pol Bury exemplifies another approach to "moving sculpture": while following Gabo, such artists as Len Lye and Tinguely conceive of kinetics in terms of rapid motion, often violent and noisy; Bury, a master of understatement, specializes in the elaboration of slowness. A Belgian, who in recent years has worked and exhibited in New York, Bury prefers motion so slow as to be almost imperceptible, interpreting slowness "as a field of 'actions' in which the eye is no longer able to trace an object's journey. . . ."[9] By "journey" Bury means a trajectory; he is intent on eliminating any effect of "programmization." Movement links objects to other, similar objects, whether twitching metal needles as in his early *Vibratile* (1963), or meticulously fashioned balls of wood as in *18 Stacked Balls* (1966).

[9] Pol Bury, "Time Dilates," *Studio International,* June 1965.

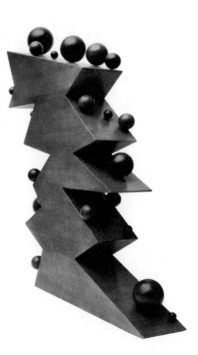

Pol Bury: *25 Boules sur 10 Plans Inclinés.* 1965. Wood and cork. 135 cm. × 120 cm. × 20 cm. Photograph courtesy of Lefèbre Gallery, New York.

Pol Bury: *Sphère sur un Cylindre.* 1969.
Stainless steel. 55 cm. × 20 cm. Photo-
graph courtesy of Lefèbre Gallery,
New York.

Affixed discreetly by wiring to sculptured plywood pedestals or
cabinets, the balls of different sizes gently graze and "rub" against
one another. As Bury puts it: "We dare henceforward speak of the
activity no longer in terms of geometry, but almost in the language of
the boudoir." Bury is the Henry James of understated motion and
rapports which could pass unnoticed: "Only linked slownesses have
the capacity to create, keep alive and re-create these foreseen and
unforeseen contacts, these tentative gentle strokings." The limited
animation, the sensual aspect of which is so stressed by the artist,
hardly affects the actual form of the construction, its relief; our atten-
tion is not held for long by such minimal stirrings. In contradistinc-
tion, the impression created by a roomful of Bury's sculptures is
vividly rendered by Jack Burnham: "Through silence, one *feels* the
creaking of cords, spools and linked shapes from all directions. Out
of the corners of the eyes hundreds of multisensual movements take
place imperceptibly."[10]

In 1967 Bury first exhibited a sculpture with motion generated by

[10] Jack Burnham, *Beyond Modern Sculpture* (New York: George Braziller,
1968), p. 272.

electromagnets. Stainless steel was to become his preferred material, although he has works in copper such as *17 Half-Spheres on a Plateau* and in brass such as *25 Brass Eggs;* his forms are not limited to spherical ones but those on the whole are the most satisfying. Of exceptional interest in his *Sphere on Cylinder* (1969), a two-part composition consisting of one stainless-steel ball atop a stainless-steel cylinder. Rotation is produced by an electromagnet concealed within the cylinder, while a weight within the sphere enhances randomness by shifts in the center of gravity. Here Bury's aesthetics undergo a marked change: to the related movement of his "stillnesses" he now substitutes the arythmic movement of the sphere inspired by two uncorrelated forces, that of the electromagnets and the shifting weight. The stark simplicity of this beautiful sculpture permits one to view Bury as a Brancusi of kinetics.

ROBERT BREER

Robert Breer had long experimented with animated films, "flip" books, and mutascopes before undertaking moving sculptures in the early sixties. Those were first based on rotation. He gained renown with *Rug* (1969), a soft plastic sheet, crumpled and organic in appearance, which crawls along the floor slowly and relentlessly propelled by hidden battery-driven wheels. Breer has said of *Rug:* "The only way I can think of it in relation to a machine is that since it's not an animal, it must be a machine."[11] Conceived in the mid-sixties, *Self-Propelled Styrofoam Floats* (1970) are mobiles of various geometric forms each of which carries in its undercarriage an electric motor that can reverse itself, i.e., the direction of the float, when an obstacle is encountered. Aesthetically, the fleet of floats was seen by the artist "as a single composition which would constantly rearrange itself. . . . By their consistent and slow movement, I hoped to put emphasis on change of position rather than motion itself."[12]

[11] Robert Breer quoted by K. G. Pontus Hultén, *The Machine* (New York: Museum of Modern Art, 1968).

[12] Artist's statement, catalog to the exhibition at Galeria Bonino, New York, 1966.

Robert Breer: *Table.* 1967. Three self-propelled floats: styrofoam, canvas, and metal components. Each unit: 30″ × 24″. Photograph courtesy of Bonino Gallery, New York.

Breer's flock of creeping self-propelled geometric objects might be placed—conceptually—between Tony Smith's group of interchangeable *Rocks* and Bury's tremulous "slownesses." The unpredictable pattern set by Breer's motorized forms might be likened to that of capricious "chessmen." Breer's kinetic game is to the art of the sixties what Calder's famed *Circus* was to the Surrealists of the thirties.

CASTRO-CID

For Jack Burnham, who views kinetic art as having had its beginning in eighteenth-century automata, Castro-Cid's cybernetic boxes are the *ne plus ultra* of kinetic art. While it is relatively easy to startle an audience by the performance of a self-destructive machine as does Tinguely, it is far less easy to interest a viewer in the timid performance of encased systems powered by air jets which keep plastic spheres within a defined cycle of movement. According to Burnham, "The poetic imprecision of these games . . . exist in the fact that they imitate a level of technology which they have little hope of

duplicating."[13] What we should expect from art is to offer us alternatives to the technological achievement, not with unsuccessful attempts to duplicate them. Castro-Cid's cybernetic automata, as much as Schöffer's kinetic sequences, are modern versions of Utopia, as boring as that paradise in which all men are expected to spend their time unto eternity singing hymns. In lieu of angels, this paradise will be peopled with Trova's charioteers, tailored to fit into the Procrustean Eden of a managerial society. Trova's Oscar-like robots are the complementary opposite of the Intruder, glorified by de Chirico, Giacometti, and Matta.

<div align="right">N.C.</div>

HANS HAACKE

Haacke's gravity-controlled water boxes have rain for natural prototype. In the last decade he has been experimenting with transparent Plexiglas-sealed liquid containers which are set in motion by hand, in most cases by turning the container over. In his early *Rain Tower* (1963) water falls from the upper level or chamber of a tall, narrow rectangular box through a number of perforated partitions to the lowest level. *Rain Tower* was replaced by a smaller and simplified container, easier to handle, *Dripper* (1963), with water passing through but one perforated partition or two set closely together and enabling the viewer to focus his attention on a single performance rather than trying to follow a series of successive events. It takes a few brief minutes for the water to run its course, but while it is "raining," the viewer is enchanted by the variations in the cadence of the fall, drops converging, merging, sliding along the box sides, forming tiny vortexes and whirlpools, sparkling. And, fortunately, the viewer is not prevented from turning the box over and starting a new performance, never identical with the previous one.

The simulation of rain was paralleled by the simulation of the rippling motion of a wave. *Wave I* (1964) is contained in a long, narrow and flat Plexiglas box suspended from the ceiling; when the box is set swinging by hand, "a wave rolls through the confined

[13] Burnham, *op. cit.,* p. 350.

channel and breaks back on itself at each end."[14] Due to the flatness of the container, the irregular outline assumed by the water produces a startling "frontal" effect. Water and air and swinging motion create the wave pattern. In contradistinction, other containers, apt to be cylinders, hold immiscible liquids of different densities and those again must be overturned by hand to activate the flow, with the liquids swirling and gliding and undulating around each other in the attempt to bypass one another while each "assumes the best shape it can for doing so."

Manipulation by the viewer is decidedly uncalled for in a work such as *Condensation* (1965). Haacke's tightly sealed acrylic-plastic *Condensation* boxes are designed to show the slow cycle of evaporation and condensation of liquid when exposed to heat either generated by the light of a lamp or of sunshine in a window. Heat— energy from without—causes water in the shallow pool at the bottom of the container to evaporate and to rise as fine vapor to the top of the container, where it gradually condenses into droplets, which, growing larger and heavier as they merge, trickle down the interior walls of the box to start the cycle of evaporation all over again. The trickling droplets trace an ever-changing pattern on the transparent walls, glistening like beads in the light.

Aesthetically Haacke has likened his water boxes to *haiku* poems, one of which reads:

> *The dew of the rouge-flower*
> *When spilled*
> *Is simply water.*

Substitution of man-made aquariums for a flower—nature's receptacle—or a tree,—nature's obstacle—: is enchantment shattered or enhanced? The Japanese poet depicts a natural phenomenon while Haacke isolates an inorganic process that can be repeated at will. The question need never have arisen had not Haacke gone on to an indiscriminate use of "systems" (his expression). He has sought con-

14 George Rickey, *Constructivism* (New York: George Braziller, 1967), p. 207.

Hans Haacke: *Large Wave.* 1965. Acrylic, plastic, and water. 12″ × 96″ × 1″.
Photograph courtesy of Howard Wise Gallery, New York.

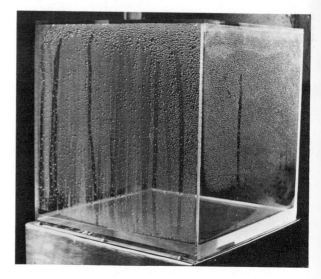

Hans Haacke: *Condensation.* 1965. Plexiglass and water. 30″ × 30″ × 30″. In the collection of Willoughby Sharp, New York. Photograph courtesy of Howard Wise Gallery, New York.

frontations between inorganic reversible systems and organic irreversible ones. The latter include growing grass in his *Grass Cube* (1967) and *Grass Mound* (1969), planted on the opening day of the exhibitions and allowed to grow for the duration; likewise, chicks hatching on the opening day and becoming part of the exhibition as they continue to grow. The motivation here is apparently "to make something which lives in time and make the 'spectator' experience time."[15] Haacke's mistake is to believe that man can experience time. Perceiving motion in time, melting icicles, sails billowing, sea gulls swooping, can generate aesthetic pleasure, but not movement that can neither be seen or heard. Awareness of invisible movement may stir our curiosity, but aesthetic pleasure and curiosity are not to be confused.

E.C.

[15] Bitite Vinklers, "Hans Haacke," *Art International,* September 1969.

Light-Sculpture: Dan Flavin, Chryssa

Until recently light works dealt with either reflections or projections of light. With the development of fluorescent tubes, it became possible for the artist to use the source of light as a self-referent element. In the United States the two pioneering artists of neon sculpture are Dan Flavin and Chryssa.

DAN FLAVIN

Dan Flavin has the backing of the Minimalists, who view his work as expanding the field of what Jack Burnham calls "Minimalist Systemic Esthetics."[1] Flavin's first breakthrough in the new field was achieved with *The Diagonal of May 25, 1963* upon his discovery of standard fluorescent fixtures, tubes of two, four, six and eight feet in length. He concluded that these could be used in light art much the way line is used in painting. This notion would explain his transposition of a Barnett Newman canvas into a neon "sculpture," *The Nominal Three* (*to William of Ockham*) (1963–1964). ("Sculpture" is a term avoided by the artist himself.) Flavin's work consists of a progression of eight-foot cool-white fluorescent tubes, a unit of one, a second unit of two, a third unit of three. In *Untitled* (*to Jean Boggs*) (1969) Flavin reinterprets the aesthetics of Morris Louis of the *Vertical Pillar Series* (1968). This piece, fitted tightly into a 45-degree corner, consists of four vertical eight-foot colored lights, blue, yellow, red, and green, with the green almost concealed behind the other three. Depending on the spectator's vantage point, there may be additionally the glow of green or blue falling upon the other colors, as well as reflections upon the partition walls. Noland's multiple horizontal color bands may well have inspired Flavin's tunnel-like interior

[1] Jack Burnham, "A Dan Flavin Retrospective in Ottawa," *Artforum,* December 1969.

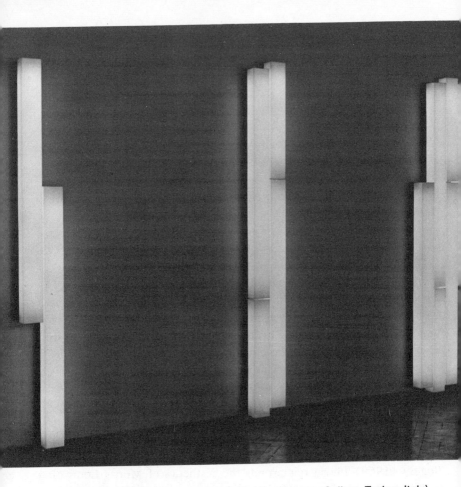

Dan Flavin: Untitled (Installation shot at the Sperone Gallery, Torino, Italy). 1968. Fluorescent light. Photograph courtesy of Dwan Gallery, New York.

with the nine parallel crossbars bisecting the ceiling in a luminous repetition of blue, pink, yellow, red, in *Untitled* (*to S.M.*) (1969).

Dan Flavin's color syntax is peculiar. In the already mentioned work dedicated to Jean Boggs, he seems to use colored lights to illustrate his aesthetics as is suggested by the isolation of the green

light from the cluster of the three primary colors, yellow, blue, and red. Moreover, in a piece entitled *A Primary Picture* (1964) Flavin forms a square of neon lights with the painter's primaries of red, blue, and yellow. He must expect the viewers to forget that in terms of light, yellow is not a primary color since it is generated by a combination of green and red. From a formalist, one would have expected adherence to Greenberg's formula that each art has to "determine through operations peculiar to itself the effects peculiar and exclusive to itself" and that, furthermore, "the task of self-criticism became to eliminate from the effects of each art any and every effect that might conceivably be borrowed from or by the medium of any other art."[2] Dan Flavin has chosen to filter light through colored plastics instead of limiting himself to the colors of the cathode tube, the negative cool blue and the positive cool red. In so doing, he has exposed himself to the criticism that he is intent on producing decorative effects. Another point calls for consideration: it is questionable whether neon light can be viewed as counterpoint of line in painting. Duchamp's remark that the line is a crack drew attention to the fact that lines tend to recede, yet, as is known, light does the exact opposite. Furthermore, for a light to be visualized as a line, it needs to be freed from its container, however transparent, yet so obviously present. This—so far—has only been achieved by recourse to the laser ray, so brilliantly demonstrated by Robert Whitman in *Dark* (1967), when he streaked a ray, narrow, intense, and glowless, upon the wall, overcoming both the contradiction line-color and line-light. What a wisecrack!

Dan Flavin succeeds best with his most sculptural works, particularly those which lend themselves to an interplay of light and nonlight, i.e., lights facing the viewer and those turned toward the wall, with but their fixtures confronting the viewer. Those handsome variations are manifest, *par excellence,* in *Untitled* (*to Jane and Brydon Smith*) (1969). This light-sculpture consists of two complementarily opposite units, each cutting across a corner of the exhibit space by means of horizontal and vertical bars forming escalating T's, one

[2] Clement Greenberg, "Modernist Painting," in *The New Art,* ed. Gregory Battcock (New York: Dutton Paperbacks, 1966).

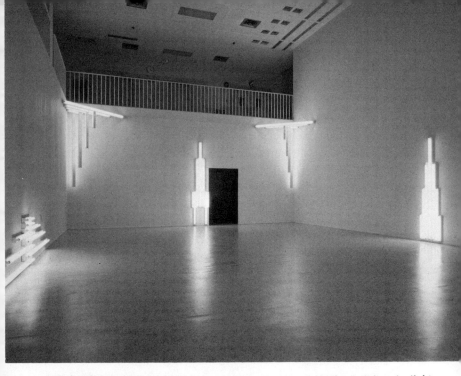

Dan Flavin: Untitled (*To Jane and Brydon Smith*). 1969. Cool white, daylight, and blue fluorescent light. Room size: 162″ × 331″ × 573″. Photograph courtesy of Dwan Gallery, New York.

right side up, the other inverted. The horizontal bars are fronted with cool white light, the verticals are seen as mat fixtures reflecting a very pale bluish glow upon the angled walls.

CHRYSSA

Chryssa's approach is emphatically that of a sculptor. Unlike Dan Flavin, who aims at creating the illusion that neon sculpture is linear despite the obvious presence of the tubes, however transparent, Chryssa produces the illusion of volume by successive rows of curvilinear or rectilinear forms of neon tubing. The dominant impression given by her neon sculptures is that they are functional structures, an

impression in large part due to the exposed "entrails": wires, plugs, sockets, receptacles. Tantalizingly, Chryssa walks the tightrope between letter and design, known or unknown sign, familiar or unfamiliar function. As in her earlier Lettrist bronzes and graphic works, Chryssa's approach to neon light has been inspired by Times Square advertising. Gordon Brown has pointed out that Chryssa "usually wants the neon to flow uninterruptedly whereas, in commercial signs,

Chryssa: *Newspaper* (Stock Exchange quotations). 1959–1960. Oil on canvas. 24″ × 36″. In the collection of the artist.

Chryssa: *Neon Bird*. 1969. Neon enclosed in bronze-colored plexiglass. 54″ × 42″. In the collection of the artist.

elements that are not part of the design are painted out."[3] Neon works such as *Analysis of the Letter A* (1965) and *Analysis of the Letter Y* (1967), as well as the series called *Ampersand,* are original elaborations of a neon calligraphy.

Her neon structures, whether monochrome or not, are apt to be enclosed in gray-tinted Plexiglas boxes, enveloping the light, as it were, in an "aerium" of night. In her series of studies for *Gates to Times Square* Chryssa has at times resorted to bright colors, always

[3] "Notes on Neon from Chryssa," *Arts Magazine,* March 1967.

intent, however, on avoiding Impressionist blurrings of juxtaposed colors. In certain works she used interruptions of neon flow, thereby introducing a time-sequence element. As an alternative to the tinted boxes, Chryssa experimented with black neon tubing as in *Gates # 15,* more appropriately called *Flock of Morning Birds . . . ,* in which form and image blend felicitously.

Chryssa: *Analysis of the Letter Y.* 1967. Neon and plexiglass. 18¾″ × 23½″ × 18½″. In the collection of the artist.

Recent Developments in Tek Art

According to Leonardo, painting is the art of knowing how to see, *saper vedere*. Today, for some artists, knowing how to see means joining forces with the engineer. One of the earliest contrivances used to help man broaden his field of vision was the magnifying glass. Later, by means of the microscope and the telescope, whole new classes of objects were introduced into the field of our perception. But no one would seriously claim that lenses influenced the development and evolution of painting. In the history of art anamorphic images inspired by lenses and convex mirrors are but eccentricities. As for the ordinary mirror, its main function is to provide the artist with the advantages of a secondary point of view. Since Narcissus learned to distinguish reality from illusion the mirror lost the power to create extraordinary visions.

I suggest that today's artists interested in the "performance" of light take into account the difference between image and vision. Having seen the Acropolis only by daylight or moonlight, when I first saw the temple illuminated brightly at night, it was experienced by me as a new vision. To preserve this vision's image the camera was called upon: what appears in the vision will disappear in the night when the floodlights are extinguished. However, if we were to see the Acropolis lit nightly, there would be no difference between saying, "I prefer the image of the Acropolis that I see at night to the one I see in the daytime," and saying, "I prefer the night vision to the day vision." But when I say, "I saw the Acropolis in a new light," I am drawing attention to the effect that artificial light has upon the image of the monument. Through the illumination of an object previously swallowed by darkness we experience a new vision.

How can man exploit the phenomenon of vision apart from describing what he sees in his vision? A vision, whether produced by a

natural cause, such as sunset, lightning, flames, or induced by drugs can stimulate inspiration. Prophets have ascended high summits to gaze at the rising sun and descended with an armful of divine laws, or with a poem as did Nietzsche; Monet saw the sun dissolving the cathedral's sculptured surface and painted an image that had remained unseen.

A vision appearing in a given light and light projected to perform a given task should be clearly differentiated. Sun pouring through the stained glass of Chartres serves to enhance a religious ceremony. Light, in other words, is being used for dramatic effects. This holds also for the illuminated colors used by Warhol in *The Chelsea Girls*. In contradistinction, some artists play with light to isolate the vision of an image reflected in a mirror or projected onto a screen. Thus Schöffer, by means of lights and mirrors, creates a perfect illusion of an unfathomable and frightening abyss. This modern magician should be commissioned to renew the outmoded and illusionist tricks of the Coney Islands and Tivolis of the world.

The image must be new. Vibrating mirrors or polished surfaces blurring reflections as those of Robert Whitman in his *Pool* tend to strike us as *déjà vu*. Yet Francis Bacon, working with brush and paint, achieved superb futuristic blurring in his latest series of portraits.

Robert Rauschenberg in his *Soundings* (1968) has called upon technology to make chairs appear on the screen each time a noise is made. "He spake and chairs appeared." Rauschenberg was fascinated by the possibility of sound bringing forth visual images. In an age of rapid technological advances the astonishment caused by this kind of invention is of short duration. Sounding chairs could be used as substitutes for real chairs in a performance of Ionesco's *Les Chaises*. In his brilliant sketch *Open Court* (1966), Rauschenberg split wide open an audiovisual image in order to create the sensation of diachronic ambiguity: the electronically registered sound of the ball hitting the rackets of tennis players continued to be heard after darkness had fallen upon the stage and the players had presumably stopped playing. In an analogous scene in *Blow Up* Antonioni was only able to

suggest a shift in levels of reality by mimes playing tennis without ball or rackets.

To judge from the best entries to the competition organized by "Experimentation in Art and Technology" it seems obvious that art can be "dematerialized." What remains to be seen is what advantages the artist can derive from this feat. In a statement explaining their choice, the jury of the competition says that the winners went "beyond a demonstration of technical prowess or an intricate orchestration of art and technology" and that the artist and engineer together created "a well-executed realization of fantasy." The statement adds that "the unexpected and extraordinary . . . [was] stimulated . . . by probing into the workings of natural laws."[1] In *The Machine* Pontus Hultén points out that one team of competitors succeeded in realizing the prediction of Gabo that sculpture could be dematerialized. The winner of the first prize engineered an object containing dust "activated by acoustic vibrations produced by the rhythm of heartbeats." The third prize went to *Fakir in 3/4 time,* the first machine to do the Indian rope trick. Pontus Hultén says of "cybernetic sculpture," based on Gabo's principle of the standing wave, that "the technical solution that produces this illusionistic feat is at once so discreet and so efficient that it strikes us as perfect."

From an instrumentalist point of view precision is both truth and perfection. For the fakir precision serves to produce the illusion of truth. Is the goal of art to turn artists into modern fakirs? According to Rauschenberg, an apostle of the technological creed, the role of the artist today is to "create within the technological world in order to satisfy the traditional involvement of the artist with relevant forces shaping society," adding that "the collaboration of artist and engineer emerges as a revolutionary process."[2] This is but a half-truth, for it does not take into account the fact that technological developments heighten and exacerbate social contradictions as much as they satisfy

[1] K. G. Pontus Hultén, *The Machine* (New York: Museum of Modern Art, 1968).

[2] Robert Rauschenberg, *E.A.T. News,* No. 2, June 1967.

other social and economic needs. An involvement with technology will make the artist subservient to science. Thus the brief period of autonomy art achieved by liberating itself from church and state would have ended. Moreover, the artist is in danger of alienating himself from his vision with the engineers harnessing it to the field of natural laws. The historic process of artistic development requires, on the contrary, that the artist exacerbate the social contradictions created by technological developments and oppose doubt to certainty, fear to illusions and poets to fakirs.

Likewise, the Argentinian Le Parc becomes a new Vasarely by combining projections of rays and reflections of light upon polished surfaces. More theatrical and less Impressionistic, the German Otto Piene projects upon the walls a phantasmagoric ballet of lights generated by miniscule incandescent lamps clustered in the shape of onion flowers. To the PULSA group at Yale University we owe pleasant nocturnal scenarios of cybernetic fireworks orchestrated by computer-directed phosphorescent lights.

Vision and insight should not be confused. Without insight, the technician, whether artist or engineer, cannot solve his problems. But great art is the result of a new vision. Power of vision is acquired through speculation, derived from *speculum,* mirror. Where there is no vision, we can just as well say a light has failed.

The art of making objects and the art of projecting lights should be clearly differentiated. The object is determined by place in space while light—like sound—is determined by time in space. Furthermore, experimental work with light by such kineticists as Schöffer, Otto Piene and Le Parc, has made useful the distinction between projections of structures in space and projections of images upon the screen (cinematography). Abstract films are aesthetically unsatisfactory not because they are abstract *per se* but because three-dimensional light is interpreted in flat colors. In the sixties the most experimental cinematographic images have been made for the television screen. The latter is to the kinetic image what the easel is to the static image.

With TV the cube comes to life: "Television is the new everything," Warhol has remarked, meaning by this, I suppose, that it is one of the newer products offered by technology with which the artist can explore the field of perception. As such it is being used as either a super-mirror or as a magic box. The major exponent of the super-mirror is Les Levine, who by an ingenious use of a unit enclosing several cameras with their lenses set at different angles offers the spectator simultaneously images of himself or herself at close, medium and long range. A clever technical achievement undoubtedly! It is now for an artist to find a scenario commensurate with the possibilities.

Nam June Paik is the John Cage of the television set: by artful manipulations he explodes abstract patterns of light or runs a spectrum of flowing colored ribbons across the screen. The spectator is invited to handle the controls and have the illusion that he is producing the imagery. So far the emphasis has been on the experimental aspect of TV kineticism, for the artistic results are still fragmentary. According to John Margolies, the "Resident Thinker" at the New York Architectural League, we can best appreciate these avant-garde works by viewing them on the level of "process perception" rather than on that of "content perception."[3] Taking his cue from McLuhan, Margolies writes: "Process level analysis of the art experience is concerned with art as process of perception, a way of experiencing how one sees rather than what one sees." Apparently an acceptable way of confronting television is by taking advantage of the many options it provides to the viewer, who can change sound and image at will, in the meantime sitting or lying down, reading, eating or talking. Margolies comes to the conclusion that art "is something one goes to see at the museum or theatre" while television "has none of the pretension associated with art experience" because "that insidious little box with its super-real image . . . is accepted in the home situation." The change of decor from the concert hall or the cinema to the home, regardless of its effects on our process of perception, in

[3] John Margolies, "TV: The Next Medium," *Art in America,* September–October 1969.

Les Levine: *Iris.* 1968. Three TV cameras and six monitors in an 8′ × 5′ console. In the collection of Mr. and Mrs. Robert Kardon, Philadelphia.

Nam June Paik: *Marshall McGhost.* 1968. Electronically distorted television image. 18″ × 14″. Photograph courtesy of Bonino Gallery, New York.

no way alters the structure of musical sounds or kinetic images. The problem poses itself, Margolies notwithstanding: what kind of imagistic structure—in terms of content perception—that is best suited for projection onto a small screen in the home situation? Les Levine's experiments with multiple screens will acquire aesthetic value if and when an artist learns to orchestrate projections much the way a composer orchestrates sounds emanating from various musical instruments.

HOLOGRAMS

Holography came into its own with the discovery, in the early sixties, of the laser ray. Holography has been defined as "a threshold step whereby one can record an object and reconstruct it visually in total, so that there is no way visually of telling whether it is or is not there."[4] Its most promising future in art may well be in the realm of the spectacle, eventually replacing the cinema, by reconstructing the total image of persons and objects. Billy Apple, however, foresees the time when, thanks to the laser ray, it will be possible to project

[4] Lloyd Cross, as quoted in foreword to *N Dimensional Space* (New York: Finch College Museum of Art, 1970).

simultaneously the hologram of an egg and, in this total image, the hologram of the embryo within the egg, concluding: "One might actually have the experience of going back to the womb, and then looking out from it."[5] It remains to be seen what advantages an artist can derive from such experiments.

N.C.

[5] Billy Apple, "Live Stills," *Arts Magazine,* February 1967.

Games

1. GAMES AND OPTIONS

If art is a language game (Wittgenstein), the artist will be playing a new game each time he changes the rules of his syntax. Unless we rule out the absurd from the domain of art, why not establish a category of "games without rules"?

" 'In a game the players are confronted with a situation in which "they can make use of their ingenuity to outwit each other."[1] By extension, whenever we find a situation in which one side tries to outwit the other, we should be able to discover the rules according to which they proceed. The Ancients had already placed merchants and players under the protection of the same divinity, Mercury-Hermes. Mercury is the god of interpretation, *hermeneia* in Greek. Interpreting rules is involved in playing games. Conversely, interpretation of the course of action leads to the formation of rules. Speech, viewed as a special type of activity, can be studied in terms of a game. Poets use their ingenuity in interpreting rules of grammar and syntax to produce a new interplay of words. When a player's interpretation taxes our credulity, we suspect that cunning has been substituted for ingenuity. Mercury would not have recognized this distinction: he was widely held responsible for encouraging his followers to cheat. Cheating, known as *ruse de guerre,* has been admired in the game of war ever since Ulysses devised the wooden horse. When cheating is used to deceive the uninitiated only, it is apt to be called poetic license, as in the case of the *deus ex machina;* it is branded as treason or hailed as heroism when it upsets the balance of power, as in the case of Prometheus stealing the fire."[2]

[1] J. C. McKinsey, *Introduction to the Theory of Games* (The Rand Series [New York: McGraw-Hill Book Company, 1952]), p. 1.

[2] Nicolas Calas, "Introduction" to *Games Without Rules* (New York: Fischbach Gallery, 1966).

Joe Jones: *Pool Games.* 1966.
Mixed media. In the collection
of the artist.

Among the games for an exhibition at the Fischbach Gallery was
George Brecht's deck of cards that no player could use to outwit his
opponent since the cards did not fall into any recognizable suit or
order; and a game by Nicolas Calas with chessmen identical in shape
and color for both players. Joe Jones, known for his electrically
controlled assemblages of musical instruments, had devised for this
occasion a double game, a pool game linked by hidden electrical
wires to an "orchestra." Whenever the metal billiard balls passed
over an electrically charged point of the green table, a corresponding
musical instrument would be set in motion. Gradually a whole con-
cert of aleatory music would take its cue from the pool game. Opera-

tionally the players served as pawns of a musical game. Ay-O's *Finger Game,* with its traplike holes, brought to the fore the fear of not winning which prevents the timorous from playing. The ambiguity between changes in rules and/or meaning is inherent in the immovable *Sculptmetal Knees* of Jasper Johns: is the implication that of knees knocking against each other or those of a partner?

Sidestepping the issue, certain artists—D'Arcangelo, Les Levine, Joe Moss—contributed solitaires and toys for adults, enchanting building blocks, balls, sound boxes.

Unlike "Games Without Rules," which aimed at exploiting the absurd, "Options," organized by the Milwaukee Art Center, drew attention to a growing tendency to "deny one of the prime tenets of tradition—that art should be fixed, set, and unchangeable, the established and final statement of the artist."[3] The analogy between the optional situation in a work of art and the game situation was clearly drawn by Lawrence Alloway in his introduction. Options offered included invitations to "walk in," "sit in," "insert hands," "pull me," "hold me," "squeeze me," "turn on," "talk to bulb," or otherwise handle an object. The spectator was expected to take advantage of his "right to draw on the art content of the work." When Alloway added that in Optional art the spectator is "in a sense, winning though the artist is not losing," he appears to be classifying Optional art works with toys. Optional art provides an engaging alternative to Optical art that reduces the spectator to a docile retinal response.

The catalog includes statements by contributing artists. De Maria's objects provide the spectator with but one option, Castro-Cid's *Electronic Instrument* offers as many alternatives as does the piano. "Yet is different since the nature of the reinforcement is unpredictable" (Castro-Cid). Öyvind Fahlström alone views options in postoperational terms. He insists that priority should be given to the emotional-intellectual response: "finding out about yourself by having to make choices. Elusive-mysterious quality of a never-fixed work of art—at

3 Tracy Atkinson, "Foreword" to *Options* (Milwaukee: The Milwaukee Art Center, 1969).

the same time the elements are very determined, personal (artist's personality)."

Alloway in his Introduction draws attention to objectless art games, to George Brecht and Robert Watt's "mailing to an audience, sometimes randomly chosen, of an assortment of things," as well as the correspondence of Ray Johnson which includes drawings and collages. Ray Johnson is to the letter what Cornell is to the box, and to Pop art what Madame de Sévigné was to Versailles. In the New York art world Ray Johnson stands midway between painters who reduce writing to the act of painting and to artists who dig the earth or wrap its cliffs to draw attention to themselves, or rather to their performance. Somewhere between the village idiot and the mandarin there is room for the clown, his antics amuse the crowd. The clown is the opposite of the dandy, whose saving grace is wit.

Öyvind Fahlström multiplies options to the point where a player is invited to recompose the picture. His works are antipuzzles for the cutout pieces are not expected to fit the order of a preestablished pattern; they are also antigames since there is no advantage gained by following one option rather than another, whether on canvas or posed on floats in a pool. When a viewer assumes the role of a player, he is likely to discover that each juxtaposition of pieces offers insights inciting to meditations.

"The *Planetarium* is based on Nathalie Sarraute's novel. Forty-two silhouette-like figures stand out against a background of empty space. At the bottom stands a smaller figure, the ego of the monologue, and the picture is contained in a speech bubble coming out of its mouth. . . . There are ninety-four magnetized costumes, inspired by comic strips, that can be put on the figures who thus change identity and even sex as the conversation piece proceeds. . . . The conversation remains just as fragmentary and meaningless whichever way the figures in the game are moved."[4]

Wittgenstein had envisioned the possibility of regarding the dream

[4] Öyvind Fahlström in catalog for **XXXIII Esposizione Internazionale d'Arte**, Venezia 1966.

Öyvind Fahlström: *The Planetarium*. 1963. Variable diptych, tempera on 188 cutouts, and vinyl on canvas. 197 cm. × 234.57 cm. × 57 cm. In the collection of Daniel Cordier, France. Photograph courtesy of Sidney Janis Gallery, New York.

as "a game in which paper figures were put together to form a story, or at any rate were somehow assembled. The materials might be collected and stored in a scrapbook, full of pictures and anecdotes."[5]

[5] Ludwig Wittgenstein, *Lectures and Conversations* (Berkeley, Calif.: University of California Press, 1967), p. 49.

Öyvind Fahlström: *Blue Pool*. 1969. Variable structure: enamel on steel, tank, dyed water, tempera on vinyl on styrofoam, and lead keels. 6″ × 42″ × 21″. Photograph courtesy of Sidney Janis Gallery, New York.

2. GAMES VERSUS CONTRACTS

"The theory of game is the logical foundation of a theory of rational conflict."[6] Analysis of art in terms of a game is at the antipodes of appreciation through affective identification with the work. Since "God is dead," psychoanalysis is probably the most widely accepted method of accounting for affective identification. Psychoanalytical treatment is based on the assumption that the patient will come to recognize the correctness of the analyst's assessment. As Wittgenstein has said: "If you are led by psychoanalysis to say that you really thought so and so or that really your motive was so and so, this is not a matter of discovery but of persuasion."[7]

The basic model of a rational form of agreement is the contract—regardless whether it was jubilantly or reluctantly signed by one or both of the contractual parties. Viewed as a prototype of agreement the contract is the opposite of the game, which is the prototype of a rational conflict. The action involved in playing the game should be

[6] Anatol Rapoport, *Two-Person Game Theory* (2d ed.; Ann Arbor, Mich.: Ann Arbor Science Paperbacks, 1969), p. 145.

[7] Wittgenstein, *op. cit.*, III, 33, p. 104.

differentiated from that involved in executing the clauses of a contract. A typical contract calls for the carrying out of a task (work) for remuneration. A game requires the undertaking of moves dictated by strategy. More broadly, work is constructive while strategic moves are polemical. In a game a distinction is to be established between winner and loser. The execution of the clauses of a contract is confirmation of the initial agreement. Subjectively the agreement could be described as a meeting of minds that, carried to its extreme, could lead to total identification. This was vividly expressed in a theological frame of reference by Christ when he said, "I and my father are one," and on the artistic level by Flaubert when he said, "Madame Bovary c'est moi." The opportunity given to the reader (or viewer) to identify himself with a hero is what validates poetry and art in the eyes of Aristotle and Freud.

The recent shift in art from techniques that encourage identification to those which stress irreducible differences between individuals reflects a loss of confidence in a contractual order and a mounting aggressiveness toward one's neighbors. To the romantic literature of love, Malraux, Sartre, and Robbe-Grillet oppose what the Surrealist writer Julien Gracq aptly calls *"la littérature du non."* Literature and art of the "no" have become a game in which the author "wins" by withholding information about the hero and precipitating events.

The spirit of the game requires that the player be not only rational but also ruthless.[8] Psychologically the function of games serves to channelize aggression. Obsessively the victor challenges ever better players. Likewise, the art of the "no" continues to search for further elaboration of the technique of dissociation. Contractual agreement, being the opposite of challenge, is measured in terms of fulfillment. The love pact *par excellence* provides the greatest sense of fulfillment by creating the illusion that the I and the Thou have transcended their separate selves and fused into one. The yearning for this fusion finds its expression in lyricism.

According to Anatol Rapoport, the current interest in game the-

[8] Rapoport, *op. cit.*, p. 104.

ories is due to the climate of war. (Yet some of the most lyrical and beautiful letters ever addressed to a woman were written by Napoleon Bonaparte during a military campaign. Has the lyrical vein that runs through modern art from Gauguin to de Kooning dried up?)

N.C.

Documenta

Modern art is characterized by a succession of returns to new beginnings. After a return to nature, to the colors of the spectrum, to the art of the primitives, to basic geometric forms, to fundamental structures, to deep emotions, to primary dreams and myths, to primary structures, we now witness a return to nature viewed as a sum total of the four elements. The spiritual father of the movement is Gaston Bachelard, author of *La Psychanalyse du Feu* and of later works of questionable merit such as a book on water and dreams, another on air and illusions, a third on earth and reveries and a more recent one called *The Poetics of Space*.[1] Since painting and sculpture consist in making objects, a rejection of objects in the name of one of the four elements can be defined as a nonobject art. Nonobject art has been labeled "conceptual." The uninitiated may find it as hard to understand what operations are involved in the production of a conceptual work as the physiologist does in understanding those involved in immaculate conception.

For all practical purposes conceptual art includes the elaboration of a plan for a happening to be enacted by a mechanized apparatus or the delimitation of a space to the mercy of the elements. An extreme example of nonobject art is given by Robert Smithson: in the devastation that "steel tractors, dumping engines, drills and explosives" bring to "the crust of the earth," Robert Smithson finds a confirmation of Heraclitus' remark that "the most beautiful world is like a heap of rubble tossed down in confusion." When Heraclitus coined this aphorism, however, our world was a cosmos (world) within the universe (cosmos) and destruction did not have the terrifying meaning it has acquired since man learned how to split the

[1] Gaston Bachelard, *La Poétique de l'Espace* (Paris: Presses Universitaires de France, 1967).

324

microcosm (or atom). Seen in its historical perspective, Smithson's statement sounds more like an infantile version of the chilling verdict of that anarchist Emile Henry, who, hurling a bomb into a crowded café, exclaimed *"Il n'y a pas d'innocents."* (No one is innocent.) Anarchism carried to the point of nihilism should be denounced today with the same vigor as were the nihilists of the nineteenth century by liberals such as Turgenev and radicals such as Lenin. The nihilist is to history what the atheist is to religion: a sterile negation. In an atheist world where all men were guilty, anarchists might be justified in destroying the whole of mankind. Similarly, when artists denegrate art objects, they espouse devastation.

Culturally a work of art is most comprehensively evaluated in a historical context, as do the neo-Hegelians, Marxists, and Freudians. For those who put history in brackets, the work of art is best described either phenomenologically, as by the gestaltists, or factually, as by the exponents of the information theory.

The gestaltists tend to consider the viewer as the receptor of optical phenomena. From this premise Nicolas Schöffer draws the conclusion that the object is but a "second degree" intermediary between the idea and its effect.[2] By substituting projections of light for solid sculpture, Schöffer believes that he establishes a direct rapport between the artist and the viewer. Since he replaces the object by a performance of lights, one could say that he has dematerialized the sculpture much the way film dematerialized theatre performance.

If the work of art is viewed as a source of information rather than as a phenomenon, one should, theoretically, be able to substitute literary and photographic documents for the object itself. Max Bense, however, seems to exclude this possibility by claiming that, while "the aesthetic process in painting is directed toward creation, the aesthetic process of photography has to do with transmission."[3] How is one to determine whether a painting is creation or not? Furthermore, how is one to determine when a work which provides information, whether

[2] Nicolas Schöffer, "Idée, Objet, Effet," *Art International,* January 1968.
[3] Quoted by Lawrence Alloway, Introduction to *Artists and Photographs* (New York: Multiples, Inc., 1970).

painting or photograph, is a work of art? More to the point is Dennis Oppenheim's contention that the photographic documentation is a "secondary statement . . . after the fact," the fact being, as Alloway points out, "the work out in the field."[4] Theoretically, it might be asked, why not reverse the order and view the work, transitory as it is, whether in the field, gallery or warehouse, as secondary in importance to the photographic document?

Unlike Oppenheim, Richard Serra wants his work to be comprehended as "presence."[5] His assemblage of crop (the waste product of the hot roll mill) or lead plates is to be seen, he explains, in "suspended animation, arrested motion. . . . The apparent potential for disorder, for movement endows the structure with a quality outside of its physical or relational definition." The artist has avoided using joints, clips, gluing, welding, as those seem to him "unnecessary and irrelevant and tend to function as interposed elements." To heighten this sense of unstable presence Serra suggests we train ourselves to look at works in terms of "procedural time," which is "the time of the film in its making" as opposed to the foreshortened "literary time." Serra demonstrated his idea in a film in which the camera registered the endeavors of a group of men to assemble the heavy lead walls of a "box." According to the artist, "the potential of the camera as an active device (tool) is being considered not only for its perceptual possibilities, but also as an element in the structure. Means and ends are being made explicit." He claims that by such means the viewer "experiences the time and place of subject and object simultaneously." I doubt it! What the viewer could *see* in Serra's movie was the action of a group of men moving and assembling the lead plates. What the camera *registered* was the place, and the working hours it took these men to complete their task. But the sculpture's "presence" is comprehended not in terms of motion and time, but in terms of the force of gravity that—in lieu of bolts—holds the sides together. Presence can only be either presence of something moving or not moving. To speak of "suspended animation" as does Serra is to avoid

[4] *Ibid.*
[5] Richard Serra, "Play It Again, Sam," *Arts Magazine,* February 1970.

the main issue. The question inescapably arises, what need had a sculptor today to surrender to the law of gravity when man's greatest achievements were brought about by defying gravity?

To Serra's "presence" Michael Heizer opposes "the real space."[6] Heizer objects to the use of objects on socioeconomic grounds: "The position of art as malleable barter-exchange item falters as the cumulative economic structure gluts." Disgusted by museums and collections that are "stuffed" with objects, Heizer explores "real space." This artist, who spent much of his youth involved in archaeo-

[6] "The Art of Michael Heizer," *Artforum,* December 1969.

Richard Serra: *One Ton Prop (House of Cards).* 1969. Lead. 48″ × 55″ × 55″. In the collection of George Waterman, Providence. Photograph courtesy of Leo Castelli Gallery, New York.

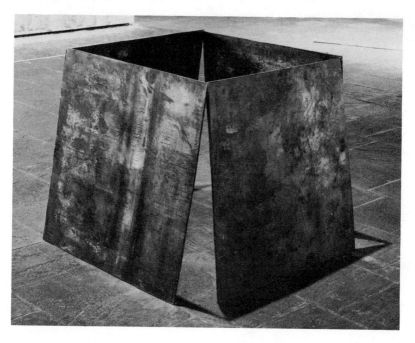

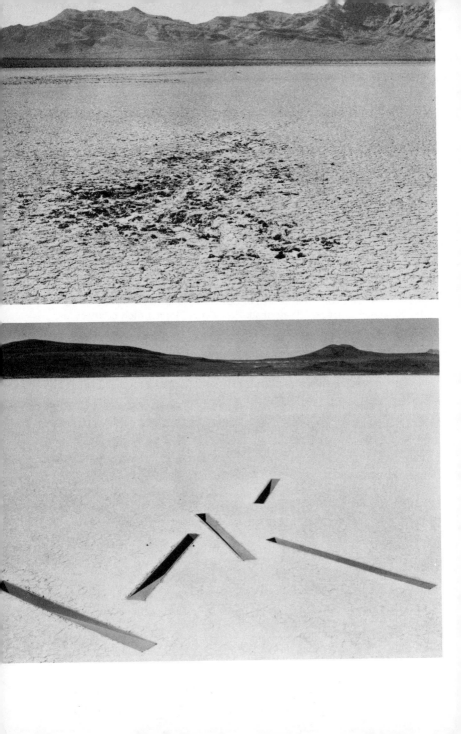

logical digs, is preoccupied with geographic locations. Possible sites for his works are first chosen on maps and eventually determined by aerial and ground survey. About his *Dissipate #8 of Nine Nevada Depressions* (55' × 50' area; Black Rock Desert, Nevada; August 1968) Heizer says that "there is no longer any photo that even loosely describes this work. These photos are taken 365 days apart. Next year the third and possibly final photo will be taken. It will probably only be the landscape."[7] All then that will remain of the work will be the photographic statement.

Christo's innovation consists in packaging patently immovable objects, be it buildings or the cliffs of the Australian coast. One is tempted to view those antipackages as false gifts. As for the photographic documentation of these provisionary wrappings, they are basically without interest, for the stupendous undertaking of wrapping the cliffs of the Australian coast is as worthless as was the labor of Sisyphus. Unlike the latter, Christo is not the victim of a cruel punishment but an applauded performer on the current art scene.

As Lawrence Alloway points out in the previously quoted provocative essay, accompanying the show "Artists and Photographs," the photographic image printed onto silk screen—as used by Warhol and Rauschenberg—helps to achieve the "twentieth-century dream of an instant, unrevised, all-at-once art form." In this context the snapshot might be viewed as a handier substitute for Duchamp's ready-mades. It should be recalled that when first exhibited these ready-mades were presented as antiart; yet when reproduced in the sixties they became documents about objects that in the meantime had acquired artistic

[7] Grégoire Müller, "Michael Heizer," *Arts Magazine,* January 1970.

(*Left above*) Michael Heizer: *#1 of Nine Nevada Depressions.* 1968–1970. Third deteriorated condition, Las Vegas. Photograph courtesy of Dwan Gallery, New York. (*Left below*) Michael Heizer: *Dissipate #8 of Nevada Depressions.* 1968. Black Rock Desert, Nevada. 45' × 50' area; each liner 144" × 12" × 0" × 12". Photograph courtesy of Dwan Gallery, New York.

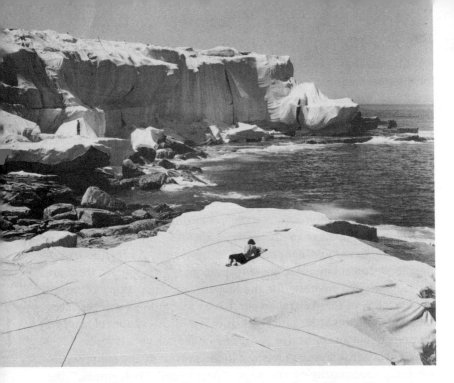

(*Above, and, detail, at right*) Christo: *Wrapped Coast* (One million square feet) realized at Little Bay, near Sydney, Australia. 1968–1969. 1,000,000 square feet of woven polypropylene and 35 miles of 1¼″ rope. 84′ high, one mile wide, 150′–400′ deep. Sponsor: Aspen Center of Contemporary Art. Photographs courtesy of John Gibson Commissions, Inc., New York.

meaning. Malraux made us aware that with photography we can have museums without walls; nonobject artists realize that, if they are to hold the attention of the art world at large, they must submit photographs of their works.

The document as such is of interest when viewed in terms of its historical sequence, for it is out of the fabric of documents that history is made. By a publication of a series of documents on Happenings, Kaprow finally bowed to history, first having defied it with performances which challenged the very notion of structure of dura-

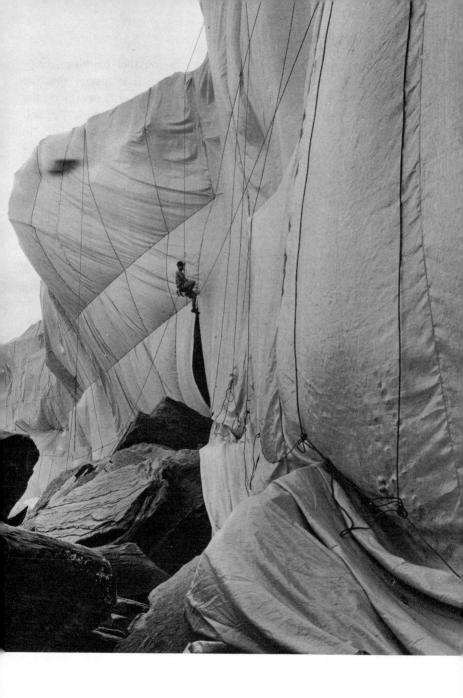

tion. Documents, unlike self-referent works, whether paintings, Happenings or Earthworks, require interpretation. It is history that the critic projects into the future. Like the farmer, the critic works on the assumption that the sun will rise tomorrow. Tomorrow he will classify other documents, shifting them as evidence accumulates in favor of one or another interpretation. He has done this before; he will do it again.

Heizer and his co-field workers delude themselves in believing that their repudiation of objects means negation of a social order which is bent on the mass production of worthless items. Symptomatically, many of the artists who prefer documents to objects offer for sale, through galleries, projects of field works. While documents may serve as evidence that a "work" existed or exists in some part of the world, the project serves notice that under certain arrangements a given project will be carried out. Those artists mistakenly believe that substitution of project and documents for object constitutes conceptual art.

The instructions contained in the plan are subject to correction, both structurally, in terms of function, and aesthetically, in terms of clarity. The blueprint is not a substitute for the work, nor the reading of the score a substitute for the performance of music. If it were so, Beethoven, in a fit of despair, would not have sought to smash the instrument which produced the sounds he composed but could not hear. The plan is a "proposition," stated in a technical language, not in a natural language belonging to the real world. As Wittgenstein has pointed out, we cannot rationally understand what is inside from what is without—his reason for claiming that the relation of the subject to the outside world is mystical and cannot be expressed in words. That which is indicated in technical language is kept outside the world of reality and hence apart from the inherent irrationality of the relation between the subject and the objects of that world. As long as a plan is not "realized," it avoids the risk of being exposed to the mysterious interrelation between the individual and the object, whether poem or edifice.

Historically, the mystery of a work of art derives from reinterpreta-

tion of the magic power once attributed to an extraordinary object by the primitive and the "presence" of a divinity in an icon. By beauty, the classicists meant the mystery of order, while by mystery the Romantics, from Hegel to Wittgenstein, meant the mystery of existence. Earthworks depend on premeditation, planning and documentation, which means that any mystery they might possess is negative, and developed in terms of the formula: "It is not. . . ."

N.C.

Dennis Oppenheim: *Maze* (Whitewater, Wisconsin). 1970. Hay, straw, corn, and cattle. 600′ × 1000′. Photograph courtesy of John Gibson Commissions, Inc., New York. "Schema taken from laboratory maze, transferred to a seeded alfalfa field, and cattle stampeded through to food deposits (corn). Concern is given here to the flow of moving bodies through an imposed structure, and the transference of material from external areas (food deposits) to the digestive tracts of animals. The site was selected for its particular surface characteristics (similar to the spotted hides of the cattle)."

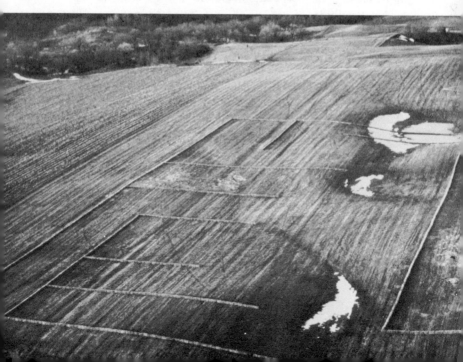

The Sphinx 1970

From the Romantics to the Surrealists artists relied heavily on the insight of poets. With the establishment of museums of modern art, especially New York's, the scholarship of the curators—stylistic analysis—gradually assumed the former role of poetic revelation. When Duchamp's ready-mades and the Surrealists' "found objects" were recognized as works of art, it became apparent that the function of antiart in our day was to reform, not to challenge art. Harold Rosenberg correctly diagnosed the situation when he interpreted modern art as the art of a culture that institutionalized change. Modern art, viewed as the "tradition of the new," the term Rosenberg so aptly coined, became, after World War II, the consolation prize of radical intellectuals who had once expected the Russian revolution to kindle the fires of "perpetual revolution."

The "tradition of the new" is a two-step process. First comes alienation from the currently predominant art style, then the cultivation of a new style. Authentic alienation, however, as understood by the Hegelians and post-Hegelians, whether Marxist, Freudian, or Existentialist, cannot be reduced to the repudiation or defense of a given style. Indeed, nothing could be more reassuring for the directors of museums who cultivate the tradition of the new, than to watch young artists protesting their exclusion from exhibitions. What else is their protest but an adolescent form of courtship?

By emphasizing style curators and critics circumvent the real problem of alienation. The belief that the work of art is a self-referent object presupposes its detachment from events that led to its production. Furthermore, the study of a given work of art in terms of self-reference discourages comparisons with works following a different system of self-reference. Each system is reduced to a language game whose rules are set by critics turned grammarians. A minute scrutiny

of the pictorial vocabulary replaces those sets of analogies by means of which systems of cross-references are elaborated. The loss of perspective in painting has been paralleled by the loss of perspective in time. Hence succession of changes are discarded, and descriptions of changes in the rules of the artist's language game take their place.

Games are for the "now moment," that battle cry of John Cage. His motto had a true ring when it became the imperative of a generation which developed a neurotic fear of being robbed of peacetime affluence, so characteristic of the Pop artists. Today's vanguard artists feel cheated when told that the war in Vietnam is conducted to save freedom, when sold sports cars which at their slightest mishap could become flaming coffins, when informed that our affluent society cannot function without unemployment.

Les Levine, by naming his handsome vacuum-made plastic multiples "disposables," focuses on the built-in obsolescence of manufactured goods. Disposables are generally graded below replaceable but indispensable goods, such as clothes, dishes, and hardware. Among disposables we could list such impermanent objects as the diggings in desert and snow, the submarine works and cliff wrappings of what has been aptly labeled Arte Povera. Most of its practitioners ostentatiously exhibit their poverty. One wants to ask for whose sake this poverty? Not for self-improvement, as was the poverty of Diogenes the Cynic; not for salvation, as was that of hermits; not for charity, as was that of St. Francis. Their poverty courts the despised but envied wealthy. What could be more titillating for the man who has everything from a cornfield by van Gogh to a color field by Noland, than to purchase a ditch in the desert, soon to be disposed of by nature?

Disposable art's function is to celebrate technology in the name of one-dimensional man. It is symptomatic that in a competition organized by Experiments in Art and Technology in 1967 for "works of art made in collaboration of an engineer and artist" the prizes were given only to the engineers, and exhibited in the "Machine Show" at the Museum of Modern Art. Tek artists might be reminded of Baudelaire's claim that "true civilization does not lie in gas, nor steam, nor turntables. It lies in the reduction of original sin." Commenting on these

words, Herbert Marcuse noted that reduction of original sin can only be achieved by a "revolt against culture based on toil, domination and renunciation."[1] A technological art must perforce serve the interests of those who are at the controls, for: "Efficiency and repression converge: raising the productivity of labor is the sacrosanct ideal of capitalist and Stalinist Stakhanovism," adds Marcuse. Efficiency can only be developed at the expense of expression of emotion: "The industrialization that prevails in all sectors of human life produces a distance between generations that is not compensated by the greatest family," says Konrad Lorenz.[2] Mass media tend, in a managerial society, to impose an impersonal father to a real one, says Marcuse in his *Obsolescence of Psychoanalysis*.[3] The only substitute for the absence of close family relations is to be found in "the instinctive need to be the member of a closely knit group fighting for common ideals," claims Konrad Lorenz. This in turn, as he points out, explains the formation of juvenile gangs. According to this behavioral scientist, "Without the concentrated dedication of militant enthusiasm neither art, nor science, nor indeed any of the great endeavors of humanity could have come into being."

Tek art turns the artist into a technician who, for the sake of experimenting with new tools, sacrifices iconic associations evoked by memory. Expressionism is existentialist, Tek art is instrumentalist. The technological revolution made it possible for the first time in history for human beings throughout the world, in their information about one another, to become a community united by shared knowledge and danger, says Margaret Mead.[4] Simultaneously this community finds itself divided by a broad generation gap: since those

[1] Herbert Marcuse, *Eros and Civilization* (New York: Vintage Books, 1955), Ch. 7.

[2] Konrad Lorenz, *On Aggression* (New York: Bantam Matrix Editions, 1967), Ch. 13.

[3] Herbert Marcuse, *The Obsolescence of Psychoanalysis* (Chicago: Black Swan Press, 1969).

[4] Margaret Mead, *Culture and Commitment* (New York: Doubleday and Company, 1970), Ch. 3.

born after World War II have the events presented to them "in their complex immediacy" and "are no longer bound by the simplified linear sequence dictated by the printed word." The younger people's attitude toward their elders reminds Dr. Mead of the children of immigrants watching their parents managing, often unsuccessfully and awkwardly, the tasks imposed upon them by their new conditions. Dr. Mead calls this new culture of our day "prefigurative" to distinguish it both from the "postfigurative" culture of the immigrants who cling to memories of their native land and to the "co-figurative" culture of the pioneer countries in which children of the immigrants are reared.

Let it be recalled that Nietzsche was the first to dramatize the contradiction between a civilization that had made possible the unification of all the people of the world into one state and the inability of these same people to overcome their narrow-minded parochial ways of thinking.

Margaret Mead notes in passing that some of the dissident younger generation "try to adapt to their own purposes the words of an aging Marxist, Herbert Marcuse." Why not? The Marxists are historical-minded radical political thinkers who advocate change in prefigurative terms. This is what distinguishes them both from the utopian socialists, who, in the name of the assumed goodness of natural man dream of restoring the postfigurative terrestrial paradise on a high level of civilization, and from the Fascists, who in the name of superman would have restored the rule of a chosen people, but on an international scale.

Marxists, true Marxists, struggle in the name of a prefigurative view of society to bring about the overthrow of capitalism, for they aim at establishing a classless international society. Rather than concentrate their attention on technological problems in the manner .of the pragmetic managerial élite of America and Russia, Marxists such as the Belgian economist Ernest Mandel follow closely the effects of automation upon concentration of capital, upon competition between America, Europe and Japan, upon the wage differential

between various capitalist centers, upon the contradiction between the capitalist and the noncapitalist world and the consequences that these antagonisms could eventually have upon workers of the industrialized countries and the masses of the underdeveloped countries.

The Marxists and the cultural anthropologists proceed from different premises. The former study civilization from its origin to the present in terms of economic structures that determine working conditions, the latter study cultural patterns as they emerge from a close scrutiny of sets of interpersonal relations. With this distinction in mind we can avoid both reducing art to an epiphenomenon, as do dogmatic Marxists, and dissolving class antagonisms into sets of interpersonal relations, as do the pragmatists. To the extent that art reflects a given order it has a meaning that can and should be interpreted in cultural terms. Marcuse's claim that young radicals must reject contemporary culture as a product of oppression stems from his belief that art could be reduced to form. To the extent that art "reflects" and "expresses," its form is "linguistic" and serves to transmit cultural messages. Art viewed as a language through which emotions are expressed should be backed by radicals, for expression of emotion undermines controls, even when it serves the cause of oppressors, as in the case of Fascist Ezra Pound and Nazi Emil Nolde.

Since art substitutes communication for action (which is what sublimation means), a prefigurative art is one that could correspond to the needs of a culture that rejects a postfigurative Freudian view of Oedipus. Our contemporary culture should view Oedipus' ordeals of guilt and self-hatred as an intolerable injustice, more rightly reserved for those whose crime was committed intentionally rather than in ignorance. Nietzsche's hero, a superman for having overcome guilt feelings, was rejuvenated by Otto Rank through a psychoanalytical myth which equates the hero with the younger brother in the role of a savior. Today, however, militant youth has rejected all attempts to justify salvation in postfigurative terms, whether Nietzschean, Freudian, or Rankian, on the assumption that *the future is now*.

Interpreted literally, this doctrine has led ultraleftists to confuse

tasks best reserved for the future with present ones. The systematic pursuit of a strategy developed from this premise, instead of alleviating the pangs of revolution's birth, would precipitate a miscarriage leading to a super-Fascist regime.

The future-is-now is a challenge to the Stalinists, who, for half a century, encouraged their followers both to sacrifice the present in the name of the future, and delay the struggle that would give birth to this future so that their bureaucracy could be maintained. Mao, in the mid-sixties, exploited the aggressivity of youth to overthrow the Communist bureaucracy that had developed in China. Margaret Mead interprets this as an attempt "to turn the restive young against their parents as a way of preserving the momentum of the revolution made by grandparent generation."[5] For Dr. Mead this cultural revolution is "a tremendous effort to transform the desire to destroy, which characterizes the attitudes of young activists all around the world, into an effective instrument for the preservation of the recently established Chinese Communist regime."[6] From a socialist point of view, however, the Chinese Communist regime and the momentum of the revolution are not synonymous. The rejuvenated socialist momentum will be once again prematurely spent if the Maoists cling to the chauvinistic Stalinist doctrine of socialism in a single country.

For the hippies the future-is-now means that a culture defended and supported by work and oppression should be defied by the cult of sex and play. Theoretically, the hippies' position could be upheld in terms of Wilhelm Reich's interpretation of Freud's theory of sexuality as incompatible with his latter-day theory of sublimation. With the hippies art is replaced by would-be Dionysiac orgies. The hippies seem to be a modern counterpart of the fifteenth-century nudist Adamite orgiastic cult.

The comradeship of militants leads to a reinterpretation of interpersonal relationships that makes of fratricide a crime worse than patricide. Lorenz's major contribution to genetic psychology is his discovery that animals also cultivate repressions and that their

[5] Mead, *op. cit.,* Ch. 3.
[6] *Ibid.*

strange rituals are compensations for repressed aggressive urges directed against members of their species.[7] Modern militant art groups tend to overcome interpersonal rivalry by elaborate play. Famous are the Surrealists for their word and picture games, and the Happenings of the proto-Pop artists. Such groups cultivate aggressivity in lieu of repression of emotions, lyrical outbursts in lieu of perfection, distraction at the expense of careerism. The jargon, mannerisms, tastes, passions evolved within a militant group become the trademark of a subculture and serve as criteria for determining the cultural value of the works produced by its poets and artists. This subculture's significance will be determined by its ability to interrupt the tradition of the new. One of the important effects of telecommunication has been to undermine the prestige of centers of Surrealist or Communist orthodoxy, and encourage the mushrooming of pluralistic views on Marxism and Surrealism.

Group activity would at this time be of enormous help to the black artists of America. After recalling that Malcolm X had said, "There can be no Black-White unity until there is first some Black unity," we should add that there can be no art by black artists before black painters and sculptors undertake to perform in groups of militant artists, black or mixed.

Today the militant activity of vanguard artists is concentrated in protest, for the greatest scandal of our day is political. Protest leads to alienation from the establishment, not from society, from faceless authority, not from the faces of one's brothers. Protest is identified with a revolt against injustice, not with negation of culture, as proposed by Marcuse. Negation for negation's sake, whether in art or politics, is but a form of despair.

The historical function of an artistic and literary vanguard is to shift our point of view by focusing attention on a new set of key images. Since the humanists taught that *knowledge is power,* artists came to believe that their role was to *know how to see.* The *see what I know* viewpoint of the modern artist corresponds to the libertarian's faith in his own self. After World War II art was to come more and

[7] Lorenz, *op. cit.,* Ch. 5.

more under the control of a managerial elite. Today, works are apt to be treated as optical phenomena: whether the artist is wise or foolish, saved or damned, becomes irrelevant, superceded by the problem of the good or bad gestalt.

Knowledge is power: *know how to see/ see what I know.* What does the artist expect from those he feeds with the information contained in his work? Sympathy and esteem. The greatest are the artists who receive admiration for attempting the impossible: indistinguishability between illustrations and reality (Classicism), reduction to oneness of multiple points of view (the Baroque), spiritualization of reality (Romanticism), materialization of the dream (Surrealism), fusion of the work with the self (Abstract Expressionism), elimination of contrast between figure and ground (Geometric Abstraction).

The unachievable goal of Barnett Newman, that greatest of color-field painters, was to generate light with a few vertical planes. In contrast, Ad Reinhardt *avoided* making a painting as dark as black so as to imply mystery. The presence of mystery is in the enigma. From fear of Oedipus Reinhardt *avoided* it. Not so Marcel Duchamp.

To Oedipus the artist should oppose the Sphinx, a hybrid who is to nature what adulteration is to art, a fusion of unmatching parts. The historical task of the poet is to outrage (*hybris*) by withholding knowledge and by challenging established values. The Sphinx challenged Oedipus with a riddle, punning images and meaning. Oedipus disentangled the knot and revealed to the world the secret of the riddle, thus liberating man from the need to worship inhuman figures.

What a joke to have permitted a man to answer a hybrid: "Man." Joking at the expense of another's mistakes is a form of irony. With puzzles and irony we juggle with meaning and nonsense, reason and folly. The appreciation of irony requires that we shift emphasis from style to performance. The supreme irony consists in joking at one's own expense, as did Socrates when he said, "I know one thing, that I know nothing." Before art could produce its Socrates, the artist had to discover his own particular world of play, the modern equivalent of the Athenian banquets.

With Renoir's *Moulin de la Galette,* Toulouse-Lautrec's *Moulin*

Rouge, Manet's *Le Bar des Folies-Bergères,* Seurat's *Le Cirque,* Degas' ballets, we enter the artist's world of fun and say farewell to both the *fêtes galantes* of Watteau's patrons and the crude amusements of Breughel's peasants. With Duchamp, play, at the expense of the artist's own performance, raises painting to the height of Socratic irony.

Assuming the role of the Sphinx, the poet-artist sees darkly, in prefigurative terms, what Oedipus saw in co-figurative terms, Man; and what Freud saw in postfigurative terms, Oedipus.

> *What is the creature who*
> *roars like a lion,*
> *soars like an eagle*
> *and talks in riddles?*

N.C.

Index

(Page numbers in **boldface** indicate illustrations.)